Creating 3D Game Art for the iPhone with Unity

Praise for Creating 3D Game Art for the iPhone with Unity

As the sophisticated tools for creating and implementing assets for gaming become more accessible to the artist, the knowledge of how we employ them in the commercial pipeline is not only important but more essential than ever. This title serves as a comprehensive guide along this path of taking a strong concept idea and streamlining it into an exciting and fully realized project! Wes guides you through the many steps involved and the use of these powerful 3D tools (modo, Blender, and Unity) to help demystify the process of game creation and artistic expression.

Warner McGee, Illustrator/Character Designer

Simply put, this book contains the "secret sauce" for adding 3D to your iPhone or iPad game. Nice job Wes!

Bob Bennett, Luxology LLC

"Wes does a great job of holding the reader's hand while walking though the nitty gritty of game development for the Apple mobile devices. The barrier between art and technical knowhow is blurred enough for an artist to stay comfortable handling the technical aspects of game development. A great book for the game developer in all of us."

Yazan Malkosh, Managing Director, 9b studios

Creating 3D Game Art for the iPhone with Unity

Featuring modo and Blender Pipelines

Wes McDermott

AMSTERDAM • BOSTON • HEIDELBERG • LONDON • NEW YORK • OXFORD
PARIS • SAN DIEGO • SAN FRANCISCO • SINGAPORE • SYDNEY • TOKYO

Focal Press is an imprint of Elsevier

Focal Press is an imprint of Elsevier
30 Corporate Drive, Suite 400, Burlington, MA 01803, USA
The Boulevard, Langford Lane, Kidlington, Oxford, OX5 1GB, UK

Notices

The character designs and concepts for Tater, Thumper, and the Dead Bang game are intellectual properties of Wes McDermott.

Tater and Thumper illustration created by Warner McGee.

Knowledge and best practice in this field are constantly changing. As new research and experience broaden our understanding, changes in research methods, professional practices, or medical treatment may become necessary.

Practitioners and researchers must always rely on their own experience and knowledge in evaluating and using any information, methods, compounds, or experiments described herein. In using such information or methods they should be mindful of their own safety and the safety of others, including parties for whom they have a professional responsibility.

To the fullest extent of the law, neither the Publisher nor the authors, contributors, or editors, assume any liability for any injury and/or damage to persons or property as a matter of products liability, negligence or otherwise, or from any use or operation of any methods, products, instructions, or ideas contained in the material herein.

Library of Congress Cataloging-in-Publication Data
Application submitted.

British Library Cataloguing-in-Publication Data
A catalogue record for this book is available from the British Library.

ISBN: 978-0-240-81563-3

For information on all Focal Press publications
visit our website at *www.elsevierdirect.com*

Printed in the United States of America
10 11 12 13 14 5 4 3 2 1

Typeset by: diacriTech, Chennai, India

Working together to grow
libraries in developing countries

www.elsevier.com | www.bookaid.org | www.sabre.org

ELSEVIER BOOK AID International Sabre Foundation

Contents

Contents

Contents

Dedication

To my wife Ann Marie, daughter Abby, and son Logan.

Acknowledgments

To my Lord and Savior Jesus Christ, thank you for my blessings and opportunities. Apart from you, I can do nothing. To my wife Ann Marie, daughter Abby, and son Logan, thank you for your encouragement, support, and patience through the long nights and weekends I had while working on this book. I love you guys!

One person alone can't write a book. There were several amazing and talented people who provided input, help, and support throughout the entire process. To those, I sincerely thank you.

To Oleg Pridiuk, the book's technical editor, your technical input and industry experience was an amazing asset to the book. I couldn't have made it without you! I'm so glad you were on this journey.

I'd also like to thank several integral Unity team members Paulius Liekis, Alexey Orlov, Renaldas Zioma, Tom Higgins, and David Helgason for their gracious support and technical input as well as everyone else at Unity Technologies. You guys love what you do and believe in your product and it really shows. This release of Unity is simply awesome, and it's been great to write a book on such an incredible application.

To Warner McGee, who provided the incredible illustration of Tater, it was awesome to collaborate with you on this project! Your work never ceases to amaze me, and I thank you for your hard work illustrating Tater.

To Efraim Meulenberg (Tornado Twins), who graciously provided a camera control rig from UnityPrefabs.com. You were quick to lend a helping hand to a fellow developer and are always fun to talk with. I greatly appreciate your support!

To Bob Berkebile, whose iTween Animation System provided a quick and easy solution for the book's demo app. Thanks for lending a helping hand with some coding.

To Thomas Rauscher, the creator of Pano2VR, thank you for providing me a copy of Pano2VR for the book. I greatly appreciate it!

To Yazan Malkosh, thank you for your support on this book. You are an amazing 3D artist, whose work I've always admired.

Acknowledgments

To Bob Bennet of Luxology and the entire modo development team, you guys have been very supportive in my writing efforts, and I very much appreciate it! Keep on making modo awesome!

Thank you, to all of my friends and family who've always supported me as well as all of the wonderful artists I've met online via Twitter and other social media outlets, your support helped to keep me going on this project.

Finally, thank you, the reader, for buying this book. I hope you enjoy it and that it helps you to better understand creating 3D content for iPhone and iPad development using Unity iOS.

Prologue: Thump'n Noggins

As a 3D artist, you'll find yourself presented with numerous opportunities and avenues to explore within different industries. The skills of a 3D artist are used in visual effects, motion graphics, print, architecture, medical, and, of course, games, to name a few. I've been working as a 3D artist for over 11 years and have always been more of a 3D generalist having worked in video, print, and multimedia. Of all the different types of projects I've worked on, creating interactive 3D graphics has been by far the most fun.

I started creating interactive training content at my day job using Flash. Needing to produce more complex training using 3D content, I began to use Microsoft's XNA Game Studio. It was very rewarding to build 3D content and then be able to bring it to life, so to speak, through interacting with the content in a game environment. For me, it was much more rewarding than just rendering an animation. With games, I could create animations and then program scenarios in which a user could interact with my content in real time. I was hooked!

I've read tons of game art books in my time and each one always left me with many questions. Most game art books discuss the typical scenarios of building low-polygon objects, creating normal maps, and so on. But these books never talk about the why. In order to maintain a generalist approach, they leave out the most important aspect of creating real-time content, which is how the 3D content specifically relates to a specific game engine. 3D art is technical, and creating 3D games is even more technical. I feel that you can't realistically talk about creating 3D game content without thoroughly discussing how it relates to the game engine and hardware the content is targeted for and this is what I consider to be this book's main strength. The fundamental difference between this book and a typical game art book is that we are going to take an in-depth look at creating game models, textures, and animation so that they're properly optimized for a specific game engine and hardware that they will run on. Our focus for this book is creating game assets for use in Unity iOS, which was created by Unity Technologies for creating games to deploy on all of Apple's iDevices such as the iPhone, iPod Touch, and iPad.

Why Focus on Games for the iPhone, iPad, and Unity iOS?

I think it's amazing that there are now many ways to get your work, i.e., game, shown and available to mass audiences. The two markets that have caught my interests over the last few years are Xbox LIVE Indie Games and Apple's App Store. My first interest in independent game development was through

Xbox LIVE Indie Games, which uses Microsoft XNA Game Studio. However, being more art orientated, I found that coding games using XNA can be a slow process and rather difficult to grasp. Being a multimedia developer, I'm very familiar with programming in terms of scripted languages such as Flash ActionScript, JavaScript, and Python. Unity iOS provides the perfect solution in that you get a full 3D environment similar to the 3D apps for building scenes in an intuitive, artistic manner as well as the ability to code games in a scripted language such as JavaScript. Unity iOS allows me to focus on my strengths, which is the art-side of game development while still being able to code and create an engaging interactive experience. It's the best of both worlds, fused into an application built from the ground up for rapid game development.

Unity also has the ability to publish games on multiple platforms such as Wii, iPhone and iPad, Android, desktop, and Web and with Unity 3.0, support for Xbox 360 and PS3 as well. For instance, with Unity, it takes little effort to port your game from the iPhone to another platform such as the Web. Unity also supports the major 3D animation packages and mainstream formats such as FBX. As an artist, I find Unity to be an indispensable tool for creating interactive 3D content and my game engine of choice due to its ease of use and artist-friendly tool set.

A game engine such as Unity needs hardware to run on and as stated Unity iOS will run on various hardware platforms, most notably of which is Apple's iDevices such as the iPhone, iPod Touch, and iPad. Apple's iDevices provide an elegant operating system, referred to as iOS, and provides a cohesive standard for development across all of its platforms. It has been said that Apple's keeping such an iron-clad grasp on its hardware and OS makes for an inferior product, but as a game developer, I feel that this closed environment takes the "guess-work" out of how my particular game will run on the platform. With the iOS, there is a handful of devices my game can be targeted for, and although internal hardware between the devices such as the iPhone and iPad differ, for the most part, the hardware provides a standard in terms of developing for the iOS devices, which makes it easy to target optimizations and build games that run on each platform with little effort. Now, as new generations of the devices such as the iPhone 4 are made available, the hardware will certainly change and become more powerful. So, the number of device generations you want to support with your game will dictate the level of support complexity in terms of building optimized content that will run well on all of the iDevices.

Not only does Apple's iOS provide a standardized environment but it also comes backed with a massive marketplace. With the invention of the App Store, Apple established a mass market for developers to publish and sell content, which continues to rapidly expand each day. At the time of this writing there is currently over 250 thousands apps available and over 5 billion downloads. Also, Apple has paid out over 1 billion dollars to developers. There are over 1000 games powered by Unity available on the App Store, and this

Writing Code with Unity
Unity also supports C# as well as JavaScript languages. If you've used C# with XNA Game Studio, then coming over to Unity is a breeze. No matter what level of programming experience you have, Unity has something for you.

number continues to grow rapidly. Several of these games have been critically acclaimed in the top 25 and top 100 lists on the App Store. Unity has proven time and time again to be a solid development platform and the best middleware solution for creating games for the iPhone and iPad.

However, Apple's App Store is not without its controversy, and as a game developer, it's best to always look at every opportunity. Many have stated that the market is way over saturated and tough for the independent game developers to get noticed. I can definitely agree this can be the case, but if you have a passion to create games, it can be deeply rewarding to publish a game that has potential to be placed in front of millions of users. With the App Store, the market is there, and you'll never know how successful your game could be unless you try.

Also, Apple does review the apps submitted and retains the right to reject your application. During the writing of this book, I as well as all developers went through a tough time and faced the possible exclusion of Unity iOS from the platform when Apple changed their Terms of Service in Section 3.3.1 of the SDK agreement. Of course, the amazing development team behind Unity was able to weather this storm and as it turned out, Apple amended the TOS to allow third-party development tools.

I really like Apple's development environment and solely choose to develop for the iPhone and iPad. A standardized developing environment, backed with powerful hardware capable of running high-end games and a massive marketplace, makes using Unity iOS and Apple's iDevices a premiere solution for independent game developers. With that said, as a game developer, it's always best to not put all of your eggs in one basket so to speak. Diversifying your platforms can be a good thing, and although Apple's platform is great, it's not the only game in town. There's Android and Windows Mobile to name a few other key players in the mobile market.

Prerequisites: What Should I Know?

At this point, you're probably asking yourself, "Ok, this sounds good, but what do I need to know?" As stated earlier, the focus of this book is to address a particular need in game development, which is creating 3D content. In this book, we won't be covering the process of creating an entire game. However, we will be taking an in-depth and unique look at how 3D content specifically relates to Unity iOS in terms of building highly optimized content specifically for deployment on the iPhone and iPad.

> *In this book, we won't be covering the process of creating an entire game. However, we will be taking an in-depth and unique look at how 3D content specifically relates to Unity in terms of building highly optimized content specifically for deployment on the iPhone and iPad.*

This book will cover in-depth the principles behind creating 3D content for the iPhone and iPad using Unity iOS, as this book is written for registered iPhone

developers and 3D artists who are looking to increase their knowledge on creating 3D game art. By understanding these principles, you will be armed with the technical knowledge to begin creating content for your own games. Although topics are covered in-depth and are not just theory, we won't be going through complete step-by-step tutorials. I've always felt that step-by-step tutorials only guide one through the creation of a specific game object or model, which rarely relates to your own projects and needs. By learning the principles behind the process, you'll be able to focus on creating your own content.

With this in mind, you will need to have a working foundation of the tools that we'll be using throughout this book, which are modo, Blender, and Unity iOS. This book won't discuss how to use these tools from a beginner's point of view. Instead, it will focus on using these tools for the specific workflow of creating optimized game art. For example, in Chapter 1, "Getting to Know the iDevice Hardware and Unity," we'll discuss the technical aspects of the iOS devices and how they relate to Unity iOS, but a working knowledge of Unity iOS will be needed as we won't discuss basics such as importing assets or attaching components. Similarly, a working knowledge of a 3D program is needed. For instance, we'll be building assets in modo, but you'll need to know the modeling tools and understand UV mapping. The reason for not covering such basics is that it allows the topics in the book to focus on specific more advanced tasks as they relate to creating optimized game content for deployment on the iPhone and iPad.

This is a highly specialized book, and it's written to be the book I wish I had when I was getting into Unity iOS and game development for the iPhone. It's about trimming the fat in order to get to the meat of the discussions and maximize the important concepts the book needs to cover and what most other game books leave out.

In this book, I'll be using a combination of the Unity iOS Basic and Advanced Licenses. The Basic License is the least expensive, entry-level route to getting into developing games for the iPhone using Unity iOS. The book's demo app will be published with the Basic License. You can see the differences between the Basic and Pro licenses by visiting this link http://unity3d.com/unity/licenses#iphone.

I use Luxology's modo software as my primary 3D creation tool. Modo is great for game development as well in that it provides a streamlined modeling and 3D painting tool set. Modo's rendering pipeline allows for quick and easy baking of textures and lightmaps. That being said, the concepts illustrated in this book are based off principles to game development that can carry over to any 3D application, so feel free to use your application of choice while following along. I'm a firm believer that tools are only tools, and it's the artist and their skill set that makes a game good. A good example of this is in the usage of Blender within this book. In my everyday workflow, I use Autodesk Maya in conjunction with modo. Maya is my 3D app of choice for rigging and character animation, but to help keep this book open to as many as possible,

I will be using Blender for the rigging and animation portions of this book. The main reason being that Blender is an open-source application, which doesn't add any additional cost to your pipeline and is more readily available. Also, since we are discussing key principles to rigging and animation for iPhone games using Unity iOS, it doesn't really matter which 3D application you use and it really comes down to personal preference.

Even though this is a game art book, we'll be covering the process of creating game art in conjunction with a particular game engine in-depth, which means we can't entirely leave out programming concepts. It would be beneficial to have a working knowledge of basic programming concepts within Unity iOS.

Getting Down to the Core Principles

I've mentioned earlier that we won't be going through any step-by-step tutorials throughout this book. Now, if you're a little bummed, hold on and let's take a look at why I've decided to omit exhaustive step-by-step tutorials. I've been studying 3D for a long time and have definitely gone through my fare share of tutorials over the years. One thing that I've noticed is that I seemed to never take much away from step-by-step tutorials. Now, these types of tutorials are great for beginners and were just what I needed when first learning how to model. However, when I was looking to move to the next level, step-by-step just didn't cut it. What I found was that by following along in a "3D-by-number fashion," I was missing the vital principles behind the process. I was missing the "why" driving the techniques. Also, I found that more times than not, I'd get so bogged down in 40 plus pages worth of complicated steps, that I'd completely miss the whole point behind the techniques of building the model, not to mention the fact that I was only learning how to create a specific object.

I feel it's very important to communicate the core principles and techniques behind the 3D creation process, so that you, the reader, can take these principles and use them to build your own projects instead of recreating something specific I came up with. The point is, once you understand the core principles behind a process, you can use these principles to work out your own techniques and ultimately get up to speed on your own projects much quicker.

Although we're on the topic of your own projects, I wanted to also quickly reiterate the fact that which 3D applications you use is completely up to you. I mentioned that I'd be using a modo/Blender pipeline throughout this book; however, the topics covered can be used in any 3D application. One app isn't particularly better than another, and I strongly urge you to always keep in mind developing and or customizing your own pipeline.

Artists work differently, and no one way is the correct or only way to get a project done. You don't have to use modo or Blender to follow along with this

book. In fact, as I already mentioned, I'm more of a modo/Maya user myself. Since it is free, Blender was chosen for the animation chapters and also makes a great companion to modo due to modo's current lack of mesh skinning features without digging into your pocket book. I simply took my workflow from Maya and extended it to Blender. Answering the "why" behind the techniques and not step-by-step instruction makes this possible.

Meet "Tater"

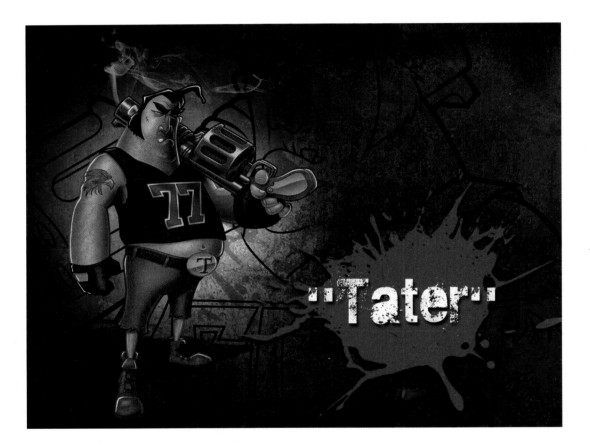

Tater is a character that I developed with the help of the extremely talented character artist and illustrator Warner McGee, http://www.warnermcgee.com. I had a concept for Tater and contacted Warner to help flesh out and add his artistic expertise to Tater's design. Not being an illustrator myself, I handed Warner some very basic sketches of the design and he worked his magic from there, producing the version of Tater showcased in this book. It was awesome to work with Warner on this project, and it was a lot of fun to see him develop my original concept into a fully realized character. Since Tater will be used in

other projects beyond this book, I also created a back story in order to create an immersive game property.

Tater is a reluctant hero from a personal game project I've been working on called "Dead Bang." The content that we'll be exploring in this book are elements taken from Tater's world and the Dead Bang game concept. In Dead Bang chapter 1, Tater is the only surviving member of a small country town in a zombie apocalyptic nightmare caused by peculiar device called the "Brain Masher." Armed with his trusty sidekick, "Thumper," a lethal-modified shotgun that Tater yields with a surgical-like accuracy, decapitating the heads of the walking dead with each pull of the trigger, Tater scourges the land looking to rid his hometown of the unwelcomed guests and to disable the Brain Masher device. The only thing that Tater likes more than disintegrating zombie heads, which he affectionately refers to as "Thump'n Noggins," is devouring a fresh bag of "Bernie's BBQ Potato Chips," which earned him the nickname, "Tater."

Throughout this book, we'll be taking a look at some elements from Tater's world to illustrate the topics covered in the book. We'll look at the creation and animation of Tater and Thumper as well as an environment from the "Dead Bang" world so that they are optimized to run on both the iPhone and iPad.

Book Resources

In addition to the content found in this book, you also find a wealth of bonus material in the form of video walkthroughs on the book's resource web site. You can get to the book's resources by visiting http://wesmcdermott.com and clicking the "Creating 3D Game Art for the iPhone Book Site" link. From the book's official web site, click the "Tater's Weapon Load out" link. When prompted for the login, enter "tater" for the username and "thumpNoggins" for the password. At the beginning of each chapter that has extra video content, you'll be reminded to check the resource site, which will be signified by callout "Tater's Weapon Load Out."

The book also has its own iPhone and iPad app called "Tater." The app serves as a creative demo, running the content discussed throughout the book on the actual iDevices. With "Tater," you can run through Tater's training trash yard shooting targets. The app showcases all of the game assets and animations discussed in the book. You can find more information on how to get the "Tater" app on the book's official web site.

The Adventure Begins …

We've got a lot to cover, and we'll begin by taking a detailed look under the hood of the iDevice hardware and Unity. Once we've got a solid understanding of the hardware driving our game, we can begin building optimized content.

When you're ready, jump into Chapter 1, "Getting to Know the iDevice Hardware and Unity iOS," and as Tater would put it, "let's thump some noggins!"

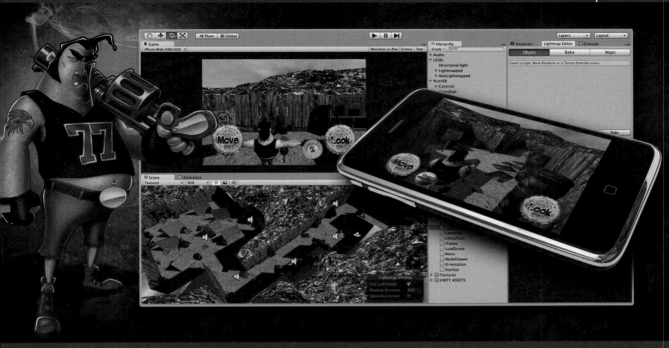

Getting to Know the iDevice Hardware and Unity iOS

The technical understanding behind creating game assets is more in-depth than just modeling low-resolution geometry. Before we can get into actual modeling or creating texture maps, we'll first need to have a solid understanding of the hardware and game engine that the content will run on. Each platform or device will have it's own limitations, and what might run well on one platform doesn't mean it will run as well on another. For instance, the faster processor in the iPhone 4 or iPad, in some cases, may help in the processing draw calls than the slower processor in the iPhone 3GS. Another good example is that although the iPad has a 400 MHz boost in chip performance, the lack of an upgraded GPU introduces new bottlenecks in performance to be aware of. This is where the project's "game budget" comes into play. Your game budget is the blueprint or guide through which your game content is created. There are three specifications to be aware of when evaluating the hardware of the iPhone and iPad, which are memory bandwidth, polygon rate, and pixel fill rate. For instance, if you have a fast-paced game concept, you'll need to denote a high frame rate in your game budget such as 30–60 frames per second (fps), and all of the content

Creating 3D Game Art for the iPhone with Unity. DOI: 10.1016/B978-0-240-81563-3.00001-2

1

you create must be optimized to allow the game to meet this frame rate budget. You'll also need to take into consideration that with the iPad, you're essentially rendering to a pixel count that is over five times that of the iPhone 3GS and around 1.2 times that of the iPhone 4 screen, which results in 5–1.2 times the amount of data being processed per frame. Without a solid understanding of the capabilities and limitations of the device your game is targeting, you won't know what optimizations to the game content that will be needed to achieve your game's budgeted frame rate. Essentially, it would be like working in the dark.

The goal of this chapter is to turn the lights on so to speak by familiarizing you with the iPhone and iPad hardware as well as take a look under the hood of the Unity iOS game engine. By familiarizing ourselves with the different iDevices and what's going on under the hood of Unity iOS, we can then understand the "why" behind building optimized content for these devices. We will also be able to properly determine the frame rate, poly-count, and texture size budgets in our overall game budget, which is determined by a balance of the type of game you're creating and the targeted frame rate, all of which is ultimately controlled by the hardware's memory bandwidth, polygon rate, and pixel fill rate.

iDevice Hardware

Technically Artistic

When discussing game development, topics can quickly become very technical and programmatic as we're discussing real-time graphic implementations and mobile hardware limitations. Being a 3D artist, I found that it wasn't the modeling and texturing that was difficult in creating game art, but it was in understanding the technical limitations of the hardware and OpenGL implementations to creating real-time graphics that I had a tough time. Not to worry, this chapter's main goal is to discuss the following topics from the point of view of the game artist.

In this section, we're going to discuss the hardware for the iPhone and iPad, and at this point, I'd like to make a couple of distinctions between the device models. Throughout the book, I will refer to the term "iDevices" to encompass all of the devices, i.e., iPhone, iPad, and iPod Touch. The term "iOS" is Apple's official name for the OS or operating system common to all of the iDevices. I'd also like to add that this book will not be covering the iPhone 3G or the iPod Touch second generation and below. As of the writing of this book, these devices are second- and third-generation devices, and I wanted to concentrate on the most current devices. I'll break this section into two categories, which are the ARM central processing unit (CPU) and PowerVR SGX graphics processing unit (GPU). As we cover the iDevice hardware, we'll also discuss how these categories relate to Unity iOS.

ARM CPU

The CPU is the processing unit, and the iDevices use the ARM architecture with the Cortex-A8 core at version ARMv7-A, and from an artist's perspective, the CPU handles calculations. In Fig. 1.1, you can see a break down of the hardware differences in each of the iDevices. Each model of the iDevices contains different or updated hardware that can affect your game's performance such as how the hardware affects pixel fill rate.

Both the iPad and iPhone 4 contain the A4 processor. The iPhone 3GS and iPod Touch third generation both use an ARM Cortex-A8 that has been under-clocked to 600 MHz. As far as performance goes across these three

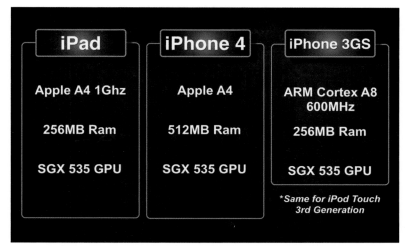

iPad	iPhone 4	iPhone 3GS
Apple A4 1Ghz	Apple A4	ARM Cortex A8 600MHz
256MB Ram	512MB Ram	256MB Ram
SGX 535 GPU	SGX 535 GPU	SGX 535 GPU
		*Same for iPod Touch 3rd Generation

FIG 1.1 Here You Can See a Chart Listing the Different Hardware Components in the iDevices.

devices, you can say as a basic rule that the iPad is the fastest in terms of processing, followed by the iPhone 4 due to the A4 being under-clocked and finally not far behind at all is the 3GS. Again, I stress that this is a very basic rule, and your content will really drive these results in terms of how pixel fill rate and polygon throughput affect your game. Profiling your game on the devices with your specific content is the safest and most accurate way to gauge performance, but it can be helpful to have general ideas in place about the device capabilities in the early stages of development.

There are many aspects to how the CPU affects your Unity iOS powered game. For instance, the CPU also processes scripts and physics calculations as well as holding the entire OS and other programs being run. Since this book is on creating game art, we'll focus the next subsections to be particular to the game's art content on our game objects and what operations are important to the CPU in these terms.

Draw Calls

The draw call can be thought of as a "request" to the GPU to draw the objects in your scene and can be the area in which the CPU causes a bottleneck in performance. As we'll discuss in the GPU section, the iPhone and iPad uses OpenGL ES 2.0 (OGLES) emulating OGLES 1.1 shaders on the hardware level, and with this implementation, vertex data is copied for each draw call on every frame of the game loop. The vertex data is the vertices that make up our 3D objects and the information attached to each vertex such as position, normal and UV data, just like a 3D mesh's vertices in modo has positional, normal, and UV coordinate data.

On a particular note, just because one might be more oriented toward the art-side of game development doesn't mean they should steer clear of code, and it certainly doesn't mean that artists can't understand technical aspects. In fact, with independent game development, there's a high probability that not only are you building 3D content but you're coding the game as well. More often than not, I see great scripts and programs written by amazing artists instead of hardcore programmers. The point here being, scripting sometimes has the negative connotation of something to be feared and I say that couldn't be further from the truth. You never know what you're capable of until you jump in and give it a shot.

Game Loop

Inside the Unity iOS game loop is where the components of our game are updated. The game loop is always running regardless of user input. From a 3D artist's perspective, you can think of the game loop as an animation. In a 3D animation, your scene runs at a given frame rate, and in each frame of the animation, something is calculated such as key-frame interpolation. A game engine's game loop is basically doing the same thing.

The vertex data is transformed or moved in 3D space on the CPU. The result of this transformation is appended to an internal vertex buffer. This vertex buffer is like a big list or a container that holds all of the vertex data. Since the vertex data is copied on the CPU, this takes up around one-third of the frame time on the CPU side, which wastes memory bandwidth due to the fact that the iPhone shares its memory between the CPU and GPU. On the iPhone and iPad, we need to pay close attention to the vertex count of our objects and keep this count as low as possible as the vertex count is more important than actual triangle count. As you'll read in Chapter 2, we'll talk about how to determine what the maximum number of vertices you can render per individual frame.

I used to get confused by the "per frame" section of that statement. It helped me as a 3D artist to think about my game scene just like a scene in modo. For instance, if I have an animation setup in modo, the render camera will render the portion of that scene that the camera can see in its view frustum as set in the camera's properties, for each frame of the animation. The same is true in Unity iOS. In Fig. 1.2, you can see an illustration that depicts the way in which I visualize a scene's total vertex count per frame.

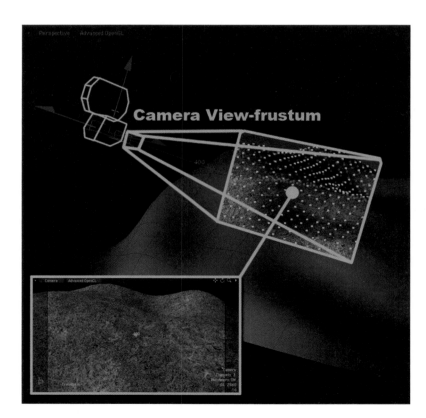

FIG 1.2 In This Image, the Yellow Highlighted Areas Represent the Camera's View Frustum and the Vertices Visible per Frame.

With each frame of the game loop, only a certain amount of vertices are visible within the camera's view frustum for a given frame, and within this frame, we should keep the vertex count for all of the objects in the scene to around 10 k. Now, this is a suggestion as to what works best on the iDevice hardware, but depending on your game and game content, this could possibly be pushed. The point being, with game development, there aren't any absolute answers when it comes to optimization. You have to optimize content to your game's performance standards, i.e., your frame rate budget. There are a lot of techniques to optimizing our vertex count as we'll discuss in the modeling chapters, and there are also rendering optimizations for the camera's view such as occlusion culling for controlling vertices that are sent to the vertex buffer.

It's obvious that the faster the CPU, the faster the calculations are going to be. However, just because you have more power doesn't necessarily mean you should throw more vertices to the system without regard to other performance considerations such as pixel fill rate as we'll discuss later in this chapter.

Batching

Batching is a means to automatically reduce draw calls in your scene. There are two methods in Unity iOS, which are dynamic and static batching. It's important to note that draw calls are a performance bottleneck that can largely be dependent on the CPU. Draw calls are generated each time the CPU needs to send data to the GPU for rendering. The GPU is very fast at processing large amounts of data; however, they aren't very good at switching what they're doing on a per-frame basis. This is why batching is good since it sends a large amount of data to be processed at one time. With that said, it always best to test both the CPU and GPU when determining bottlenecks as if your device has fill rate issues, which can be found on the iPad or iPhone 4, then the draw call bottleneck can get shifted to the GPU.

Dynamic Batching Here is how dynamic batching works at run time.

1. Group visible objects in the scene by material and sort them.
 a. If the objects in this sorted group have the same material, Unity iOS will then apply transformations to every vertex on CPU. Setting the transform is not done on the GPU.
 b. Append results to a temporarily internal dynamic vertex buffer.
2. Set the material and shader for the group only once.
3. Draw the combined geometry only once.

Both the vertex transformation and draw calls are taxing on the CPU side. The single instruction, multiple data (SIMD) coprocessor found on the iDevices supports vector floating point (VFP) extension of the ARM architecture, which handles the vertex transformations, thanks to some optimized routines in Unity iOS written to take advantage of the VFP coprocessor. The VFP coprocessor is actually working faster than the GPU and thus is used by Unity iOS to gain performance in batching objects to reduce draw calls.

The point to focus on in regards to the VFP and Unity iOS is the key to dynamic batching, which can be stated as follows. As long as it takes less time to apply the vertex transformations on the CPU rather than just issuing a draw call, it's better to batch. This is governed by a simple rule that as long as the object is smaller than 300 vertices, it will be less expensive to transform the vertices on the CPU, and thus, it will be batched. Any object over this 300-vertex limit is just quicker to draw and won't be batched or handled by the VFP coprocessor routines mentioned above.

While we are talking about the VFP coprocessor in the iDevices, I should mention that Unity iOS also offloads skinning calculations to the VFP, which is much faster than utilizing GPU skinning. Unity has optimized bone weight skinning paths to take advantage of the VFP coprocessor as well.

Static Batching Static batching is the other method Unity iOS uses to reduce draw calls. It works similarly to dynamic batching with the main differences being you can't move the objects in the scene at run time, and there isn't a 300-vertex limit for objects that can be batched. Objects need to be marked as static in the Unity iOS Editor, and this creates a vertex buffer for the objects marked as static. Static batching combines objects into one mesh, but it treats those objects as still being separate. Internally, it creates a shared mesh, and the objects in the scene point to this shared mesh. This allows Unity iOS to perform culling on the visible objects.

Here is how static batching works at run time.

1. Group visible objects in the scene by material and sort them.
 a. Add triangle indices from the stored static vertex buffer of objects marked as static in the Unity iOS Editor to an internal index buffer. This index buffer contains much less data than the dynamic vertex buffer from dynamic batching, which causes it to be much faster on the CPU.
2. Set the material and shader for the group only once.
3. Draw the combined geometry only once.

Static batching works well for environment objects in your game.

Unity iOS now includes lightmapping and occlusion tools, which affect the conditions for static batching to work which are, use the same material, affected by same set of lights, use the same lightmap and have the same scale.

As we've discussed in this section, the iPhone and iPad CPU handles important aspects of your game in terms of how your game content is drawn and in terms of sending data to the GPU and math calculation performance. Thus far, we've briefly touched on concepts such as batching and VFP skinning to familiarize you with the base architecture of the iDevices and Unity iOS. In the later chapters, we'll discuss in-depth how to build optimized meshes in modo to reduce vertex count. We'll also thoroughly look at batching our objects by discussing what makes or breaks a batch as well as how our game

character's textures and materials relate to batching. In Chapter 5, we'll discuss the VFP-optimized paths for bone weighting and rigging as we setup Tater for animation using Blender.

GPU

The GPU is the graphics processing unit and handles the rendering of our scene. Between the different iPhone models, you'll find that they all use the same GPU, which is the PowerVR SGX535.

The SGX 535 supports OpenGL ES 2.0. With Unity iOS, iPhone developers can use both the 1.1 and 2.0 versions of OpenGL ES. What this means for developers is that we can utilize shaders that support a programmable pipeline also, there will be no need to convert 1.1 shader to 2.0 every time the device meets a new shader in the game. In Fig. 1.3, you can see the clock speed of the SGX 535 GPU and how this relates to pixel fill rate and triangle throughput. The fill rate is the number of pixels that can be drawn to the screen per second, and throughput is the amount of triangles that can be processed per second.

As you can see in Fig. 1.3, the 3GS GPU can process 7 million triangles per second and around 2.5 pixels per second. However, as with the CPU, I'd also like to reiterate the fact that although it looks like the SGX is a rendering beast, it doesn't mean you can throw everything but the kitchen sink at it without regard. Your game's performance isn't entirely dictated by CPU and GPU speeds. For instance, RAM and slow Flash memory can also be a bottleneck as well, especially when trying to load larger texture sizes such as 1024 × 1024.

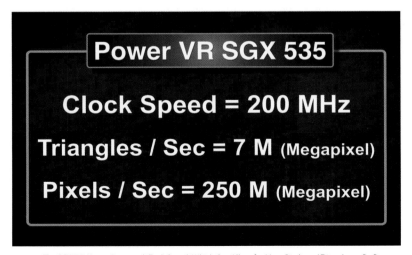

FIG 1.3 The SGX535 Has an Increased Clock Speed, Which Can Allow for More Pixels and Triangles to Be Drawn.

It all comes down to a balance between the player experience in terms of frame rate and game graphics. You will always need to profile for performance to match your game budget. Faster hardware is a plus and allows you to do more, but you must remember that building for the cutting-edge hardware will inevitably alienate a good degree of your potential market due to users with older models.

Screen Resolutions

The iPhone 4, 3GS, and iPad all have different screen resolutions, and if you want your graphics to look awesome, you'll need to build to match the resolution of each device. For instance, if you build your game graphics based off the screen of the 3GS at 480 × 320 and then scale these graphics to the iPad at 1024 × 768, then your graphics and textures are going to look pretty ugly as they are scaled from the lower resolution to a higher screen resolution. In Fig. 1.4, you can see a menu from the book's demo app and how the menu was adapted for each of the screen resolutions across the iDevices.

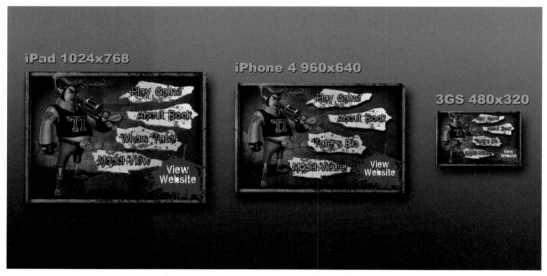

FIG 1.4 Here You Can See a Menu at Each of the Supported Resolutions for the Different iDevices.

Fill-Rate Limited

The 3GS, iPhone 4, and iPad are all using the SGX 535 GPU; however, with the iPhone 4 and iPad, the GPU has to do more work to draw your game on the higher resolution screens. This can cause games that run well on the 3GS to drop in frame rate on the iPad and iPhone 4 in certain conditions. In Fig. 1.5, you can see the differences in resolution and how this relates to the GPU having to work harder on the iPhone 4 and iPad as it renders 4–5.1 times the screen real estate.

The fill rate is the number of pixels the GPU can render to the screen per second. With the iPhone 4 and iPad, you can experience a drop in frame rate when a transparent surface fills the screen. This is because on the iPhone 4 and iPad,

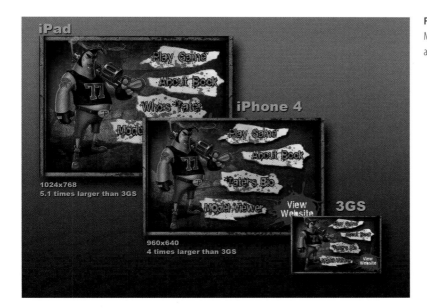

FIG 1.5 The SGX 535 Has to Render to More Pixels on the iPhone 4 and iPad and Can Cause Fill-Rate Issues.

the GPU can be thought of as fill-rate limited, meaning that GPU is maxed out and is the bottleneck. Again, this is because these devices have the same GPU as the 3GS, but have to render 4–5.1 times the screen resolution. I ran into this very issue creating the book's resource app, as we'll discuss in Chapter 4.

Tile-Based Rendering

The SGX uses tile-based deferred (TBD) rendering. The concept behind a TBD rendering is to only render what is seen by the camera. By doing this, the TBD renderer doesn't waste clock speed and memory bandwidth on trying to figure out the pixels of objects that are hidden behind other objects, which is referred to as Overdraw. To help visualize what Overdraw is, in Fig. 1.6, I've used the Overdraw viewport rendering setting in Unity iOS to visualize Overdraw and showcase an example of how it relates to a scene. This isn't utilized for iPhone output as the TBD renderer of the GPU handles keeping Overdraw low by rejecting occluded fragments before they are rasterized.

Rasterization is the process through which vector data is converted into pixels. Ok, so what's a fragment? Well, you can think of a fragment as the state of a pixel or a potential pixel in that it updates an actual pixel in the frame buffer. A pixel is a picture element, and it represents the content from the frame buffer, which is basically a container that holds graphical information in memory such as color and depth. During the rasterization phase on the GPU, triangles are broken down into pixel-sized fragments for each pixel that covers the geometry. A fragment has data associated with it such as pixel location in the frame buffer, depth, UV sets coordinates, and color

FIG 1.6 This Image Uses Unity's Overdraw Viewport Rendering to Help Visualize the Concept of Overdraw. You Can See the Planes that Are Overlapping in the Viewport as They Are Shaded in a Darker Red Color.

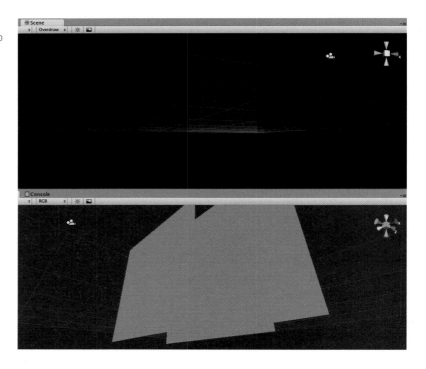

information. This data, which is associated with the fragment, is interpolated from the transformed vertices of the geometry or the texture in memory. If the fragment passes the rasterization tests that are performed at the raster stage on the GPU, the fragment updates the pixel in the frame buffer. I like to think of a fragment as the DNA so to speak of a pixel. In Fig. 1.7, you can see an illustration that represents fragment data as it relates to an actual pixel.

FIG 1.7 A Fragment Represents the Data of the 3D Model and Can Be Interpolated into a Pixel Shown on Screen.

A tile-based renderer will divide up the screen into smaller, more manageable blocks called tiles and will render each one independently. This is efficient, especially on mobile platforms with limited memory bandwidth and power consumption such as the iPhone and iPad. The smaller the tile the GPU is rendering, the easier it is to process, and thus, the less it has to go out to the shared memory of the system and ultimately utilizes less memory bandwidth. The TBD renderer also uses less power consumption and utilizes the texture cache in a more streamlined fashion, which again is very important on the iPhone due to memory limitations. The iPhone has a dedicated unit to handle vertex processing, which runs calculations in parallel with rasterization. In order to optimize this, the vertex processing happens one frame ahead of rasterization, which is the reason for keeping the vertex count below 10 K per frame.

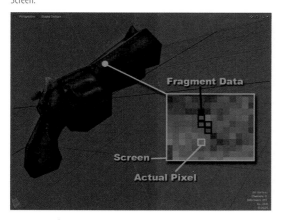

FIG 1.8 I like to Visualize the TBD Renderer of the iPhone to Be Similar to Modo's Bucket Rendering.

Again, as a 3D artist, it helped me to visualize the TBD renderer on the iPhone to be similar to the Bucket rendering in modo or mental ray as shown in Fig. 1.8.

RAM

There is a difference in RAM among the iDevices. The iPhone 4 contains twice the amount of RAM of the iPad and 3GS at 512 MB while both the 3GS and iPad contain only 256 MB. It's important to understand the RAM available and what you have to work with. The entire amount of RAM is available to your application, as some of it must be saved for running the OS and other apps with multitasking. Your textures are usually the main culprit when it comes eating up RAM in your game. That's why, it's very important to use optimized compressed textures to minimize the RAM usage in your game. In Unity iOS, you can use the Statistics window to check the video RAM (VRAM) usage of your scene as shown in Fig. 1.9.

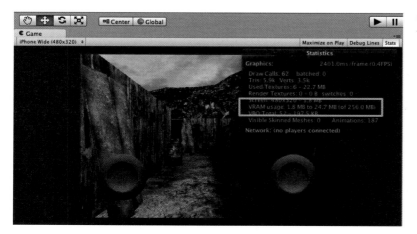

FIG 1.9 You Can Monitor the VRAM in the Statistics Window.

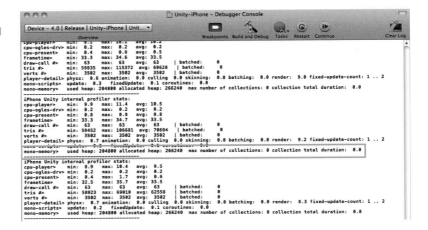

Also, you can use the Unity iOS Internal Profiler to check the memory usage when profiling your game's performance in Xcode as shown in Fig. 1.10.

It can be helpful to understand how the texture size translates into texture memory. It's basically the count of the total number of pixels in the image, multiplied by the number of bits in each pixel. For instance, a 1 K texture contains 1,048,576 pixels (1024 times 1024). You can then multiply this number by 24 bits per pixel (1,048,576 times 24) to get 25,165,824 pixels in the entire image. Finally, divide this number by the bits in each byte, which would be 8 (25,165,824 bits times 8 bits in a byte) to get 3,125,728 or roughly 3 MB per 1 K textures. Now, this doesn't account for compression, so if we compress this texture in Unity iOS using the Texture Importer to PVRTC 4-bit, we can then reduce this amount of memory to 0.5 MB with negligible difference.

OpenGL ES

OpenGL ES is a subset application programming interface (API) of OpenGL and is used on all iPhone OS devices since its core design is for use with mobile technology.

I've already mentioned that the SGX535 supports OpenGL ES 2.0. What this really boils down to with Unity iOS on the iPhone is the type of shaders you're able to use in your Unity iOS projects. Unity iOS will allow you to build for both OpenGL ES versions 1.1 and 2.0. This allows you to build different Unity iOS scenes, which target different devices and OpenGL ES version, and at run time load a specific OpenGL scene based on the iPhone device running the game.

The difference between OpenGL ES 1.1 and 2.0 is that version 1.1 supports a fixed-function graphics pipeline (FFP) and version 2.0 supports a fully pro-grammable graphics pipeline (FPP). Again, what this basically dictates is the type of shader you can utilize or write for your game.

Fixed-Function Pipeline

A FFP uses "fixed" or predefined functionality throughout the various stages of the pipeline, which include the command processing, 3D transformations, lighting calculations, rasterization, fog, and depth testing. You have the ability to enable or disable parts of the pipeline as well as configure various parameters, but the calculations or algorithms are predefined and cannot be changed.

Fully Programmable Pipeline

A FPP replaces many of the "fixed" stages of the FFP with fully programmable stages. This allows you to write the code that will perform the calculations for each stage in the programmable pipeline. A FFP opens the door for enhanced shaders for your games as well as increased optimizations due to the fact that complex algorithms can be executed in a single pass on the shader and will definitely save on important CPU cycles. In Fig. 1.11, you can see a diagram of both pipelines.

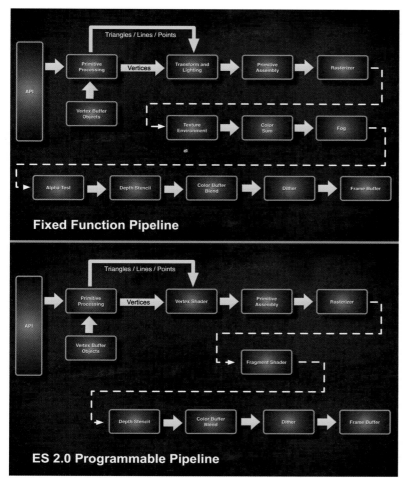

FIG 1.11 This Diagram Illustrates the Different Pipelines Available in OpenGL ES 1.1 and 2.0 Versions.

Texturing

It's very important to get your texture sizes down for the iPhone since the texture cache on board is small. The TBD renderer is optimized to handle the texture cache efficiently, but you still must keep a close eye on your texture sizes and compress them to bring down the size. The iPhone uses a hardware compression scheme called PVRTC, which allows you to compress to 2 or 4 bits per pixel. This compression will help to reduce memory bandwidth. When you're working out of your memory budget for textures, you'll need to make some decisions on how to compress your textures. In Unity iOS, you can set the texture compression for your texture assets in the setting menu as shown in Fig. 1.12. However, in order for your textures to compress, they need to be in a power of 2, i.e., 1024 × 1024, 512 × 612, and so on.

Texture compression is also important since the memory on the iPhone is shared between the CPU and GPU as mentioned earlier. If your textures begin to take up most of the memory, you can quickly become in danger of your game crashing on the iPhone.

Texture Units With OpenGL ES 1.1, you only have two texture units (TUs) available, and with OpenGL ES 2.0, you can have up to eight texture units

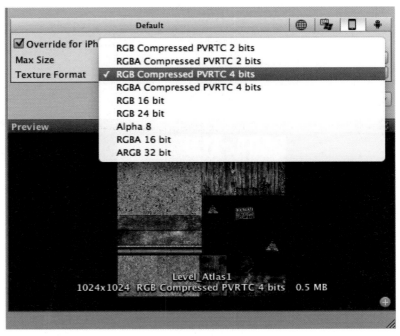

FIG 1.12 You Don't Need to Compress Your Textures Outside of Unity iOS. Texture Compression Can Be Set per Texture in Unity iOS.

available. Textures need to be filtered, and it's the job of the texture unit to apply operations to the pixels. For example, on iDevices that use OpenGL ES 1.1, you can use combiners in your Unity shaders, which determine how to combine the textures together, in order to combine two textures. It helps me to think of combiners like Photoshop blending modes, i.e., add and multiply. With the 3GS, iPhone 4 and iPad, you can combine up to eight textures since you have eight texture units available.

There are some performance gains to be made when only sampling one texture, as we'll discuss in the texturing chapters. For instance, instead of relying on a lightmap shader, which combines an RGB image with a light-map via a multiply operation, you could just bake the lighting into the diffuse map and thus only need to apply one texture to your material as shown in Fig. 1.13.

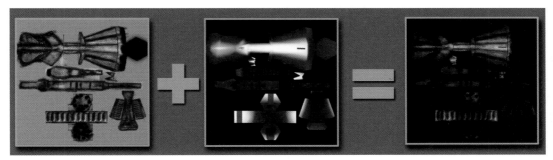

FIG 1.13 Instead of Using a Lightmap Shader, You Could Manually Combine Your Lightmap and Diffuse Texture in Photoshop and Only Use One Texture.

Alpha Operations There are two different ways to handle transparency in your textures, which are alpha blending and alpha testing. Alpha blending is the least expensive operation on the iPhone since with the TBD renderer, there isn't any additional memory bandwidth required to read color values from the frame buffer. With alpha testing, the alpha value is compared with a fixed value and is much more taxing on the system. In Fig. 1.14, you can see one of the iPhone shaders that ship with Unity iOS and that alpha testing has been disabled. Also, notice that the shader is set to use alpha blending instead.

Over the last several pages, we've been discussing the iPhone hardware and how it relates to Unity iOS. Now that we have an understanding of the hardware, we are at a position where we can realistically determine our game budget, as we'll discuss in the next section.

Determining Your Game Budget

Before you can begin creating any game objects, you will need to create what I call the game budget. Your game budget outlines the standards that you will adhere to when creating content as well as coding your game. To begin, you'll

FIG 1.14 Here You Can See that the Shader Is Set to Use Alpha Blending Instead of Alpha Testing.

```
Compiled-iPhone Transparent Vertex Color.shader ×
1   Shader "iPhone/Transparent/Vertex Color" {
2   Properties {
3       _Color ("Main Color", Color) = (1,1,1,1)
4       _SpecColor ("Spec Color", Color) = (1,1,1,0)
5       _Emission ("Emmisive Color", Color) = (0,0,0,0)
6       _Shininess ("Shininess", Range (0.1, 1)) = 0.7
7       _MainTex ("Base (RGB) Trans (A)", 2D) = "white" {}
8   }
9
10  Category {
11      Tags {"Queue"="Transparent" "IgnoreProjector"="True" "RenderType"="Transparent"}
12      ZWrite Off
13      Alphatest Greater 0
14      Blend SrcAlpha OneMinusSrcAlpha
15      SubShader {
16          Material {
17              Diffuse [_Color]
18              Ambient [_Color]
19              Shininess [_Shininess]
20              Specular [_SpecColor]
21              Emission [_Emission]
22          }
23          Pass {
24              ColorMaterial AmbientAndDiffuse
25              Lighting Off
26              SeparateSpecular On
27              SetTexture [_MainTex] {
28                  Combine texture * primary, texture * primary
29              }
30              SetTexture [_MainTex] {
31                  constantColor [_Color]
32                  Combine previous * constant DOUBLE, previous * constant
33              }
34          }
35      }
36  }
37  }
    ~
    ~
    ~
    ~
    ~
    ~
```

need to decide what type of game you're going to create and what specific requirements this game will need. For instance, my game, Dead Bang, is a third-person shooter and is designed to be fast paced. What this means is that, I need to design and optimize the game in order to maintain a frame rate of at least 30 fps, which would keep the game play running smoothly. Now that I know the frame rate I want to adhere to, I can set the frame budget, which is derived from the frame time and is the most important budget for your game. Almost all of the optimizations you do will be to adhere to your frame budget.

Frame Rate Budget

Frame time is measured in milliseconds, so if I would like to target a frame rate of 30 fps, I would take 1000 divided by 30, which gives me a frame time of 33.3 milliseconds. What this means is that when profiling my game, I need to make sure that my frame time, which is the time it takes a frame to finish rendering is no longer than 33.3 milliseconds and thus my frame budget becomes 33.3 milliseconds. In order to determine if your game is meeting the required frame budget, you need to use the Internal Profiler. In Chapter 9, we will take a look at profiling a game in order to find areas that need to be optimized. For now, in Fig. 1.15, you can see the frametime variable in the Unity Internal Profiler within Xcode reflecting my required frame budget.

```
------------------------------------------
iPhone Unity internal profiler stats:
cpu-player>     min:  3.3   max:  6.6   avg:  4.5
cpu-ogles-drv>  min:  0.4   max:  0.6   avg:  0.4
cpu-present>    min:  1.1   max:  2.5   avg:  1.2
frametime>      min: 31.9   max: 34.9   avg: 33.5
draw-call #>    min:   2   max:    2   avg:   2   | batched:     5
tris #>         min:  28   max:   28   avg:  28   | batched:    26
verts #>        min:  24   max:   24   avg:  24   | batched:    20
player-detail>  physx:  1.4 animation:  0.0 culling  0.3 skinning:  0.0 batching:  0.0 render:  2.3 fixed-update-count: 1 .. 2
mono-scripts>   update:  0.1   fixedUpdate:  0.0 coroutines:  0.0
mono-memory>    used heap: 200704 allocated heap: 266240  max number of collections: 0 collection total duration:  0.0
------------------------------------------
(gdb) |
```

FIG 1.15 You Can Use the Internal Profiler to Find Bottlenecks in Your Game.

Rendering Budget

Next, I need to determine where I want to spend most of my time in terms of how long it takes for Unity iOS to process a frame or the frame time. For example, my game doesn't use much in the way of physics calculations, so I've determined that I can spend most of my frame time in rendering.

Vertex Budget

In order to work out your vertex budget for individual game objects, you again need to think about the type of game you're creating. If you are creating a game that requires a lot of objects in the scene, then you'll need to reduce the vertex count per object. As I mentioned earlier, you'll want to take the base value of less than 10 K vertices per frame and distribute these vertices to what you consider to be the most important game objects. For example, you might want to give your hero character a bit more resolution in terms of vertex count while reducing the count for the enemies. This budget is subjective to your game requirements, but you can see that without understanding the constraints of the hardware, it would be impossible to create assets that run smoothly on the iPhone and iPad.

Texture Budget

We've discussed that texture memory can take up a lot of the resources on the iPhone, and your texture budget will be the combined size of memory resources you're prepared to allocate textures to in your game. You'll want to minimize how much memory your textures are eating up in your game, and there are several options for reducing the load such as using texture compression, shared materials, and texture atlases. Different devices are going to have different requirements as well. For instance, the iPad and iPhone 4 are going to need higher resolution textures since the screen size is larger, but you'll find that optimization becomes a little trickier since the iPad and iPhone are still only using the same PowerVR SGX535 GPU found in the 3GS despite having a larger screen as we discussed earlier.

It All Sums Up

As we work through the chapters in this book, we'll take a more in-depth look at optimization at the various stages of modeling and texturing. However, the important thing to remember is that all of our budgets sum up to one factor, which is to meet the frame budget. The goal for any game in terms of

optimization is to run smoothly, and the only way to achieve this is to make sure your content is optimized enough to maintain a constant frame rate. It is very detrimental for a game to constantly drop frame rate. The main area you'll focus on optimizing your game in terms of game art is through the following:

1. Lowering draw calls through batching objects.
2. Keeping the vertex count down per frame.
3. Compressing textures and reducing memory bandwidth through shared materials and texture atlases.
4. Using optimized shaders and not using alpha testing.

Summary

This concludes our overall discussion of the iPhone and iPad hardware and how it relates to Unity iOS. I can't stress enough how vital it is to understand the platform you are working on. Now that we've discussed the hardware specifications and determined a game budget, we can begin actually building content and getting to work on a game. In Chapter 2, we'll begin taking a look at modeling Tater for the iPhone and iPad and Unity iOS.

Creating Game Objects Using modo
Tater and Thumper

In this chapter, we're going to take an in-depth look at creating a "hero" character and his main weapon. Now, I say the word "hero," but I don't mean it in the sense of the character having a heroic trait. Instead, what I am referring to is a game's main character or asset. It's the "hero" object that gets most of the attention in regards to polygon count and system resources. As we discussed in Chapter 1, "Getting to Know the iDevice Hardware and Unity iOS," when dealing with a mobile device such as the iPhone and iPad, you must always be aware of the limited resources available. Like an old miser, constantly counting every penny, you must watch over each vertex and make sure not a one goes to waste. Throughout this chapter, I'll be discussing techniques and principles behind creating optimized game models for the iDevices. To illustrate the concepts, we'll be looking at the process behind creating Tater and his trusty sidekick of mass destruction, Thumper, as shown in Fig. 2.1. We'll begin by discussing how to determine the project's polygon budget.

Creating 3D Game Art for the iPhone with Unity. DOI: 10.1016/B978-0-240-81563-3.00002-4

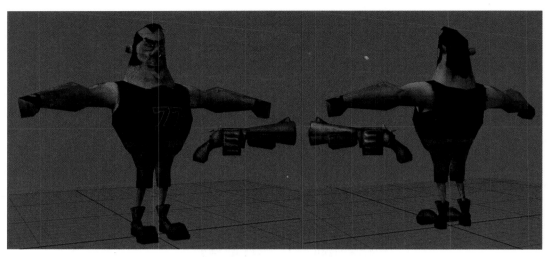

FIG 2.1 Here You Can See Tater and Thumper, the Main Assets We'll Be Focusing on Throughout This Chapter.

Tater's Weapon Load Out
Go to the resource site to view the video walkthrough for this chapter.

Planning the Vertex Budget

We talked a lot in Chapter 1, "Getting to Know the iDevice Hardware and Unity iOS," about the game budget. Part of working out a game budget is to come up with a budget for the amount of vertices your models will be made up of. The vertex budget is the process of deciding exactly how many vertices the objects that make up your scene contain and is shown per frame of the game loop, while still maintaining your game budget's frame rate. This is key to the modeling process because you can't model anything without knowing the limitations of the targeted device, your game's target frame rate and your overall vertex budget. You need to have a vertex count worked out before a single polygon is created in your 3D application. In Chapter 1, "Getting to Know the iDevice Hardware and Unity iOS," we filled in the first piece of this puzzle by discussing the various hardware components found in the different iDevices in order to gain an understanding of its limitations and thus establish a baseline to follow in order to create optimized geometry for the iPhone and iPad. In the next section, we'll take a look at how you can go about determining your vertex budget.

Testing Performance

So we've determined that planning the vertex budget is the first step before creating any actual geometry, but how is this budget actually determined? In game development, you'll hear the phrase, "it depends" quite often. Although it may sound like a quick answer to a complicated question, however, it's actually the truth. Determining a vertex budget or any budget in game development depends solely on your game. The type of game you're

looking to create bares a lot of weight in regards to how you determine your vertex budget. For instance, if you're game is heavy on rendering such as by utilizing lots of objects in the scene, then you'll need to cut back on physics simulations. By that same token, a heavy physics-based game will demand more resources from CPU and thus call for smaller vertex counts and less objects in your scene in order to balance the overall performance of the game. It's a give and take, and the type of game you're creating will dictate this balance. This is why Chapter 1, "Getting to Know the iDevice Hardware and Unity iOS," was dedicated to the iDevice hardware as understanding what the hardware is capable of and its limitations are vital when building your content.

Creating a Performance Test Scene

When you're in the early stages of developing your game, it can be extremely helpful to create a performance scene to test the capabilities of the hardware. For instance, for the book's game demo and coming from the perspective of a 3D artist, I wanted to concentrate on rendering the 3D assets. This was my primary goal, and I established early on that I wanted to spend the bulk of my frametime spent rendering. I also decided that I wanted my game to maintain a frame rate of 30 fps. With this goal set, I created a demo scene that I could install on the iPhone and iPad in order to test the performance and see how far I could push the hardware.

The demo scene either doesn't need to be complicated or doesn't need to look good. The purpose of this scene is to purely gauge performance. To save time, I went to the Unity iOS web site and downloaded the Penelope tutorial, which can be found at http://unity3d.com/support/resources/tutorials/penelope. The Penelope model looked close to the level of detail I was looking to create for Tater and would make for a good test model. I then opened up the Penelope completed project and deleted all of the assets except the model and the "PlayerRelativeSetup" scene. With this simple scene, I have a skinned mesh with animations and a default control setup to move the character around the scene as shown in Fig. 2.2.

Finally, I created a simple button and added a script that would instantiate a new instance of the Penelope model in the scene at the position of the playable character as well as display the overall vertex count for Penelope and her clones. By using the Penelope assets, I was able to quickly create a prototype scene for testing hardware performance without having to spend time creating objects. Once the game was compiled to an Xcode project, I could then run the game on a device while running the Internal Profiler to check performance as shown in Fig. 2.3.

While monitoring the Internal Profiler's frametime variable in Xcode's Console, I continued to press the "Add" button in the game to create more instances of the Penelope game object and thus increasing vertex count and skinned meshes. The vertex count is only accounting for the Penelope character and her instantiated clones. Also, the vertex count display is not accounting for

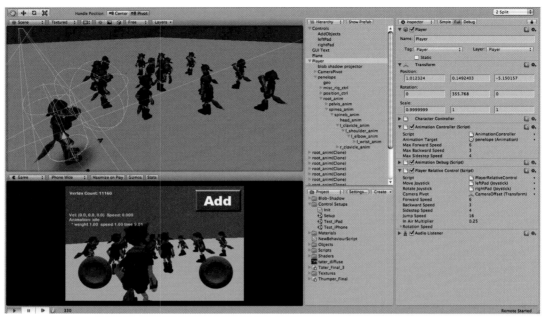

FIG 2.2 Here You Can See the Performance Test Scene in Unity iOS Made from the Penelope Tutorial Assets.

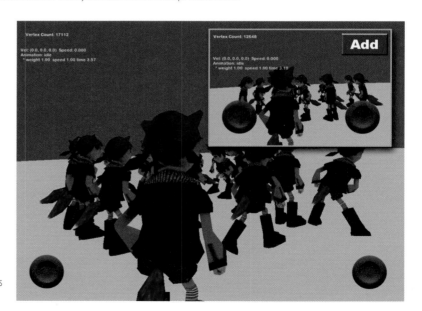

FIG 2.3 Here You Can See the Performance Scene Running on an iPod Touch Third Generation and iPad. Notice the Dramatic Differences in Vertex Count between the Two Devices at 30 fps (33.3 ms).

Occlusion Culling, but its purpose is just to give me a basic idea of vertex count when building your models in modo. Basically, I kept adding game objects until the frametime variable indicated that I was no longer hitting my goal frame rate of 30 fps.

The Internal Profiler will show frame performance information every 30 frames with the frametime variable describing how long it took to render a frame measured in milliseconds. This means that if you take 1000 and divide it by your desired frame rate that is 30, you get 33.3 ms. When testing performance, I would watch the frametime variable to see what value in milliseconds it was outputting. For example, if the frametime were indicating a value of 37 ms, I would then take 1000 and divide that by 37 to get 27.02 or 27 fps.

By knowing the vertex count of the Penelope model and making note of how many instances of Penelope I was able to add to the scene before it began to choke, I was able to get a good estimate of what the hardware could handle. This demo scene allowed me to see how many skinned meshes I could run at the same time as well as how many vertices I could render in the scene, which can be referred to as vertex throughput. Now, this is only a rough estimate of the scene's performance since I'm not taking into account script performance or physics used in an entire game. This performance scene can be used to derive a basic idea of what can be accomplished with the hardware in terms of vertex count.

In Fig. 2.4, you can see the results I got from running my performance scene on a iPod Touch third generation.

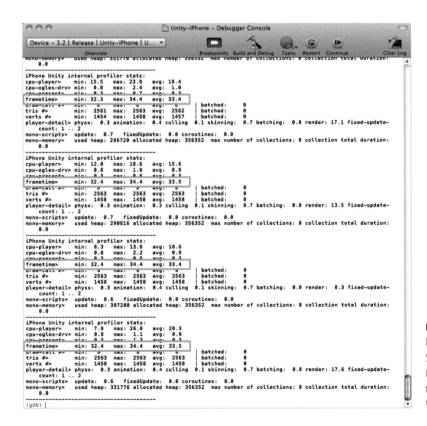

FIG 2.4 I Used the Internal Profiler to Monitor the Performance of the Demo Scene as I Continued to Add Game Objects in the Game. I Was Checking the Frametime Variable to See If It Went Beyond 33.3 ms.

Targeting Devices

When targeting a game for the iDevices, you'll need to decide which devices your game will support. A plus with iOS development is that you have a somewhat limited number of devices to target unlike other mobile platforms. However, you'll still need to decide if you're going to support all of the device generations or only the ones that will allow your game to reach it's maximum performance while still maintaining a high level of detail without having to compromise the quality of your art assets.

A viable solution is to build different resolution models and texture maps to be used on different devices. For instance, you can build higher resolution assets for the iPhone 4 and iPad, while creating lower resolution models for the iPhone 3GS and iPod Touch third generation. In Unity iOS, you then create a script attached to a startup scene that checks to see in which device the game is running and then load the scene with the optimized assets targeted for that device.

In the case of the book's demo and for my current game in production, "Dead Bang," I decided that I would optimize my assets for targeting the higher performance devices such as the iPhone 4, 3GS, and iPad. The way I looked at it was at the time of the writing of this book, the iPhone 3G and iPod Touch second-generation devices are now three generations old. I decided that it wasn't worth creating a whole set of assets at a lower resolution to support these older devices. It doesn't mean that my content won't run, but it just may not perform as smoothly as I'd like. Ultimately, it all depends on the scope of your project and what you want to accomplish.


Sneaky Fill Rates

Remember, you must always keep a close watch on the iPad and iPhone 4 for fill rate issues. Testing and profiling your game on these devices is the only sure way of finding performance issues.


By creating performance scene to test hardware and gaining a thorough understanding of the capabilities and limitations of that hardware, I determined that I wanted to keep my vertex count for my hero character, Tater, less than 800 vertices. As you will see later in this chapter, I was able to get Tater to weigh in at 659 vertices, which more than meets my vertex budget for Tater. Currently, the Unity iOS manual states that you should aim at around 10 k vertices visible per frame, and as I mentioned in Chapter 1, "Getting to Know the iDevice Hardware and Unity iOS," this is somewhat conservative given the hardware driving the iPhone 4 and iPad.

At this point, Tater's vertex count is weighing in with my game's overall vertex count quite nicely. So let's now take a look at how I was able to achieve my goals.

Sizing Things Up

When moving objects from one 3D application to another, you'll inevitably run into size issues and working with Unity iOS, modo, and Blender is no exception. Now, this isn't a problem, it's just something you have to understand and work around and it starts with defining your game units.

What Is a Game Unit

A game unit is an arbitrary means of defining size in your game scene. One game unit is equal to 1 grid square in 3D space. In Fig. 2.5, you can see that a default cube game object in Unity iOS is equal to 1 grid square or 1 unit wide by 1 unit high by 1 unit deep.

FIG 2.5 A Default Cube Game Object in Unity iOS is $1 \times 1 \times 1$ Unit.

A game unit can represent any measurement you would like. For instance, 1 game unit can be 1 ft or 1 m. It's whatever value you want it to be, although it's common practice in game development to establish a single game unit to be equal to 1 m. The reason being is that it's easier to work with physic calculations if your game is adapting real-world measurements. For instance, the rate of gravity is 9.81 m/s^2, and if you want to simulate this in your game, it will be easier if you're working with a 1 game unit to 1 m scale. If not, you'd have to work out how 9.8 m/s^2 relates to your own established scene scale to get the same result. So when creating my Unity iOS project, I adopt the scale of 1 game unit is equal to 1 m. In Unity iOS, you don't have to set a preference or setting, it's just something that you determine for your project and use this scale when creating and importing objects.

Setting Up Modo

Internally, modo is always working in meters regardless of how you set the Accuracy and Units in the Preferences. You could say that if a $1 \times 1 \times 1 \text{ m}^3$ in modo needs to be scaled to 0.01 or scaled down by a factor of 100 to be the same size as a $1 \times 1 \times 1 \text{ m}^3$ created in Unity iOS, then Unity iOS must be working internally in centimeters. With that same notion in mind, Maya internally works in centimeters, and if you export a $1 \times 1 \times 1 \text{ m}^3$ from Maya to Unity iOS, you'd need to set the Mesh Scale Factor to 1, meaning no scale conversion, for the Maya cube to equal the same size of a Unity $1 \times 1 \times 1 \text{ m}^3$, which further proves Unity's internal scale working in centimeter. By knowing the internal scale that your 3D application is working and how it relates to Unity's internal scale, you'll be able to gauge if your objects may or may not need to be scaled and by what factor.

Don't Set Scale in Unity iOS

It's very important to not set the scale for your object within Unity iOS on the object's Transform. The reason being is that when the scale is changed on the Transform, Unity iOS makes a copy of the object, which is the scaled version of the object. This wastes memory resources. Always be sure that the scale in Unity iOS is set to $1 \times 1 \times 1$ and that any scaling is done either in the 3D application or in the FBX Importer Dialog via the Scale Factor setting.

Ultimately, it's best practice to think of Unity's scale in terms of the arbitrary game unit you set for your projects. For instance, I set my game projects to have a scale of 1 game unit equal to 1 m. So in Unity iOS, 1 grid square is equal to 1 unit. In modo, I create my objects, as 1 grid square is equal to 1 unit to match my projects game unit scale. However, this means when working with modo and Unity iOS, your modo meshes will need to be scaled by 0.01 in Unity's Importing Assets Settings via the Mesh Scale Factor due to the differences in which the Unity iOS and modo internally work with scale as shown in Fig. 2.6.

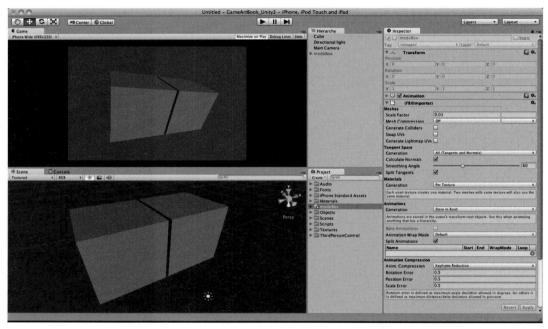

FIG 2.6 Notice that the Mesh Scale Factor Defaults to 0.01, and the Imported 1 × 1 × 1 Modo Cube Matches a Default 1 × 1 × 1 Unity iOS Cube.

You can either choose to scale the mesh in modo before export, thus not having to scale it in the import settings within Unity iOS, or simply scale the mesh by 0.01 in the import settings within Unity iOS. I prefer to scale the modo mesh in Unity's import settings, which allows me to work in meters within modo. By doing this, I don't have to worry about freezing scale in modo before export and sending my mesh over to Blender works better as we'll discuss in Chapter 5.

In modo's Preferences, under Accuracy and Units, I set the Unit System to Game Units and then set the Meters per Game Unit to 1.0. This means that every grid square in modo will be 1 game unit and will represent 1 m, which is what I am considering my Unity iOS units to be equal to as shown in Fig. 2.7.

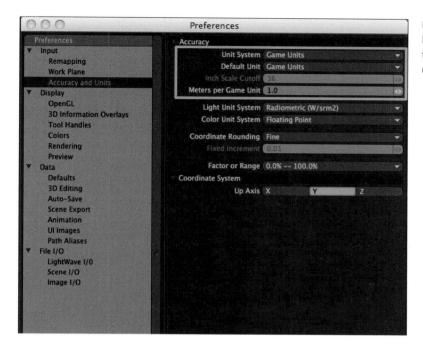

I can now begin modeling my game objects in modo from 1 game unit to 1 meter scale. For example, I determined that I wanted Tater to be around 6 ft 5 in tall, which equates to around 1.99 m as shown in Fig. 2.8.

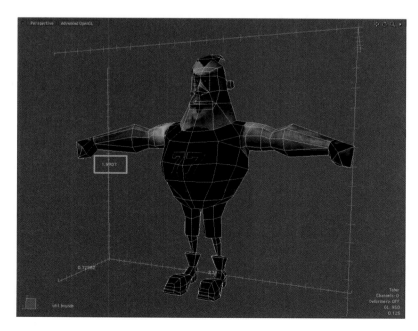

FIG 2.8 Now that My Modo Unit System Is Set to My Game Project's Game Units, I Can Begin Modeling My Game Objects to Scale.

Importing into Unity iOS

Unity iOS Transforms
Nonmesh items such as Locators and Groups are imported into Unity iOS as a Transform. In the case of a 3D application that supports bones such as Blender and Maya, bones are also imported simply as a Transform. A Transform holds the position, rotation, and scale of an object and can be manipulated the same as any other object in Unity iOS.

Once I've completed my models in modo, I'll need to import them into Unity iOS. I use FBX as the format for transferring my models between applications, and I'll need to export FBX from modo. The default FBX export from modo will export several items that aren't needed in your Unity iOS scene such as cameras, lights, texture locators, and so on. You can delete either all the nonessential items before export or these extra items in your Unity iOS project.

I created a modo script for optimizing this workflow. The script will scan through your modo scene and remove all nonmesh items and export a clean FBX with one click. The script will also bake any animation data that is set on the transforms for your mesh items. You can download the script on the book's resource site. When importing the FBX from modo, you'll need to set some parameters in the Import Assets dialog within Unity iOS. For importing static objects or objects without animation, you only need to set the Mesh Scale Factor and the Smoothing Angle. As mentioned earlier, you'll need to set the Mesh Scale Factor to 0.01 for working with objects that are set to working with the default scale in modo as shown in Fig. 2.9.

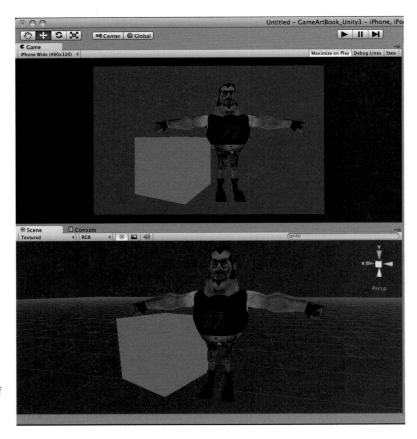

FIG 2.9 Here You Can See the Tater Model Set with a Mesh Scale Factor of 0.01 and How It Relates to a Default Unity iOS Cube.

There are other settings in the Import Assets that we'll discuss later. The Automatically calculate normals option and the Smoothing Angle parameter are very important at this stage in bringing our modo objects into Unity iOS as these settings directly affect your vertex count and we'll discuss this next.

True Vertex Count

We've previously discussed how important vertex count is, so it's vital to note that you can't regard the vertex count in your 3D program as the true number of vertices in your object. In order to get the true vertex count for your mesh, you'll need to import your object into Unity iOS and check the Rendering Statistics window in the Game View as shown in Fig. 2.10. Be aware, that Unity's Rendering Statistics window shows the resulting number of vertices sent to the GPU, which includes those added by lights and complex shaders.

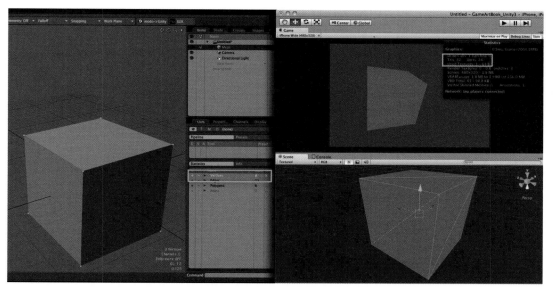

FIG 2.10 The Vertex Count in Modo Is Different than the Actual Vertex Count When the Mesh Is Rendered by the GPU.

There are several factors that cause the vertex count for your mesh to increase as it's rendered by the GPU. As a 3D artist creating game content, the concept that you can't trust the vertex count in your 3D application may seem foreign, but as you will see, you've already been dealing with these same factors in your everyday 3D work. Let's begin, by introducing the concept of triangle strips and degenerate triangles, which are the culprit behind our increased vertex count.

29

FIG 2.11 A Triangle Strip Is the Most Efficient Way of Describing a Mesh.

Zero-Angle Triangle

FIG 2.12 A Degenerate Triangle Looks Like a Line Segment and Causes an Increased Vertex Count in Unity iOS.

Degenerate Triangles

Unity iOS tries to display your mesh efficiently as possible using triangle strips. A triangle strip is a series of connecting triangles, sharing vertices as shown in Fig. 2.11. This allows for faster rendering and efficient memory usage.

However, to effectively to do this, Unity iOS must create what is called degenerate triangles or what is referred to as zero-angle triangles at points of various discontinuities such as mesh seams and UV borders. A degenerate triangle is formed by three collinear points or points that lay on the same line. It looks more like a line segment as shown in Fig. 2.12.

The performance impact of these triangles can really add up on the GPU. In the next two subsections, we'll take an in-depth look at discontinuities that create degenerate triangles.

Smoothing Angles

In modo, you can adjust the smoothing of polygons on a per-material basis via the smoothing amount and angle. Without smoothing, the polygons that make up a mesh would be visible as facets. The Smoothing Angle is used to determine the maximum angle tolerance between connected polygons. If the angle between the connected polygons is greater than the Smoothing Angle setting, no smoothing will occur. The Automatically calculate normals toggle on the Import Assets dialog within Unity iOS is doing the same thing to smooth the mesh. By activating this toggle, you can then enter a smoothing angle just as you would in modo.

The issue of increasing vertex count comes into play when the GPU needs to render a hard edge. The hard edge occurs where connected polygons form at an angle that is greater than the smoothing angle. The GPU needs to split the vertices at this angle in order to create the hard edge, and this results as a mesh seam. Hard edges in your model are an area that you can begin to see an increase in vertex count. For example, on the left side of Fig. 2.13, you can see three connected polygons that have a smoothing angle of 180 degrees. On the right side, one of the polygons has been cut and pasted so that the vertices that connected it to the other polygons have been duplicated. You can now see that a hard edge has been created. This is similar to what is happening on the GPU when a hard edge in your object is encountered. The vertices at the hard edge need to be split to create the hard edge and thus cause the vertex count to increase.

UV Seams

In the previous section, we talked about mesh seams. Now, we are going to look at the second half of this problem, which is UV borders or seams. When creating UVs for your objects, you need to minimize the amount of seams in your UV map. Just as we stated with mesh seams, when the GPU encounters a

FIG 2.13 Splitting the Vertices Created the Hard Edge, Which In Turn Increases Vertex Count.

seam in the UV map, the vertices will be split along the border and thus lead to an increased vertex count. When creating UVs for your objects, you need to minimize the amount of seams in your UV map.

UV coordinates are actually data associated with the vertices that make up your mesh. A single vertex contains additional information beyond location in 3D space such as UV coordinates and Color. In modo, you can view and edit this data represented as a 2D map in the UV Editor. Within a UV layout, you'll have UVs that are located along the UV border and are referred to as discontinuous UVs. These discontinuous UVs share vertices with another set of UVs in your map. Even though the vertices are disconnected in the UV map, which is the UV seam, they are still connected on the actual mesh. In modo, the discontinuous UVs that are associated with selected UVs are colored blue as shown in Fig. 2.14. These coordinates share the same vertex on the mesh. When the GPU encounters discontinuous UVs, it must split the vertex into two vertices and thus increase the overall vertex count for your object. In the next section, we'll discuss how to minimize UV seams in your mesh.

In Fig. 2.12, you can see a set of selected UVs and their discontinuous counter parts. These coordinates share the same vertex on the mesh. When the GPU encounters discontinuous UVs, it must split the vertex into two vertices and thus increase the overall vertex count for your object. In Chapter 3, "Understanding Textures and UV Maps," we'll discuss how to minimize UV seams in your mesh.

Using Lights

Using lights in your scene will also have an effect on the vertex count of your objects. With forward rendering, per-pixel lights can increase the number of times the mesh has to be drawn. So that it increases the draw call count and

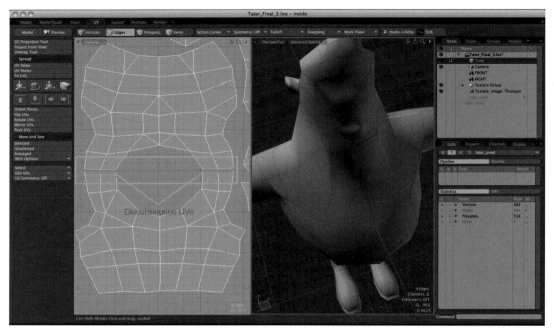

FIG 2.14 A Discontinuous UV Pair Is Shown by the Blue-Highlighted Edges. The Blue Shading of the Edge Indicates the Vertices that Are Discontinuous.

the number of vertices that need to be processed and number of pixels that have to be drawn. Even when additional lights don't cause additional draw calls (for example, in VertexLit mode), they are still not free. For example, in VertexLit shaders, more lights equal the same number of draw calls and vertices to process, but each vertex has to do more computations. This makes it more expensive. Even in deferred rendering, assuming all objects are rendered in deferred, every light will increase the reported vertex count slightly because every light has some additional geometry to rasterize in order to run the lighting shader. For example, importing in a single quad polygon space and adding a light would double the vertex count from 4 to 8.

It's best to minimize the usage of lights in your scene or even better, not use them at all. Instead, it's a good idea to bake scene lighting into the diffuse texture map or use a lightmap and apply it with one of the iPhone lightmap shaders that ship with Unity.

In Chapter 8, "Creating Lightmaps Using Beast," we'll discuss the usage of lightmaps using Beast in Unity iOS.

Modeling Tater and Thumper

In this section, we're going to take a look at how I created Tater and Thumper. We're going to discuss the important aspects of the process beginning with my workflow for creating objects for the iDevices. In Chapter 3,

"Understanding Textures and UV Maps," we'll continue this discussion with a look at creating UV maps and texturing.

My Workflow

I stated earlier that I wanted to keep the vertex count for Tater to less than 800 vertices. For Thumper, I wanted to keep its vertex count below 300 vertices. In the end, I was able to get Tater to 659 vertices and Thumper to 224 vertices. This gives me a combined count for the "hero" character and his weapon at 883 vertices. For this character, I didn't create a high-resolution mesh and then build a low-resolution version cage from it. This is a typical workflow in games as you can extrapolate a normal map from the high-resolution mesh. Instead, I went with a modified approach in that I began creating a low-resolution polygon cage and then optimized the mesh by adding geometry to detail areas of detail and reducing geometry once the base mesh was completed. As I worked on the base mesh, I used a combination of the Loop Slice and Edge Slice tools to quickly add and control edge loops on the mesh. I also tried to use quad polygons as much as possible and use triangles only in certain areas where I wanted to reduce geometry. For instance, in Fig. 2.15, I used a triangle in Tater's forearm to go from higher resolution level around the bicep to a lower resolution level around the wrist.

FIG 2.15 Here a Triangle Was Used to Reduce the Level of Detail from the Bicep to the Wrist.

When Unity iOS imports the FBX file, it will automatically be tripled, so there's no need to triple the polygons within modo.

Creating Geometry

There aren't any special techniques to modeling for game objects for the iPhone and iPad when it comes to creating geometry. You'll quickly find that you'll be using all the common concepts for creating any model such as beveling, extruding, pushing and pulling points, and dividing and merging polygons. The skill in creating iOS content is in deciding where to add detail and where you can take it away while maintaining the overall shape of the model. You have to make calculated decisions on where you want to spend your vertices. Like I mentioned, I had a self-determined budget of less than 800 vertices for Tater and less than 300 vertices for Thumper, and the trick was in deciding where to spend my budgeted vertices.

Let's look at some examples of where I decided to place resolution in the Tater and Thumper game objects. In Fig. 2.16, you can see the resolution for Tater's head. I decided to add a small amount of detail to the face by having the mouth protrude from the face. I created an edge loop to outline the mouth. The mouth resolution is reduced at the corners of the mouth were the geometry is connected to the rest of the face. I also decided to extrude the nose from the face. Notice in Fig. 2.16 that the nose is very simple. There aren't any nostrils or much detail for that matter. It just roughly resembles a nose shape. The surface detail is created by means of the texture map as shown on the right. Also, in Fig. 2.16, you can see that the eye socket areas are simple flat polygons, and the eye resolution has been left to be totally defined in the texture map.

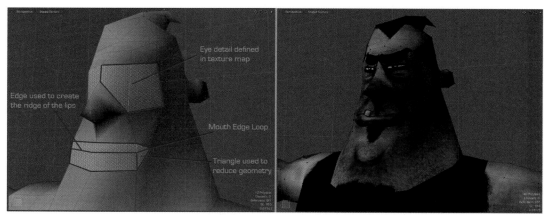

FIG 2.16 In Order to Create a Low-Resolution Mesh, Detail Needs to Only Approximate the Shape of the Model. You Can Use Texture Maps to Further Accentuate Surface Detail.

In Fig. 2.17, you can see that the ammo barrel for Thumper, outlined in red, is intended to be round. However, I only used a six-sided disk, which was extruded and divided in the middle to maintain quad polygons. Although, the ammo barrel is angular in nature, it approximates the rounded shape I was looking to create.

FIG 2.17 Round Objects Are Very Dense. By Using a Low-Resolution Disk You Can Approximate the Round Shape and Save on Precious Vertices.

Looking back at Tater, I decided that his arms are an important part of the mesh. I wanted to be sure that there was enough geometry to represent the shape of his bulky arms as well as contain a sufficient amount of edge loops to handle deforming. Tater's hands will never be open in the game, so there was no reason to build fingers. I modeled his hands as closed fists, which would be good for punching and holding weapons. Since the hands are basically round in shape, I chose them to be a good place to reduce geometry. In Fig. 2.18, you can see the edge loops that were created for the elbow and the usage of

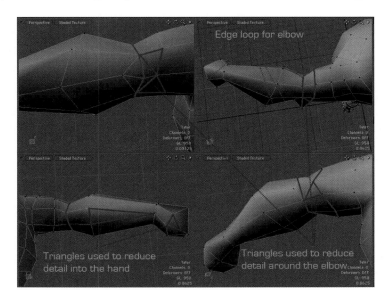

FIG 2.18 The Edge Loops Are Outlined in Blue, and the Triangles Used to Reduce Geometry Are Outlined in Red.

triangles to reduce the amount of geometry at the elbow joint and hand as outlined in red.

Taking a look at Tater's torso, you can also see how terminating edge loops with triangles as shown in Fig. 2.19 controlled resolution differences from the pants to the torso. Adding edge loops to your mesh can be vital to adding detail. For instance, as shown in Fig. 2.19, Tater's pants needed an extra edge loop to keep the roundish form, however, I would have wasted vertices if I would have continued that loop up the torso and through the head.

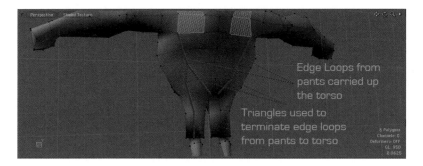

FIG 2.19 You Need to Try and Terminate Edge Loops so that They Only Retain Detail In the Areas of the Mesh in Which They're Needed. Don't Allow Edge Loops to Carry Across the Entire Mesh.

Building on the concept of terminating edge loops, in Fig. 2.20, you can see how I handled a five-point polygon on Thumper's barrel. Instead of continuing the edge loop down the barrel of the gun, which is represented by the dashed blue line, I carried it up over the top and back around as shown by the yellow line. By doing this, I split the five-point polygon into a triangle and a quad polygon.

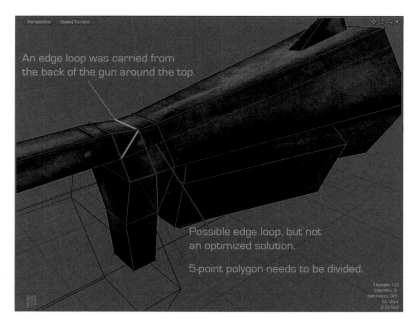

FIG 2.20 Here I Choose to Split a Five-Point Polygon to Create a Triangle and Quad Polygon while Terminating an Edge Loop.

In Fig. 2.21, you can see Tater with the edge loops selected that I determined to be the most important areas of the mesh. These selected areas are the parts that will be deformed the most when Tater is rigged and animated and are the areas that I paid particular attention to.

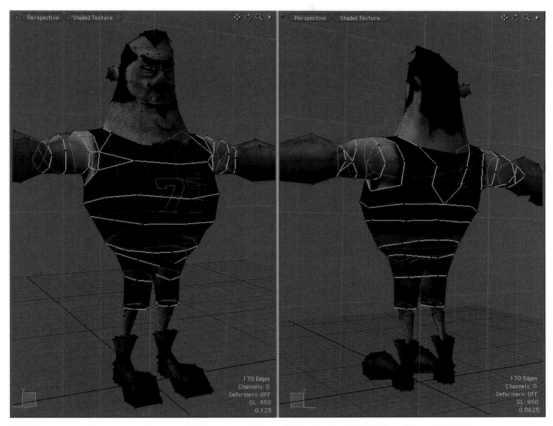

FIG 2.21 The Selected Edge Loops Are the Areas of Most Importance in Terms of where the Mesh Will Be Deformed During Animation.

Reducing Geometry

Thus far, we've discussed creating geometry in the sense of how to control resolution by placing detail only in the important parts of the model. We talked about reducing geometry by terminating edge loops and using triangles to move from higher to lower resolutions. In this section, we'll take a look at some techniques that can be used to reduce geometry when optimizing your models.

Polygon Flow and Spin Quads

It is very important to pay close attention to polygon flow on your model. It's particularly important when your model will be animated as a skinned mesh.

Topology Is Key

The topology of your mesh will give you clues as to where you need to concentrate a bulk of your vertex count. You need to be sure to provide enough resolution in the areas of your mesh that will be deformed when animated.

You need to be sure that the topology of your mesh is designed to handle the animation. In Fig. 2.22, you can see how the polygons were arranged to flow from the top of the shoulders across the chest and around the shoulders and biceps. The topology of the chest and shoulders allows for smooth movement in these areas and will deform well when Tater is animated.

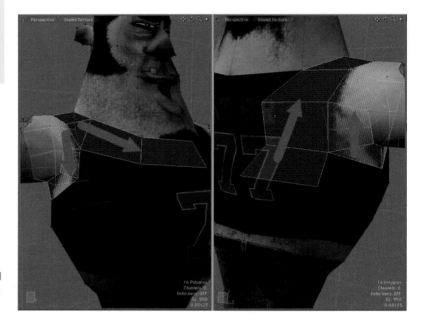

FIG 2.22 The Topology of Your Meshes Are Very Important, and You Need to Be Sure to Add Enough Detail to Allow the Topology to Deform Well when Animated.

I use the Spin Quads tool often when working out my topology for my mesh. The Spin Quads tool is great for changing the flow of polygons. For example, in Fig. 2.23, you can see how I used Spin Quads to change the topology of Tater's shoulder and neck.

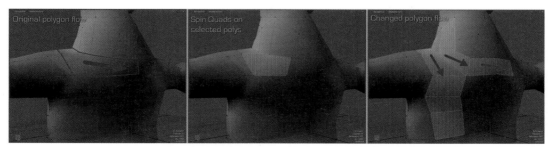

FIG 2.23 Spin Quads Was Used to Change the Topology of the Mesh.

Spin Quads can also be used to help reduce geometry. For example, whenever you see edges arranged in the shape of a "Y," you can use Spin Quads to rearrange the two polygons until one of the previous selected polygons are spun into an adjacent polygon. You then select these two polygons and merge them together to create one quad polygon as shown in Fig. 2.24. It can be a very effective technique for reducing poly count in your mesh.

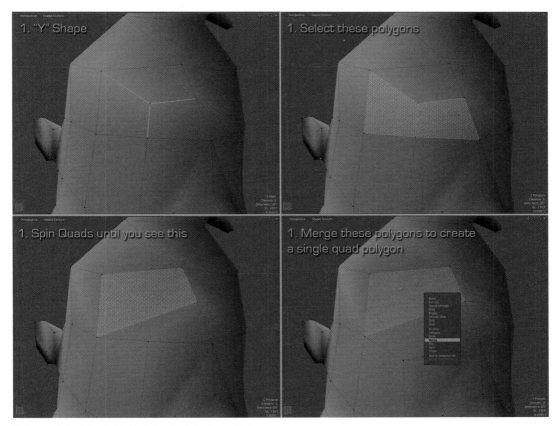

FIG 2.24 Spin Quads Can Be Used to Reduce Resolution In Your Mesh.

Merging Polygons and Removing Edges

When creating my models, I didn't try to build the most optimized model to start. Instead, my goal was to first capture the shape of the model I wanted to construct. To begin the optimization phase, I would go through the model and remove edge loops that really weren't needed to maintain my overall shape. Second, I would go through the mesh and merge triangles into quad polygons. Anytime you see two triangles together, you can simply merge

them to create a single quad. This isn't so much of a reducing technique as quad polygons are made from two triangles, but it makes the mesh much cleaner and easier to work with.

Summary

In this chapter, we discussed the principles behind creating optimized geometry for the iDevices. The real trick to creating optimized geometry is deciding how to utilize the amount of vertices you have in your budget. You have to decide where important parts of the model are to place resolution and then reduce these polygons to be able to connect them to areas with less resolution. By understanding how the vertex count is interpreted by the GPU, you can properly gauge the amount of vertices your mesh contains. As we've discussed, mesh seams and UV borders will cause the GPU to split vertices and thus increase vertex count, and by understanding this principle, you'll be able to optimize these discontinuities in your mesh. In Chapter 3, "Understanding Textures and UV Maps," we'll take a look at texturing Tater and Thumper and continue to discuss how UV seams affect the true vertex count of your game objects.

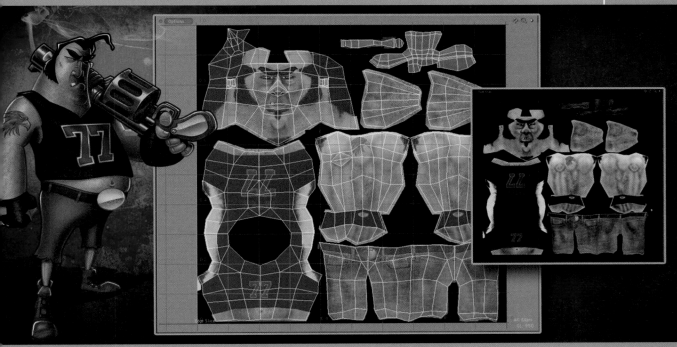

Understanding Textures and UV Maps

In this chapter, we are going to discuss my workflow for texturing Tater. We are going to discuss creating UV maps and creating diffuse maps using a 2D paint editor such as Photoshop. Finally, we'll discuss using 3D paint tools such as those found in modo to fix UV seams and add randomness to the textures.

To begin, we are going to continue with our discussion on vertex count and how the UV maps relate to vertices that are actually sent to the GPU.

Creating UV Maps

Ok, so we know that a UV seam is going to cause the GPU to split the vertices that share the same texture coordinates and thus increases vertex count. Armed with this knowledge, our mission simply becomes figuring out a UV layout that eliminates as many UV seams as possible. Our new best friend in modo is the Move and Sew tools. However, sewing UV borders is not the answer to every solution. Depending on our model, we have to make some intelligent decisions for eliminating UV seams that also allow us to easily texture our models and remove texture distortion.

Tater's Weapon Load Out
Go to the resource site to view the video walkthrough for this chapter.

Creating 3D Game Art for the iPhone with Unity. DOI: 10.1016/B978-0-240-81563-3.00003-6

41

Planning Your UV Maps

Depending on your object, you are going to have to create some UV seams, and as I stated above, the trick is to minimize these seams to as few as possible, yet still have the layout make sense for texturing. Let's look at an example. In the top half of Fig. 3.1, you can see a default modo box with the UV seams highlighted. As you can see, the UV layout from the default box allows you to easily texture the sides of the box. In the lower half of Fig. 3.2 you can see that the UV layout has overlapping UVs in such a way that there are no seams. Now, the difference between these UV layouts beside ease of texturing and texture distortion is increased vertex count due to UV seams.

FIG 3.1 Here You Can See the Default Modo Box with Two Different UV Layouts. The First UV Map Has UV Seams, and the Second UV Map Has No Seams.

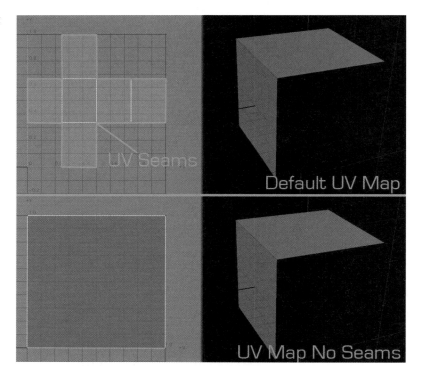

In Fig. 3.2, you can see how these UV layouts affect the vertex count in Unity iOS. Notice that the UV map without seams coupled with the object having no hard edges due to an increased smoothing angle yields the same vertex count of eight vertices between both Unity iOS and modo. Although the default UV layout increases the vertex count from 8 to 14 as shown in the first half of Fig. 3.2, it still provides the better solution in that the object can be properly textured without distortion. Yes, it is possible to use an increased smoothing angle and eliminate all UV seams, which will not cause the GPU to split vertices as shown in the second half of Fig. 3.3, but this is not always a practical solution in terms of texturing.

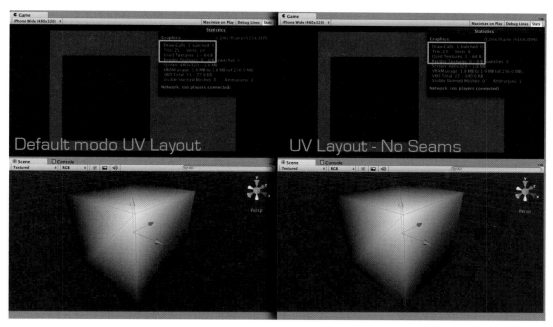

FIG 3.2 By Creating a UV Map without Seams, You Can Stop the GPU from Splitting Vertices, Yet This May Not Be the Best Solution.

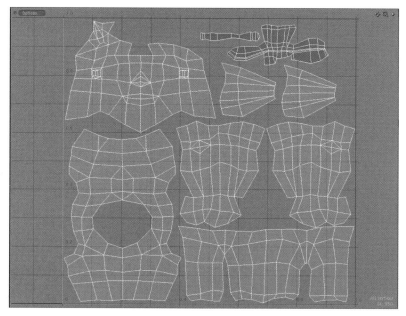

FIG 3.3 When Creating UVs for Tater, My Goal Was to Minimize Seams as Much as Possible while Removing Texture Distortion and Creating a UV Map that Was Best Suited for Texturing.

With this in mind, you have to be aware of each UV seam that you place in your map since it will cause an increase in vertex count. UV seams are inevitable, but you can control and limit them in your UV layout by combining UVs. It's vital to plan your UV layouts to accomplish this task. You not only have to be aware of UV seams, but you must also work to maximize the UV space. You need to arrange the most important areas of your mesh to utilize most of the 0 –1 UV space, which in turn allocates more pixels in the texture map. For example, with a character, you might decide that the head is more important in terms of pixel resolution than say the character's hands. This decision would lead you to layout the head UVs to take up more of the 0–1 UV space and thus allocate more texture resolution in the map. It also helps to keep in mind areas of your object that may not be easily seen by the camera. If you can't really see it, then there's no reason to waste UV space on it. Let's look at some examples using Tater and Thumper.

Creating UVs for Tater

Once the Tater model was complete, I took a survey of the mesh and made notes on the areas that I wanted to be sure to give the most precedence in terms of texture resolution. In Fig. 3.3, you can see the completed UV layout for Tater.

In Tater's case, I felt that most of the model was equally important. However, I decided that I would give the head, arms, and torso a little more UV space than the pants, legs, and shoes. The legs and shoes received the least amount of UV space since I decided that they wouldn't be as visible in game as the rest of the model. These decisions concluded my first steps in planning my UV map for Tater. By breaking the model down into sections of importance, I determined how to divide the UVs into separate UV shells or islands.

Let's take a look at creating UVs for the shirt. I needed to create a UV layout for the shirt that would allow me to easily create a texture map, and at the same time, minimize any texture distortion. First, I created an initial projection, by using the Project from View tool with the viewport set to Front view as shown in Fig. 3.4.

FIG 3.4 In the Case of the Shirt, I Created an Initial Planar Projection to Get Me in the "ballpark" for My Planned UV Layout.

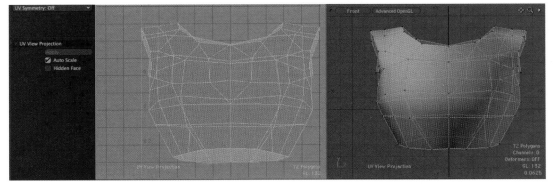

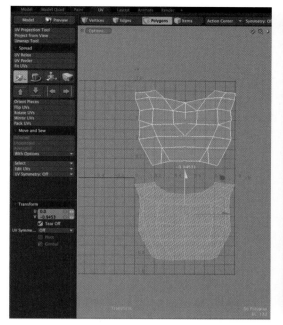

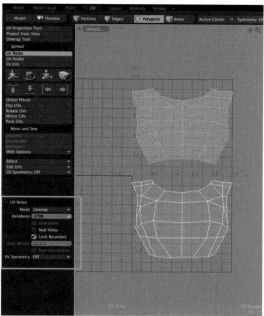

FIG 3.5 I Needed to Separate the UVs so that They Could Be Properly Relaxed.

FIG 3.6 Using Lock Boundary Works Well in This Type of Situation. We Don't Want to Relax the Border UVs, But Only the Internal UVs and Lock Boundary Does Just That.

I then selected the front of the shirt and used the Move tool with Tear Off enabled to separate the UVs into separate UV shells for the front and back of the shirt as shown in Fig. 3.5.

From there, I used the UV Relax tool with Lock Boundary enabled and relaxed each UV shell as shown in Fig. 3.6.

At this point, I have two UV shells for the front and back of the shirt, which will allow me to easily texture the shirt. However, I need to do something about the UV seams that I have created so that I can inadvertently increase the vertex count in my mesh. To eliminate some seams, I need to stitch the two halves of the shirt back together. To accomplish this, I selected the back of the shirt and used the Mirror UVs tool set to V to flip the UV shell in order to better align the two halves for stitching as shown in Fig. 3.7.

I then used the Move and Sew UVs to stitch the two UV shells together and thus eliminate two UV seams as shown in Fig. 3.8.

Once the two halves were stitched together, I did another UV Relax operation and used the Drag tool to fix any overlapping UVs. Looking back to Fig. 3.3, you can see the completed UV shell for the shirt. As you can see, the workflow is to create UVs that allow for ease of texturing, minimize UV seams by sewing edges together, and relax the UVs to remove any possible texture distortion. This is the workflow that I followed for all of the UVs in both the Tater and Thumper models.

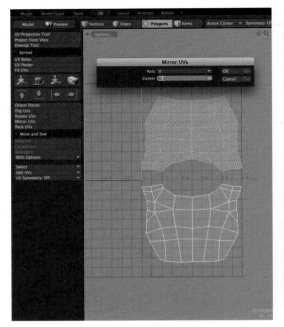

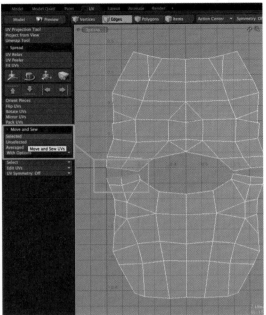

FIG 3.7 Before You Can Properly Sew the UVs, You'll Need to Align the Seams as Closely as Possible.

FIG 3.8 By Sewing the Two Halves Together, I Was Able to Remove Two Seams and Thus Stop the GPU from Having to Split These Vertices.

It can also be very useful to overlap certain UV shells. For instance, with Tater's shoes, I decided that they barely be visible in the game, so they are the smallest set of UV shells in the UV layout. To further save on space, I went ahead and overlapped both of the shoe's UV shells so they occupied the same UV coordinates. This allowed me to save a lot of space in the UV map as shown in Fig. 3.9.

For both Tater and Thumper, I didn't have a need for repeating textures. I think of these types of objects as having self-contained UVs, which is to say their UVs are meant to target specific parts on a single contained mesh. However, in contrast, a wall object will need to have its UVs repeat so that the object can represent many walls in a tiled fashion.

Creating UVs for Thumper

The UVs for the Thumper model were created in a very similar fashion to Tater. In Fig. 3.10, you can see the complete UV layout.

The UVs for Thumper were meant to occupy targeted areas on a specific mesh, so there were no repeating UVs to be concerned with. Again, I started with surveying the model and determining which areas are the most important and thus need to occupy the most UV space. Areas of the gun that are located underneath the object would definitely require less of the 0–1 space. I did follow the basic workflow of breaking apart areas of the mesh into separate

46

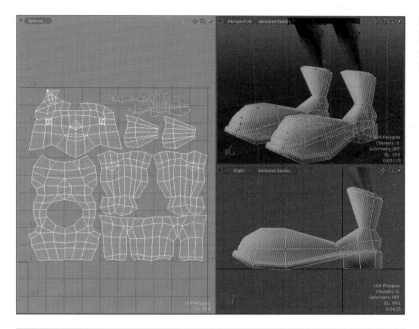

FIG 3.9 I Didn't Mind to Use a Repeating Texture for the Shoes, so in order to Save Space in the UV Map, I Overlapped Their UV Shells.

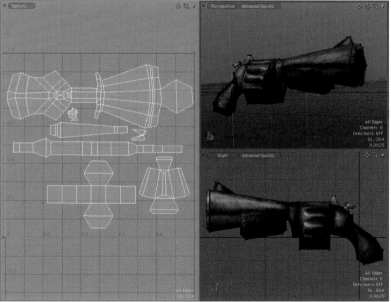

FIG 3.10 The UVs for Thumper Were Created in a Similar Fashion to Tater.

UV shells, relaxing and optimizing these areas and then sewing UV borders to minimize UV seams. However, instead of just relying on planar maps and then manually stitching borders together, I first used the Unwrap tool to unwrap the bulk of the gun. In Fig. 3.11, you can see the edges that were selected and the result from the Unwrap tool.

47

FIG 3.11 I Used the Unwrap Tool to Quickly Get the UVs Created for the Bulk of the Gun.

Notice that with the Unwrap tool, I was able to unwrap tough areas such as where the gun handle attaches to the barrel by carefully selecting the UV edges that would create the UV seams. Also take note that the handle is unwrapped, but it's still connected as much as possible to the base UV shell of the gun as shown in Fig. 3.12. My goal for this UV unwrap was to keep as many UVs continuous as possible while still being able to maintain a UV layout that makes sense when it comes to texturing.

Of course, you can't just use the Unwrap tool and have everything perfectly unwrapped. Once I had the base unwrapped, I then went and relaxed the UVs and arranged the UV shells into their final positions for the map. I also had to do a few manual projections, relax the UVS using the Relax tool, and sew the shells together to eliminate seams. In Fig. 3.13, you can see the polygons that I manually unwrapped.

In this section, we discussed creating UV maps. I'd like to reiterate that just as we found in Chapter 2 with modeling, there isn't a magic trick to optimizing your UVs. By understanding the important role UV seams play toward increasing vertex count when the mesh is rendered by the GPU, you can understand how and when to minimize the seams. Again, I have to bring up the common game industry phrase, "it depends." How you decide to

FIG 3.12 The Handle Is Nicely Unwrapped and It's Also Still Connected to the Gun, Which Keeps More UVs Continuous.

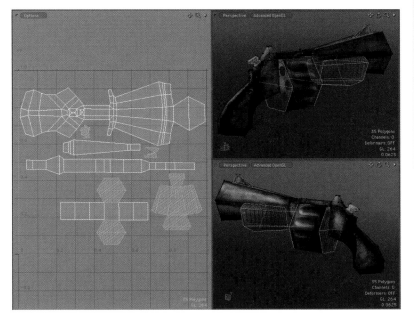

Use Unwrap Tool or Manual Projections

The Unwrap tool can be very helpful for quickly unwrapping a mesh. However, there are times with a complicated mesh that it can be difficult to figure out exactly how to select seams in order to get a clean unwrap. Also, you may find that when using the Unwrap tool, your UVs aren't being unwrapped in the most optimal way in regards to how you will be texturing in Photoshop. When I get into situations like this, I will create several smaller planar projections of the object and then manually stitch them together using the Move and Sew tools as we've discussed throughout this chapter. Sometimes, it's just easier to get your head around unwrapping the mesh so to speak by manually flattening the UVs via planar projections and then stitching them back manually.

FIG 3.13 These Selected Polygons Were Manually Unwrapped.

optimize your UVs depends on your game content and the type of game you're creating. The workflow that I stick to in creating content always begins with surveying the mesh and planning a UV layout. From there, I begin basic unwraps and then minimize UV seams. Rinse and repeat. In the

49

next section, we'll take a practical look at the process behind creating the texture map for the Tater game object.

Fundamentals of Game Textures

In the following sections, we are going to discuss the creation of the fundamentals of creating textures for the iDevice hardware. In regards to building content for the iPhone and iPad, I rely on the texture maps to bring detail to my objects. As we've discussed, the iDevice hardware, though powerful, can be somewhat limited in terms of game development, and you'll find that the best performance can be gained by using only a combination of color and lightmaps. Before we take a look at the textures for Tater and Thumper, we first need to look at some fundamentals in regards to textures and the iPhone and iPad.

Texture Formats

In this section, we are going to discuss texture formats as they relate to the iDevice hardware. These formats pertain to the formatting of the texture in system memory. There are several formats that are supported across the SGX GPU found in both the iPhone and iPad devices such as 32 bit, 16 bit, and PVRTC-compressed formats. In Fig. 3.14, you can see a list of available formats as found in the Importing Assets Settings dialog in Unity iOS.

Texture Size

When creating my textures, I typically work in a much higher resolution than will be used in my actual Unity iOS project. This essentially helps to future proof my textures when new devices are released with higher resolution capabilities as well as making it easier to support multiresolutions across

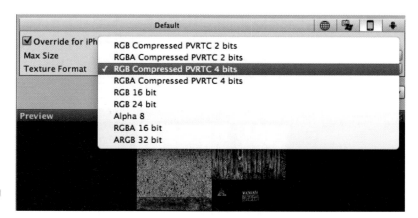

FIG 3.14 You Can Set a Texture Format in the Importing Assets Dialog within Unity iOS.

devices such as iPad to iPhone. For example, I'll typically work in a 2 K (2048 pixel) resolution when creating my textures. This not only works for the 1024-pixel resolution of the iPad but is also easily scalable down to the iPhone and iPod Touch devices, e.g., 480 × 320 for iPhone and 960 × 640 for the iPhone 4. Now, this is not the final size for textures in my game. The texture will be resized and compressed within Unity iOS. However, I feel it's important to note that when creating source textures, you need to think about the different resolutions across the iDevices. You definitely don't want to create your source textures at 480 pixels wide and then scale these textures up to working on the higher resolution devices such as the iPad and iPhone 4. It's always best to work large and then scale down to maintain the highest quality in your textures. Also, keep in mind that it's always best to create textures as a power of 2 so that they can be compressed using PVRTC compression on the iDevices.

Determining the final compressed size for a texture is dependent on several factors such as screen size and texture memory. For example, objects that are smaller in the scene, which is not only determined by physical size but also by 3D perspective of the camera, will be able to utilize much smaller image sizes. In fact, this is precisely where Mip maps come into play to optimize texture performance, which will be discussed in Chapter 9, "Working with Game Assets in Unity iOS." Over the next several sections, we'll look at the fundamentals toward how your texture budget is determined, which in turn will provide a solid foundation for determining texture size.

Power of 2 (POT) and Nonpower of Two (NPOT)

A power of 2 is any of the integer powers of the number two. Basically, it means two multiplied by itself a certain number of times. A nonpower of 2 is well, anything that's not a power of 2. Some common examples of POT resolutions are 1024 × 1024, 512 × 512, 256 × 256, and 128 × 128. It's important to understand that NPOT textures can't be compressed in Unity iOS. The desktop version of Unity iOS allows you to use NPOT as compressed textures on GUI Textures; however, if they're used on anything else, they'll be converted to RGBA 32-bit format, which will consume tons of RAM and is a very bad thing on mobile platforms such as the iPhone and iPad. POT textures support Mip maps and all wrap modes such as repeat and clamp. However, with NPOT textures, Mip maps aren't supported, and the wrap mode must be clamp to edge. POT textures are fixed in terms of aspect ratio and don't match the aspect ratio of the iPhone and iPad devices. This isn't an issue when creating textures for your game objects such as with Tater and Thumper, but with textures that need to fill the screen, e.g., menus, you will have to make some adjustments. You can choose to scale the NPOT texture in the Texture Importer dialog as shown in Fig. 3.15.

As you can see, this will essentially squish your texture as it is scaled to the larger or smaller resolution. I never use this option. Instead, I use a simple plane meshes with UI elements mapped using a texture atlas. This way,

FIG 3.15 You Can Tell Unity iOS How to Deal with NPOT Textures in the Texture Importer Dialog for Textures.

you'll be using the correct image formats for PVRTC Compression. A great tool to use for all GUI creation is "EZ GUI" from Above and Beyond Software. We'll discuss the usage of texture atlases in Chapter 4. However, it's vital to note that if you use NPOT texture sizes such as 480 × 320, you run into some heavy RAM usage, and the iPhone and iPad are not very fast in processing big RGBA textures. Also, larger textures take more time to load into RAM.

One benefit for NPOT textures in regards to interface elements (GUI) is they can be perfectly sized to the aspect ratio of the iPhone or iPad devices.

This essentially means that you can maintain a one-to-one texel (texture pixel) per screen pixel mapping, which means none of the texture's resolution is wasted. However, it's important to note that using a 512-pixel image for the UI will work in the same fashion. As we'll see in Chapter 4, you can also use a texture atlas, which can contain nonsquare texture areas for your GUI elements.

Texture Compression: PVRTC

PVRTC will compress a 32-bit file down to either 2- or 4-bits per pixel. As mentioned above, in order to use PVRTC in Unity iOS, your texture must be square or POT in size. When creating content for the iPhone and iPad, it's recommended to use the PVRTC format since it's the only format that can remain compressed in memory and can be decoded by the GPU from its compressed format. This is important because on the iPhone, you have very little memory bandwidth. Textures are often the major cause for running out of memory on the iPhone and are even more suspect on the iPad. For instance, a 256 × 256 32-bpp (bits per pixel) image with transparency will take up 256 KB of memory. However, the same texture compressed with PVRTC 4 bits will only take 32 KB of memory and PVRTC 2 bits only 16 KB, which is a major saving. The quality of the compression is very good, and with PVRTC 4 bits and in most cases, the difference is negligible. In Fig. 3.16, you can see the difference between a 32-bit and PVRTC 4-bit brick texture.

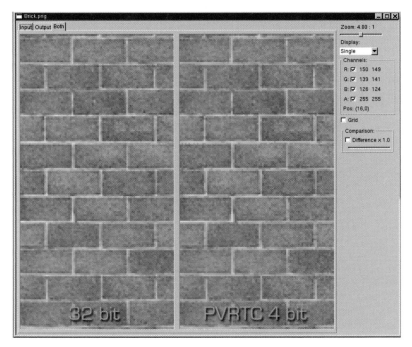

FIG 3.16 The Compression in Natural Type Surfaces Such as Brick Is Hardly Noticeable in PVRTC 4-Bit Texture Compression as Shown Using the PVRTexTool from Imagination Technologies.

53

PVRTC compression works well for natural type surfaces such as concrete, stone, and brick, and the compression is hardly noticeable.

The texture compression can and should be set directly in Unity iOS using the Texture Importer dialog as shown in Fig. 3.17. This means that when creating your textures, you can use whatever format you prefer such as PSD or PNG.

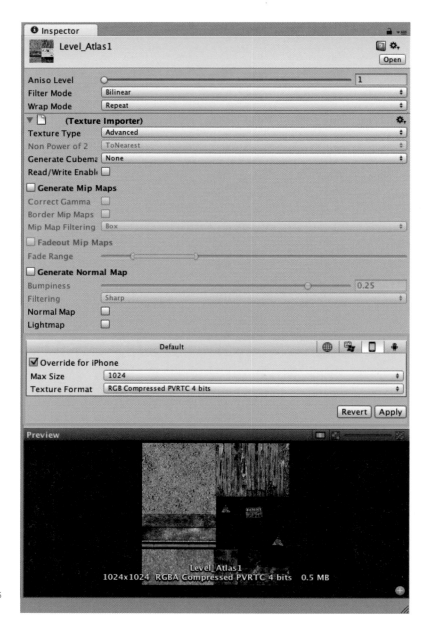

FIG 3.17 You Can Compress Textures from within Unity iOS.

I create all of my textures using Photoshop and export the file as an 8-bit PNG to my Assets folder in my Unity iOS project. I then set all of my sizing and compression within Unity. Unity iOS 3 supports several platforms; so for iPhone, you'll need to click the iPhone icon and then check the Override for iPhone box to set the size and compression scheme.

Using Mip Maps

Mip maps are a precalculated, optimized set of textures that accompany a main texture, which can help to increase rendering speed and aliasing artifacts. Using Mip maps on your textures will replace the main texture with a smaller more optimized version, as objects in your scene are farther away from the camera. In Fig. 3.18, you can see that Mip maps are enabled in the Texture Importer. Using Mip maps is a very good idea on mobile platforms. That is unless you know your texture will not be displayed very small on screen. That is to say, if you're sure each pixel of the texture will cover one or more pixels on the screen, then Mip maps are not a necessity for optimizing your textures. In Chapter 4, I'll discuss how building on the grid can help you to keep a one-to-one ratio between geometry size in terms of units and texture size in terms of pixels so that Mip maps are not necessary. I'm not a big fan of using Mip maps as they tend to blur your textures too much.

Multiple Resolutions

You need to be aware of the different resolutions between the iPhone 4, 3GS, and iPad when building your textures. For instance, if you only build textures for the 480 wide screen of the 3GS, then when your game runs on the higher resolution displays of the iPhone 4 and iPad, your content will look poor. This is why it's best to build textures at the highest resolution that will be supported, i.e., the iPad, and then scale down as needed. As mentioned, you can always add logic to your game that will load different content based off the device running the game. This way, you're sure to always give the player the best content for their device.

Texture Budget

Now that we've discussed the fundamentals of how textures are rendered by the iPhone and iPad GPU and how compression affects the amount of memory consumed by a given texture, we can now properly workout the texture budget. We discussed in Chapter 2 about the importance of budgeting our game assets in terms of how much of the system resource that would consume. The iPhone 3GS and iPad contain 256 MB of memory, while the iPhone 4 contains 512 MB. As mentioned earlier, textures are typically the culprits behind running out of memory on the iPhone and iPad.

FIG 3.18 Here You Can See that Mip Maps Can Be Enabled on the Texture Importer per Texture in Your Project.

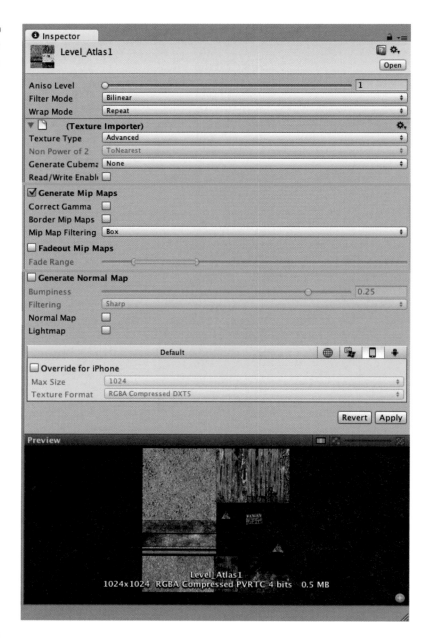

As we discussed in the previous section, it's rather simple to calculate the amount of memory a texture will consume. By determining how many textures your game objects will require and adding up the amount of memory for all the textures that will be used in your scene, you can adequately monitor your texture assets to see if they meet your texture budget. So is

the texture budget determined? Well, just as we discussed with the vertex budget, there isn't a magical formula or secret trick. It all comes down to the type of game you want to create and the device you want to deploy it to. However, the best solution is to again, create a performance test scene that you can use to work out the texture budget and use the Internal Profiler to check your game's performance. Using the Internal Profiler, you can monitor the amount of memory your game objects are consuming and thus gain an adequate representation of the system resources your game objects and textures are utilizing.

In this section, we discussed the fundamentals of creating game textures. By understanding the iDevice hardware and how the GPU is rendering textures, you will be able to properly gauge how textures can affect performance and thus know which steps to take to optimize your graphic elements.

Creating the Diffuse Map

In this section, we'll take a look at how I created the diffuse map for Tater. Due to the constraints of the iDevice hardware, I am only using a diffuse map to texture my game objects. The goal is to use the least amount of textures as possible. Running low on memory can cause the OS to terminate your app, so it's important to always be aware of how much of memory your game objects are utilizing. For example, instead of using a lightmap shader that combines a diffuse and lightmap texture, I opt to bake all of the lighting information into a single diffuse texture. Combining these textures in Photoshop is a simple method for cutting down on the amount of textures loaded into my scene.

Faking Light and Shadow

Because we need to build low-resolution meshes for the iPhone and iPad, we'll convey surface detail via textures. Since I'm not using any lights in my scene to improve performance, I will typically add subtle lighting cues into the textures. For example, you can utilize normal, bump, and specular maps to create surface detail, which can then be baked down into the diffuse map. This will give the illusion of light and shadow, without the overhead of using actual lights in your Unity iOS scene. Granted, this is an illusion and isn't going to give the same effect as using dynamic lighting. For instance, if your character is moving around a wall, the specular hits won't change nor will the bump since lights are not actually creating these effects. However, it's still a good way to add detail to your textures while keeping the overhead down. In Fig. 3.19, you can see two brick wall game objects as they are rendered in Unity's Game View as well as the modo scene used to create the bump texture. Notice that the brick wall object on the left looks much more detailed using the texture map with the bump and specular effect baked in. Adding baked lighting cues, and surface detail to your textures can go a long way to giving your work that creative edge.

FIG 3.19 By Baking the Surface Detail into the Texture Map, You Can Get Nice Lighting and Surface Effects without Having to Use Lighting or Complex Shaders.

Unity iOS OpenGL ES 2.0 Shaders

The usage of normal maps on the iDevices is not a good idea unless you absolutely need it. The GPU is just not fast enough to cope with it. For the iPad and iPhone 4, it's even worse because of the much higher screen resolution. Baking is always faster on any platform.

OpenGL ES is better for image postprocessing filters, but again, you need to be extra careful not to kill your performance with them. It is a little bit easier to write shaders in CG/GLSL (shader language) comparing with texture combiners of GLES1.1, but you would pay a performance hit for that as well. You could potentially render things like custom lighting, but again, you're going to pay in performance for that too. Essentially, you really need to know what you're doing in terms of shader code to use OGLES 2 efficiently. Bump maps overall require complex two or three pass shaders and may be too heavy for iPhone and iPad. With Unity iOS, it's strongly advised to use OGLES 1.1 until OGLES 2 is really necessary. As of the writing of this book, OGLES 2 is slow and somewhat buggy. Again, baking all you can into textures and using simple shaders are the best possible approach when working with the iPhone and iPad.

Texturing Tater

In Fig. 3.20, you can see the diffuse map that was created for Tater. In this figure, you are only seeing the color information. In Chapter 8, "Creating Lightmaps Using Beast," I will discuss the creation of the lightmap for Tater using Beast within Unity iOS. For now, we'll just focus on the diffuse map.

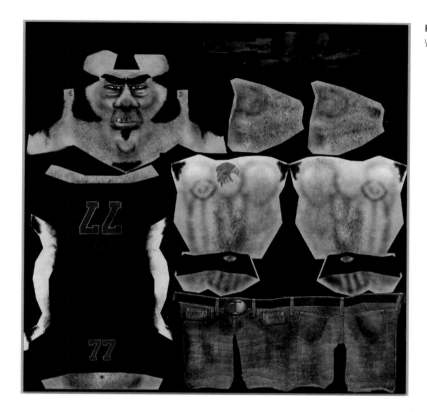

FIG 3.20 The Diffuse Map for Tater Was Painted in Photoshop.

The map in Fig. 3.20 is 2 K (2048) pixels in size, which was later resized down to 1024 × 1024 before it was imported into Unity iOS. Unity 3 supports per platform settings, which makes it much easier to have 2 K textures for high-res 3D renders, 1 K for iPhone with the click of a button. As mentioned earlier, this gives me plenty of flexibility with my texture sizes for use in different resolutions and screen sizes. In Chapter 9, "Working with Game Assets in Unity iOS," we'll discuss the compressing and resizing the diffuse texture within Unity iOS.

FIG 3.21 In Order to Create Tater's Jean Shorts, I Photographed an Old Pair of Jeans from the Front and Back to Use as a Reference as Well as Texture Source.

Reference Images

Collecting good reference images is the key to any texture work. Collecting reference should always be the first step in creating your texture maps. Not only is it vital to study the surface you want to create, but you'll also use the reference imagery to build your textures. For example, in Fig. 3.21, you can see the reference image that was used to make Tater's jean shorts. Once I had a good reference, I then used this source image to create the jean shorts.

FIG 3.22 Cutting Various Components from the Source Texture to Patch Together the Game Texture Is a Good Way to Quickly Build Up a Map.

I find that the easiest way to "unfold" a texture to fit the UV map is to simply patch it together from various pieces from the source texture as shown in Fig. 3.22. The trick is to think about the seams of the object and how you can work from the seams inward to create the texture.

For instance, with the jean shorts, I used the seam where the jeans were sewed together and copied this seam across the UV border. By working with the natural seam apparent in the object, you can easily patch the texture together, while at the same time hide the seam caused by the UV border. As shown in Fig. 3.22, you can see that the natural seams from the actual jean shorts reference image are used to hide the UV seams apparent in the UVs for the jean polygons. I used this same technique to handle all of Tater's clothes including the boots. I simply used the seams naturally found in the clothes as a starting point and mechanism for hiding the UV border seams and created a more realistic texture.

Skin Textures

Utilizing seams obviously won't work too well with skin. So to handle the face, arms, and legs, I began with a seamless patch of skin. I photographed my back and then created a seamless texture as shown in Fig. 3.23.

I used this seamless texture to create the skin in Photoshop by filling the skin areas using Edit > Fill > Use Pattern as shown in Fig. 3.24.

The pattern was the seamless skin texture. After I had the basic skin foundation, I used the Burn tool to add variation in skin tone and to build up volume. My basic workflow with textures is to lay down a base foundation and then build up detail to add variation.

Building Up Volume Through Shading

I mentioned that I used the Burn tool for the initial foundation and to create shading and variation to the skin tones. This is a very fast way to work. This process is about building up detail and after the Burn tool lays down the foundation,

FIG 3.23 Using the Patter Fill with a Seamless Texture Is a Great Way to Quickly Create a Base Foundation for the Skin Layer.

I will use a brush with a low opacity to paint in more shading cues and begin to introduce tonal variations through color. For example, in Fig. 3.25, you can

FIG 3.24 I Filled the Skin Areas with a Seamless Pattern to Quickly Create the Skin Foundation.

see Tater's cheek and how shading is created through layering. The left side of the figure shows the base foundation created with the Burn tool, and the right side shows how I continued to build up tone by using the Brush tool with a low opacity.

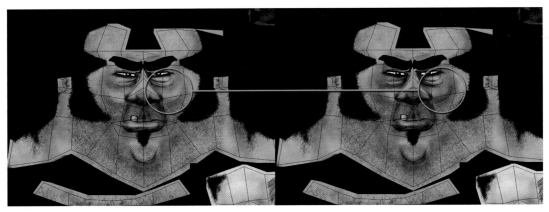

FIG 3.25 Always Remember That the Key to Texturing Is Building Up Detail by Layering Tonality.

As you can see, there's really nothing overly complicated to painting textures. If you break the process down to its basic form, its all about drawing simple shapes and shading while layering detail little by little. Always start simple and work in detail where it's needed using your reference images as a guide.

Creating Hair

Tater is a hairy dude, and painting hair was an extremely simple, yet fun process. In Photoshop, I created a custom hair brush and then began to build up hair by painting with the custom brush. To create the brush, I started with the 112 Brush Preset. Next, I increased the Size Jitter, Angle Jitter, as well as check both the Flip X and Flip Y Jitter settings on the Shape Dynamics menu. Finally, I increased the Scatter, Count, and Count Jitter on the Scattering menu. In Fig. 3.26, you can see the settings used to create the brush. Once the brush was created, it was just a matter of painting in the hair. I would frequently change the Scatter and Jitter settings to create a sense of randomness and variation in the hair.

Adding Some Wear and Tear

Once the final texture was complete, I then loaded up the texture into modo and used modo's 3D paint tools to paint dirt on the Tater texture created in Photoshop. My Tater character is a bit dirty and rough, and by adding some dirt to the texture, I not only add character but can also paint dirt over the UV seams and make the texture appear more seamless. In modo, I use the Airbrush tool with the Procedural Brush to paint the dirt. I start with a dark brown color and a very low opacity setting as shown in Fig. 3.27.

FIG 3.26 To Create the Hair, I First Need to Create a Custom Brush I Could Use to Paint Hair.

FIG 3.27 Using the Procedural Brush to Paint Noise over the Model Is Not Only Good for Adding Dirt But Also for Hiding Seams in Your Texture Map.

Again, I'm sticking with the theme of slowly building up detail. From there, the fun begins as I rotate the model and paint dirt and wear through the model. Modo allows you to paint over UV seams and across UV maps, so this technique can be very useful toward further hiding seams in your texture maps by painting some procedural noise over the UV borders.

Summary

In this chapter, we discussed several aspects for creating textures for the iPhone and iPad. We began by taking a look at the how UV seams can increase vertex count, and we went through some practical examples by discussing the creation of the UV maps for both Tater and Thumper. We also discussed the fundamentals behind textures such as PVRTC compression, power of 2, texture sizes, and determining a texture budget. The overall concept that I want to stand out in this chapter and to ultimately be the take away from the book is that by understanding the hardware limitations, game engine, and how game objects are rendered on the iPhone, you'll know how to build optimized assets. You'll understand how to determine vertex and texture budgets as well as know what it takes to make assets that allow your game to run as smoothly as possible. The key is to know your environment and the rules that govern that environment. In Chapter 4, we're going to build upon the modeling and texturing principles discussed thus far by taking a look at creating an environment for Tater.

Creating Game Objects Using modo
Training Trash Yard

In this chapter, we're going to take an in-depth look at the process of creating a game level. In order to illustrate the workflow, we'll use an example from Tater's world by building his training trash yard as shown in Fig. 4.1.

This chapter will build upon the information from the previous two chapters to provide a complete insight into the process of creating 3D content for the iDevices. We'll begin by taking a look at level design and covering some fundamental principles, and then, we'll move onto to the actual process of creating and texturing the level.

Tater's Weapon Load Out
Go to the resource site to view the video walkthrough for this chapter.

Level Design

In this section, we'll talk about the overall design of a game level and how it relates to process in which the level is constructed. There are a lot of considerations to make beyond just vertex count when it comes to creating

FIG 4.1 This Is the Level We'll Discuss Throughout the Book.

a level. The whole manner in which you construct the level can bear great importance on the performance. In Chapter 2, we looked at the creation of Tater and the process was fairly straightforward. We discussed determining a vertex budget, and from there, we modeled and UV mapped the character to adhere to that budget. However, with an entire level, there's much more to consider. Depending on your game, a level can be rather large, and you shouldn't just build the entire level into one mesh and send that off to the GPU. Well, that is to say, if you're concerned about performance you wouldn't.

When you look at designing a level, you need to think about both the technical and artistic aspects. For instance, on the artistic side, you need to think about how a level lends itself to the overall story of the game. You need to think about how each level will entice the player with something new and engaging, but also increase in difficulty to keep the player interested. You need to make sure that each level builds upon each other and supports to progress the overall story of the game.

On the technical side, you need to be constantly focused on performance. This brings us to the constant struggle we face as game developers, which is the balancing of performance artistic vision. Sure, you can throw everything but the kitchen sink into your level, and although it make look fantastic, it unfortunately doesn't run beyond 12 FPS. This would result in a failed game, as it doesn't play well.

Over the next several sections, we'll be taking a look at how to balance the art and technical limitations in order to build high-quality and optimized content.

Creating a Style

Although the focus of the book is on the technical aspects of building content, I felt it would be important to talk a bit about style. The style of your game should speak to the audience and lend itself to the experience you're trying to create for the player. As I mentioned, in this chapter, we're going to look at building a level from Tater's world. Before any content is created, I had already written out an entire synapse for my Tater character. I worked out his look, personality, and environment. I then hired Warner McGee, a talented character designer, to create the illustration and polish up Tater's overall style. Having a strong understanding of the world you want to create is key to visualizing a style for your level and characters. For instance, Tater is a bit of a country bumpkin and analyzing his personality and traits helped me to visualize the type of environment that would fit his persona. For the book, I wanted to create a level that would showcase the process behind creating optimized content while also adhering to the overall style and design of "Dead Bang" game property I have been working on. The level we'll be creating in the book is that of a trash yard. It's old and dirty and lends itself to Tater's style. Always remember that the levels you create in your games are just as much of a vital character asset as your main hero character. The next step was to sketch out the layout of the level so that when the time comes for actual modeling, I'll have a diagram to follow. All of the trial and error of the design and layout are worked out on paper first.

> *Always remember that the levels you create in your games are just as much of a vital character asset as your main hero character.*

What Can Reasonably Be Accomplished?

We previously discussed the balancing act behind technical limitations and artistic creation. When designing a style for your content, it's always good to start with the question, "What can reasonably be accomplished?" You need to consider what can be accomplished within either your self-imposed or project deadlines. You will need to decide what artistic avenues you want to explore in your game are actually possible to implement while maintaining a solid frame rate. Again, we need to balance the artistic to the technical. Remember, it's not a matter of compromising artistic vision, but a matter of finding the best solution to accommodate your style. For example, I had an idea for the trash yard for giving a hint of increased depth by adding some areas closed off by chain-link fences as shown in Fig. 4.2.

> *Always address the style issues up-front; in the design phase of your level by asking the important question, "Can this be reasonably accomplished?"*

The chain-link fence areas would also lend itself well to the trash yard theme; however, this would involve the use of an alpha transparency shader. I was a

FIG 4.2 Fence Areas Are Closed off to Player but Give the Illusion There's More to the Level.

bit cautious of this because I know that the iPad and iPhone 4 can suffer from fill-rate issues, especially when filling the screen with a transparent polygon. So, I asked the question, "Can this reasonably be accomplished?" Later in this chapter, we'll talk about how I tested this scenario, but for now, you can see the situations like this you need to address up front. It's much easier to decide to drop the fences in the design phase and go another route versus having to scrap a model and start over due to performance issues. Always address the style issues up-front, in the design phase of your level by asking the important question, "Can this be reasonably accomplished?"

Breaking Down into Sections

So, we've talked about style, and in this section, we'll start to really address the design of the level in terms of optimization. It's always a good idea to break your level down into sections as shown in Fig. 4.3.

There are several advantages to breaking the level geometry down into sections, which I've organized into three categories, Puzzle Building, Lazy Loading, and Optimize Batching.

Puzzle Building
Breaking the level design into sections give us the opportunity to create seamless tiles or puzzle-like pieces of geometry that can be used to build a level in any number of configurations as shown in Fig. 4.4.

FIG 4.3 Here the Level Is Divided into Sections.

Now, for the level showcased in this book, I didn't go as far with the level tiles as to make them totally seamless, as it wasn't necessary for my overall design, but it's an important technique to mention. However, the sections of levels I did create can be configured somewhat differently than my original layout. With Unity iOS, we now have the ability to work with mesh tiles from within the application. By using the new Vertex Snapping feature, we can simply and accurately snap tiles together by holding down the V key, hovering the mouse pointer over a desired vertex, and left-click and dragging to snap the mesh to a vertex on another tile as shown in Fig. 4.5. Vertex Snapping in Unity iOS ensures that both meshes are "snapped" precisely together and can be used to quickly connect several mesh tiles to create a level within the application.

As you can see, creating mesh tiles and using Vertex Snapping in Unity iOS is a very effective way to build a level. We'll discuss the entire process later in the "Building on the Grid" section.

Lazy Loading

Breaking the level down into sections also gives us the ability to optimize large levels by using what is referred to as lazy loading, which is the process of deferring the initialization of an object until it's absolutely needed. For instance, let's say we have a large level broken into four sections. In your game logic, you can create a methodology for loading one of the next sections when the player has reached a goal position. With that same token, you can unload a section once the player has also reached a goal position.

FIG 4.4 The Level Can Be Broken Down into Smaller Tileable Elements.

For instance, you could setup a blockade, which controls how much the player is aloud to backtrack in a level. Once the player has reached a certain position, you can safely unload the section. Now, discussing the implementation of this procedure is beyond the scope of this book, but it's important to understand the advantages to breaking the level down into sections in terms of loading. For this method, each section is saved as a separate FBX file that can be loaded when needed. Also, with each section exported as a separate file, you can implement an asset downloading mechanism to your game so that player can use In-App purchases.

Optimize Batching and Rendering

As we discussed in Chapter 1, batching is extremely important for optimizing your game's performance, and special care needs to be taken to make sure that your meshes can and will be able to batch. By breaking the level into sections, you gain two advantages in terms of rendering vertices. First, it will be easier to stay within the 300-vertex limit that is a restriction of Dynamic

FIG 4.5 Vertex Snapping Is Great for Ensuring Meshes Are Perfectly Aligned.

Batching and second; you further optimize the amount of vertices sent to the GPU in regards to the camera's view frustum.

Batching Revisited

In Chapter 1, we took a technical look at both Dynamic and Static Batching. Let's now take a more practical look at Static Batching as it pertains to creating a level. I mentioned earlier that creating our level in sections would further optimize the amount of vertices sent to the GPU. As we mentioned in Chapter 1, with Static Batching, vertices are stored in an indexed vertex buffer, which contains less data for the CPU to deal with and is thus faster than Dynamic Batching. However, we then have the caveat of not being able to transform the vertices. Static Batching creates a shared mesh. These items are not combined. They remain separate, but all of the vertices are all added to an indexed vertex buffer, which is the vital aspect of Static Batching in terms of how you create your objects. Let's take a look at an example. In Fig. 4.6, I combined two sections from a level into one in modo and added a third section to the scene in Unity iOS so that we have two meshes to be rendered. You can also see that the camera's view is only showing half of the level. Because I've marked all of the meshes to Static and adhered to the rules of creating a batch, the meshes will be batched into one draw call. However, our job toward optimization isn't done. We not only have to think about the draw call, but the camera view frustum and how it relates to the amount of vertices being stored in the indexed vertex buffer for Static Batching as well.

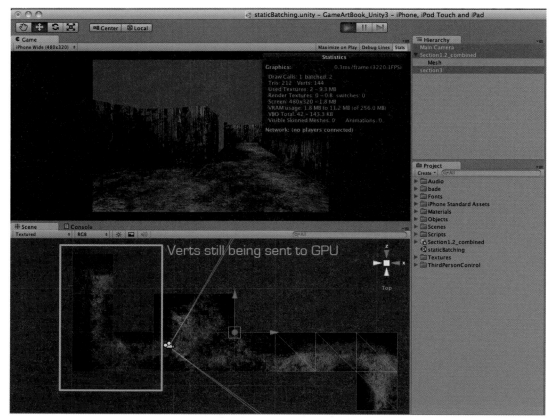

FIG 4.6 This Image Shows that even though the Camera Doesn't See the Mesh Behind It, the Verts Are Still Sent to the GPU.

I mentioned that only half of the level is being viewed. However, since the meshes for sections 1 and 2 have been combined in modo, the camera's view frustum is still within the bounding box for that mesh, and all of the vertices are being sent to the GPU even though most of them aren't being rendered, i.e., everything behind the camera. Now, in Fig. 4.7, I have properly divided the level into sections, and now, the camera's view frustum isn't overlapping the bounding box for section 1 and thus those vertices aren't being sent to the GPU. As you can see in Fig. 4.7, the vertex count as been drastically lowered to 96 verts down from 144. By breaking the level into sections, we were not only able to batch the meshes but also further minimize the amount of vertices sent to the GPU.

The question now becomes, "how do you know where to divide up the level?" Well, in terms of optimization, its quite simple. All you need to do is think about the widest area of the level that's going to be seen by the player at a given time. For instance, in Fig. 4.8, you can see how I decided on a proper division for sections 1 and 2 of the level due to the player having to

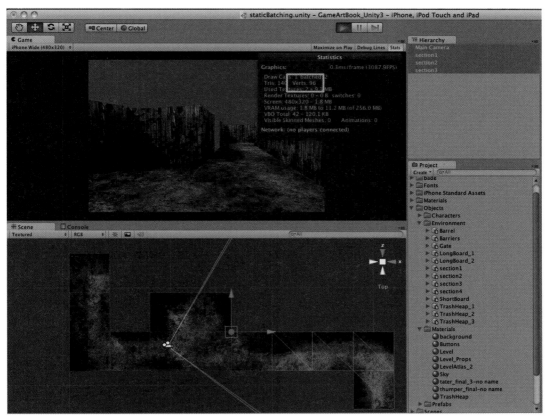

FIG 4.7 Using Sections, the Vertex Count Is Dramatically Reduced.

move down the hall and turn left in order to see more of the level. The goal is to visualize your level and decide what areas will be visible to the camera's view frustum at a given time. The Occlusion Culling tools in Unity iOS will provide a similar optimization, but it's an Advanced License feature. Also, in order to properly use Occlusion Culling, you'll need to have your geometry broken into sensibly sized pieces as we've discussed in this chapter. So by following these principles of dividing up the level, you'll also be creating the correct geometry for using Occlusion Culling if you upgrade to or already have the Advanced License.

When building any objects for Unity iOS and the iDevices, I adopt the mantra, "Build to Batch." When creating your own content, you should always stick to this important concept in order to keep your mind focused on building optimized content.

The goal is to visualize your level and decide what areas will be visible to the camera's view frustum at a given time.

FIG 4.8 This Image Shows What Areas Are Visible to the Player.

Creating the Level

In these last sections, we've covered the importance and reasoning behind breaking our levels down into sections. You can now see how this type of level design can have a dramatic impact on the scene's performance. Now, we'll move on to looking at some practical examples as I illustrate the process in creating Tater's Training Yard.

Determining the Vertex Count

Determining a proper vertex count is always an important step in the design process of your level. This budget should always be worked out before any modeling is started. In Chapter 2, we discussed creating a performance test scene using the Penelope tutorial elements provided by Unity Technologies. We don't need to cover this again, but I just wanted to reiterate the importance of testing performance and determining budgets before any actual modeling is done. It can be very detrimental to your project to realize late in the game that your models have been created with too much resolution. When this happens, you're forced to make several difficult decisions as to what other aspects of your game will need to be sacrificed to compensate.

It can be very detrimental to your project to realize late in the game that your models have been created with too much resolution. When this

happens, you're forced to make several difficult decisions as to what other aspects of your game will need to be sacrificed to compensate.

As you will recall from Chapter 2, using the test performance scene, we were able to gauge a working vertex count. We will use this vertex count as a base to follow. Again, it's not the ultimate answer that we stick to no matter what happens in our game as many factors come into play, which affect our frame rate such as script performance, texture memory, and physic calculations. However, it's very helpful to have a base number to work toward when creating models. Without this base, we'd essentially be modeling in the dark so to speak.

Further Testing

I mentioned earlier in the "What Can Reasonably Be Accomplished" section that I performed some testing with transparency before committing to a solution in the model. Again, I definitely want to reiterate that it's always easier to realize device limitations and that a particular idea won't work in the design phase rather than the finished model phase.

It's always easier to realize device limitations and that a particular idea won't work in the design phase rather than the finished model phase.

As previously mentioned, the iPad and iPhone 4 can suffer from fill-rate issues. As discussed in detail in Chapter 1, this is largely due to the fact that it's using the same 256 MB RAM and SGX 535 GPU as the iPhone 3GS to render to displays that are higher resolution. Knowing this up-front, which is another reason it pays to have a thorough understanding of the different iDevice hardware, urged me to test the transparency capabilities on the iPad and iPhone 4 before I committed to creating the chain-link fences using an alpha shader.

In Fig. 4.9, you can see the simple test scene I used to test the transparency shader and fill rate on the iPad and iPhone 4.

The scene has several of the chain-link fence polygons with a shader using alpha testing. Now, I'll also mention that using a shader that performs alpha testing can be quite expensive on the iDevices, so again, this is a good opportunity to test it up-front. The test is simple; install the scene on the iPad and iPhone while using the Internal Profiler to monitor the frame rate as I fill the entire screen with the transparent polygon. I also used the controls to quickly move in and out and around the transparent polygons as the screen goes from being filled to semifilled with the transparent polygons. I did this to try and "stress" the iPad and iPhone 4 as the GPU is being tasked with drawing the polygons. Checking the Internal Profiler's output over a period of time didn't indicate any major issues. Once the entire level was complete with all of the textures and geometry in place, I still found that the alpha test shader was still performing well with only a 1 or 2 millisecond drop.

FIG 4.9 This Scene Was Used to Test Fill-Rate Issues on the iPhone 4 and iPad.

FIG 4.10 An Example of a Texture Atlas.

Using Texture Atlas

Using texture atlases in your projects are a great way to increase texture optimizations and keep artwork consistent across multiple objects. In Fig. 4.10, you can see the texture atlas that was built for Tater's Trash Yard level.

Texture memory is vital on the iPad and iPhone 3GS and can often be the main culprit behind low performance and crashes. With the iPhone 4, you have double the amount of memory at 512 MB, but you still need to keep your texture usage as optimized and efficient as possible. This is where the usage of a texture atlas comes into play. A texture atlas is a single image that acts as a container, which houses the coordinates for several smaller image sections through which multiple objects can target. The result is that several objects can use the same texture and thus minimize the number of textures that need to be loaded in your scene. By using a texture atlas, you fit the textures for an entire level into one image map. This can dramatically increase the performance of your game by using less memory for textures. In Fig. 4.11, you can see how the objects in my level target the different areas on the texture atlas.

FIG 4.11 This Image Shows the Relation Between the Level Texture Atlas and the Actual Models.

Any empty space in your texture atlas is a missed opportunity for adding detail in your game.

Using a texture atlas is best utilized when "Building on the Grid," as we'll discuss in the next section. Building your textures on a grid allows you to optimize the atlas so that it's as efficient as possible, utilizing every single pixel in the image. The main thing to remember with texture atlases is that any empty space in your atlas is a missed opportunity for adding detail in your game. The image is going to be loaded in your game so you might as well make sure that every pixel counts.

Building on the Grid

Building on the grid is a technique common to level creation in games. It's the process of building your objects into tiles or puzzle-like pieces so that they can be snapped together in a seamless fashion to build a level. The grid comes into play as the tiles are built on a grid-based off predetermined sizes such as 256 × 256 or 512 × 512 as shown in Fig. 4.12.

Building on the grid is very efficient for building levels. Let's take a look at three important reasons. First, you get a consistent texel density as the mesh size in 3D space matches the texture on the grid in pixels. For instance, in my level, you can see that the ground mesh is created from tiles that are 512 × 512 units, and these mesh tiles directly relate to a portion of the texture atlas that is also 512 × 512 in pixels as shown in Fig. 4.13. I'll also note that this portion of the texture atlas that represents the ground occupies 512 × 512 pixels of the 1024 × 1024 pixel image. The ground portion is seamless on

FIG 4.12 This Image Shows the Texture Atlas Divided into Tiles and the Resolutions the Tiles Relate To.

all sides so that it can easily be tiled. Also note that the ground texture is in a power of two format as well as the level texture atlas. However, I can create texture areas in the texture atlas that are not a power of two, but because they are contained within the power of 2 texture atlas, they can still be compressed using PVRTC compression. If you look back to Fig. 4.12, you can see that the board textures are not in a power of 2.

The second reason is that there's no wasting of resolution in the game as building on the grid helps you to place texture resolution appropriately. For instance, let's say you have a doorway mesh that's only 128 × 256 units in size in 3D space. It would be a huge waste to map a 1024 × 1024 pixel image to this mesh. Building on the grid helps you to work

FIG 4.13 The Ground Is Made into a Tile of 512 × 512 and Is Mapped to a Texture Tile of 512 × 512 in the Texture Atlas.

out the unit to pixel ratio so that you can be assured that your mapping and texture resolution is as efficient as possible.

Now, using Mip maps can help with texture memory as their purpose is to replace a texture with a lower resolution copy of the image the further the camera is away from that texture. However, you get the side effect of having blurry textures in your scene, which I really don't like. If you're working on the grid, you can manually create this effect by being sure that your meshes are using only a specific and proportional section of the texture atlas. Again, you're not wasting any resolution, and the texture coordinates map to the specific area of the atlas, which directly relates as a 1 to 1 relationship between the meshes size in units and the texture size in pixels.

Finally, the third reason is that objects can be tiled. You can make new and different configurations of levels via connecting the tiles, which results in objects being part of a reusable library of elements as was shown in Fig. 4.4.

Does It Make Sense to Use the Grid?

When creating Tater and Thumper, we didn't use the grid. Not every object in your game makes sense to build on a grid. Organic type models don't work too well using the grid methodology. Again, we have to come back to every game being different and having its own set of requirements. It helps to know the different methodologies available so you can make the appropriate decisions for your own projects. The one thing that's common to all game projects is optimization. You need to always be thinking about the best ways to optimize your graphics, and building on the grid is just another way to help you accomplish this task.

Determining Working Texture Size

So, we've talked about building on the grid, but we really haven't gotten into the particular process. To begin, we need to determine a working texture size that will be used in modo to establish our ratio between units in 3D space to pixels in our texture atlas. In Chapter 2, I mentioned that our Unit System in modo was set to Game Units and the Meters per Game Unit setting was set to 1.0. This means that we've determined that 1 square in modo's Grid and Workplane is equal to 1 unit. For building on the grid, we need to take this one step further and create another relationship between the grid and the Game Unit Setting in modo. We need to assign, in a theoretical sense, a texture resolution to a game unit. For example, I chose 128 pixels as my working texture size, which means I will now think of each game unit/meter in modo as representing 128 pixels. That is to say, in modo, I can reference my working texture size as 128 pixels per meter. Let's look at an example to illustrate this relationship. In Fig. 4.14, you can see that I have a single ground polygon selected, and with the Dimensions tool active, I can see this polygon is 4×4 game units or 4×4 m. If I take 128 times 4, I will get 512, which as you can also see in Fig. 4.14 is the exact size in pixels that the ground texture contains in the level texture atlas. You can now see that the single ground

FIG 4.14 A Single Tile of the Ground Is a 4 × 4 Tile in Modo, Which Equals a 512 × 512 Texture (4 Times 128).

polygon is created to match the texture resolution, and a 4 × 4 m polygon equals 512 pixels in my texture map. This relationship between units in modo to pixels in my texture exists simply because I set it up that way. There isn't a setting in modo to change other than being sure that I have set the Meters per Game Unit to 1.0. The relationship between the game units and pixels is arbitrary and something that I determined on my own, based off my own project requirements.

So how did I determine that 128 pixels is what I'd use for my working texture size? To answer this question, we need to look back to the hardware. On the iDevices, we can use up to a texture size in pixels of 2048 or 2 K. Now this is on the iPhone 3GS, iPod Touch third generation and up as it specifically relates to the support of OpenGL ES 2.0. I will typically use a maximum texture resolution of 1 K (1024 × 1024 pixels) as I've found it to be a good base resolution for the higher resolution iPhone 4 and iPad screens yet can easily be downsized for 3GS. So that leaves us with anywhere from around 64–1024 pixels that we can use as our working texture size. From there, I determined that 128 would be a good base number to start with. Again, there's not an exact formula, but something that you determine yourself. I could have easily used 256 and made each of my ground polygons 2 × 2 m, but when modeling, it was easier to use a 4 × 4 size.

Creating the Ground

Now that I have a working texture size and have determined that each ground polygon will be exactly 4 × 4 m or game units in size, I can begin to layout the ground polygons. To start, the entire model is built into one mesh item.

This is the best solution as I can make sure everything is fitting together correctly, and once the entire level is built, I can get a full overall picture of the level and how I can effectively break it down into sections as I mentioned previously.

I started with a single 4 × 4 unit polygon, and from there, I used Snap to Grid to quickly snap each section together until the entire ground is completed as shown in Fig. 4.15.

FIG 4.15 I Used Snap to Grid to Snap the Sections Together.

Creating the Walls

Next, I created the walls using the same techniques used in creating the ground. Each wall is 4 × 4 units as well, which relates to 512 × 512 pixels in the texture atlas. The reason behind this is to make sure that the texel density between the ground and the walls are the exact same size. This is important because in my particular level, the ground and walls take up a major portion of the polygons. They are the foundation of the entire model and what is most widely seen. I definitely needed to avoid these two areas of the model having different resolutions because they connect directly to each other in the level. It would look very bad to have the ground mapped to 512 pixels in the image while the walls meeting up with the ground only containing say 128 or 256 pixels in the image. By building to the grid, I can be sure to match texel density between objects in my scene.

FIG 4.16 The Walls and Ground Are the Same Size, Which Is 4 × 4 Units.

In Fig. 4.16, you can see that the walls are 4 × 4 units and that they match in size to the ground polygons they are snapped to. Again, I used Snap to Grid to quickly layout the walls. Also notice that I left openings for adding the fence areas. The corners of the walls are handled a little differently. Each corner was created from two 2 unit polygons that were merged together. These two polygons created a right angle. However, when the UVs were unfolded, the two 2 unit polygons would occupy the same space as the 4 × 4 unit wall polygons and thus occupy the same texture space in the atlas.

For the fence areas, I used a single polygon that was also 4 × 4 meaning it required 512 pixels in the atlas as well. This polygon would represent the chain links in the fence. To create the fence posts, I created a 6-sided cylinder with the caps deleted. The fence posts were about 3 units tall so that meant they needed to occupy around 400 pixels (128 times 3) in the texture atlas. The gate objects were exported as a separate mesh so that they could be a reusable item. In Fig. 4.17, you can see the completed gate model.

Note in Fig. 4.17 that the gate model uses two corner wall sections as described above. Also, the ground polygons for this asset are 4 units by 2 units in size.

Creating the Props
To create some depth and randomness to the level, I created several prop objects, which consisted of barrel, two long boards, and one short board as shown in Fig. 4.18. Each one of these items was built to batch being under

FIG 4.17 The Gates Were Exported as a Separate Mesh.

FIG 4.18 The Props Will Be Randomly Distributed in the Level in Unity iOS.

300 vertices and shares the same material as the rest of the level. This allows me to place tons of these items randomly throughout the level without the cost of an additional draw call. These props are very easy to create. The barrel is a simple cylinder, and the boards are just boxes. The difficult aspect about creating a level like this isn't in the modeling stage, as the techniques used to model the assets are not advanced by any means.

Creating a Skybox

A skybox is used to create an atmosphere for your level. A skybox is typically created using a box and uses a cube map to apply a sky texture. This is a proven technique as it provides the least amount of distortion and wastes as little texture space as possible. I use CG Textures for downloading textures for my models and used the site for all the content created in this book. You can download textures for free up to 15 MB a day at http://www.cgtextures.com.

From CG Textures, you can download any sky texture in the cubemap format. The cubemap provided is in a strip format, so I use an excellent program called Pano2VR, for converting the file to a proper cubemap that would map perfectly with the automatically created UVS for a default box in modo. Pano2VR is available on both the Mac OS and PC and I use it often for creating environment maps. You can find more information about Pano2VR at http://gardengnomesoftware.com/pano2vr.php.

With that said, I found that I couldn't seem to get the quality in the sky that I wanted using a cubemap. With the cubemap, I was wasting a lot of empty space in the map, and the UVs for the box mesh wasn't utilizing the entire image map, which was causing a lot of pixelation. In Fig. 4.19, you can see the cubemap skybox and the wasted pixels.

FIG 4.19 The Wasted Pixels in the Cubemap Are Shaded Yellow.

So, I decided to go with a six-sided cylinder in order to minimize the seams the actual box method was causing. With the cylinder, I was able to perform a simple cylindrical unwrap and then scale the UVs so that they covered the entire 0–1 space, which in turn would utilize all of the pixels in the map. The next step was to create a sky map that expanded to all sides of the image. I jumped back to Pano2VR and used the Transformation tools to export a Mirror Ball format. Lastly, I imported the file into Photoshop and used the Distort > Polar Coordinates filter set to Polar to Rectangular, which produces a specific unwrapping that would fit my texture map needs. In Fig. 4.20, you can see the final map that was created and cropped to 2048 × 2048 for use in Unity iOS.

FIG 4.20 This Is the Final Map I Created for the Sky, Which Doesn't Waste Any Texture Space.

Creating the Trash Heap

Next, I'd like to talk about the heaps of trash surrounding the level. The trash heap is also very basic in terms of modeling. The process for creating the geometry was to simply create a mountain from as few polygons as possible. Again, I will use a max-smoothing angle to remove the facets in the polygons. This item will target a different texture atlas than the level. For this model, the UV layout was the key to creating a successful look. To create the UV map, I cut the UVs down into sections. I made sure that each section was proportional to each other so the texture would be a consistent size across the mesh. The UVs were overlapped and placed in the upper area of the 0–1 space. The bottom half is reserved for the target object that will be discussed in Chapter 7.

I used Luxology's ImageSynth 2.0 program to create all of the seamless textures for my maps. I went to CG Textures and downloaded several junk and trash yard photos, and using ImageSynth, I compiled a seamless texture that was used for mapping the geometry.

In Fig. 4.21, you can see the completed trash heap model. Notice that the trash heap texture uses a seamless texture in the top half of the texture atlas.

FIG 4.21 Here Is the Trash Heap Model, Which Surrounds the Level.

Texturing the Level

In this section, I want to talk about how the texture atlas for the level was created. We are going to look at how to measure the scene to determine texture size as well as creating UVs. I mentioned earlier that the entire level was created as one mesh item and then was later broken down and exported into separate objects. This made it much easier for me to create the UVs, and as I broke down the level into sections, the UV maps created were also copied. This meant that the coordinates would still line up correctly even though the sections were now saved into separate FBX files.

Measuring the Scene

The first step is to measure the scene to determine the size. As mentioned earlier, I used the Dimensions tool, selected the polygons to get the measurement, and then multiplied this by my working texture size. Remember, my working texture size was 128 pixels so selecting a wall tile displayed a 4×4 size, which equates to 512 pixels (128 times 4) in the texture map. I then measured all of the items in the scene and kept note of the size they would need to relate to in the texture map.

Creating the Textures

Before creating any UV coordinates, I created the texture atlas. This is a bit backwards from the way Tater and Thumper were created. As previously mentioned, I used CG Textures to download all of the texture reference I needed for

the level and then used my measurement outline to build the texture atlas to the correct size specifications. The goal here is to use every pixel in the image and have each pixel mapped to an object. This stage is more difficult than the modeling since you have to logically workout a way for the textures to all fit in the map, yet retain the correct size. For instance, you can see in Fig. 4.22 that with my texture atlas, I've wasted some space when creating the textures for the barrel. This isn't going to ruin me, but it's not as optimized as it should be.

FIG 4.22 The Highlighted Areas Show Wasted Texture Space.

Creating UVs

Once the texture map is complete, I then import this texture into modo and set the UV window to show the image. Now, while I create the UVs, I can use the image map as a guide to line up the coordinates to the image. Again, it's backwards to the way you'd usually work with UVs, but it also makes the UV layout process simple. In Fig. 4.23, you can see the UV map that was created and how it relates to the texture atlas.

Lightmap UVS

For this level, I used lightmapping extensively, and I needed to be sure that I created a UV map that contained coordinates that didn't overlap. Nonoverlapping UVs is the key to creating a UV layout that is correct for light-mapping and that is to say that the current UV map won't do the trick. Not to worry, creating UVs for lightmapping is by far the easiest stage in the entire process. While still working under the single mesh for the entire level, I created a new UV map, which now leaves me with two UV maps for the mesh. The first UV map is for the texture and the second is for the lightmap. Now with

FIG 4.23 Here Is the UV Map Alongside the Texture Atlas. The Red Shading Shows Overlapping UVs, Which Will Tile in the Map.

the blank UV map selected, I used the UV projection tool, with the Projection mode set to Atlas and then just left-clicked in the UV editor window to create the projection. That's it. The Atlas projection unwrapped and arranged all of the coordinates in a manner that's perfect for creating a lightmap. In Fig. 4.24, you can see the UVs that were created for the purpose of creating a lightmap.

Generate Lightmap UVs in Unity iOS

Unity iOS has a great new feature that allows you to generate UVs for lightmapping purposes in the Import Settings. We'll be taking a look at this option in Chapter 8.

FIG 4.24 Here Are the Lightmap UVs. Notice There Are No Overlapping UVs.

Summary

That brings us to the end of this chapter. We discussed several important topics such as building on the grid, breaking a level into sections, and setting a working texture size. As you can see, modeling a level isn't overly complicated in terms of modeling technique. It most certainly can be more complicated than the level shown here, but the base concepts shown in this chapter will carry over into even the most complex level designs.

However, the techniques discussed in this chapter are not complete. In Chapter 8, we will revisit this level and further discuss lightmapping by detailing the process of using Beast in Unity iOS. We will also discuss how I was able to add dirt and grime to the lightmap in order to further provide some unique and random details to the level while minimizing the repeating nature of tiling textures.

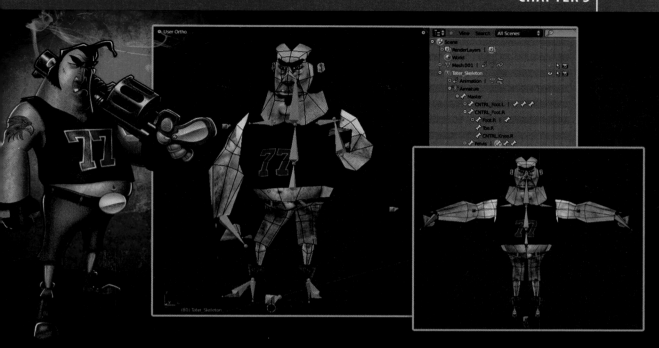

Animation Using Blender
Rigging Tater

In this chapter, we are going to take a look at the process of rigging Tater for the purpose of creating several game animations such as running, walking, and shooting. This chapter will focus on using the open-source Blender application. Most 3D applications are very expensive, and Blender, being free, can be a great alternative for the independent game developer. Blender is available for all platforms, i.e., Windows, Mac OS, and Linux. Blender was chosen as the animation package for this book as it's a great companion to a modo pipeline. Although modo has some robust animation capabilities, it lacks a bone and skinning system, which is vital to creating skinned meshes for use in Unity iOS. Now, you could create a segmented character in modo that is animated using constraints and IK, but this type of character will not fit my project requirements.

As with all the content in this book, this chapter assumes that you have a working knowledge of the software, which in the case of the next three chapters is Blender. For the Blender sections of the book, I used the 2.53 Beta. You can download Blender 2.5 at http://www.blender.org.

Tater's Weapon Load Out
Go to the resource site to view the video walkthrough for this chapter.

Creating 3D Game Art for the iPhone with Unity. DOI: 10.1016/B978-0-240-81563-3.00005-X

91

As we did with the previous chapters, we are going to take a look at the "why" before we get into the "how" by studying how bones and skinned meshes should be optimized for the iPhone and iPad hardware and how skinned meshes work in Unity iOS. By first understanding the why, we'll then be able to correctly build a rigged character for use in a game targeted for the iPhone and iPad platforms. We'll begin by taking a look at matching object sizes between modo, Blender, and Unity iOS.

One more thing worth mentioning is that even if you're not a Blender user, this chapter will contain important information toward rigging and skinning a character for use in Unity iOS and the iPhone. The information in this chapter can easily be ported to other 3D applications such as Maya, 3DS Max, LightWave 3D, SoftImage, or Cinema 4D. Be sure to check out the "My Dad Can Beat up Your Dad" sidebar.

Matching Object Size

In order to properly get our models into Unity iOS, we need to first make sure that we have established a correct workflow for maintaining the correct object size as we move from modo to Blender into Unity iOS. In Chapter 2, we discussed the sizing differences between modo and Unity iOS, and we worked out a solution to compensating for the way in which the different programs internally handle object size in terms of units of measurement. Now, we are going to add another variable into the equation so to speak as we add Blender to the mix.

> *The important thing to understand with a modo to Blender pipeline is that given the internal default units, a modo object will be half as small as a default Blender object when it's imported into Blender.*

My workflow is to create all objects using modo and use Blender for rigging, skinning, and animating skinned characters, as this currently isn't possible with modo. The important thing to understand with a modo to Blender pipeline is that given the internal default units, a modo object will be half as small as a default Blender object when it's imported into Blender. Remember from the previous chapters that in modo, we established the Default Unity iOS System to be in Game Units and that we would work with a setting of 1 meter per Game Unit. In Fig. 5.1, you can see that a default modo cube set to these specifications is exactly half the size of a default Blender cube.

It's important to understand this relationship, as Tater will be exported from Blender into Unity iOS, and I'll need to know how to correctly set the Scale Factor in the FBX Importer settings. Understanding the size ratio between modo and Blender objects will give me the vital information needed to enter the correct value. We know from Chapter 2 that when importing a default 1 meter per Game Unit object from modo to Unity iOS, we need to adjust the Scale Factor in the FBX Importer to 0.01. We also need to establish this same base setting for Blender objects imported into Unity iOS. In Fig. 5.2, you can

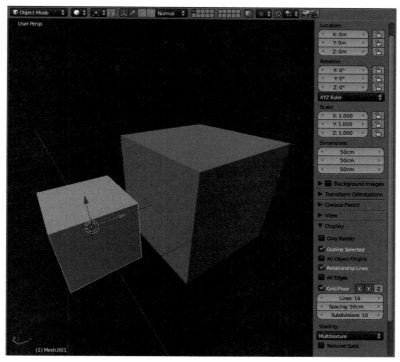

and, more importantly, the process for creating skinned meshes for Unity iOS and the iPhone, I can quickly jump from Maya to Blender without much hassle. I know what needs to be done, and I don't have to let software dictate what I can and can't accomplish.

I encourage you to not get caught up in software debates and remember that it's the artist who is in control and software is only a tool. A good principle to adopt is to always focus on the foundations of 3D and let software become a secondary thought.

FIG 5.1 A Default Modo Cube Is Half the Size of a Default Blender Cube.

see that a default Blender cube imported into Unity iOS via FBX with a Scale Factor of 1.0 (no scaling applied) is twice as large as a default Unity iOS cube. This tells me that I need to set the Scale Factor to 0.5 to have my Blender objects equal the size of the default Unity iOS objects. By setting the Scale Factor in 1.0, no scaling is applied to the imported object, and this is a great way to gauge how your 3D app's internal unit system relates to Unity iOS. Remember, importing to Unity iOS is the goal and it's best to match all of your 3D objects to Unity's default scale.

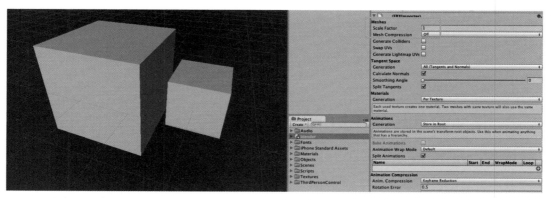

FIG 5.2 At a Scale Factor of 1.0, a Blender Cube Is Twice as Large as a Unity iOS Cube.

Remember, importing to Unity iOS is the goal, and it's best to match all of your 3D objects to Unity's default scale.

Ok, we've established that Blender objects are twice as large as Unity iOS objects and we need to adjust the Scale Factor to 0.5 upon import; however, there's a caveat to this setting when working with modo objects exported from Blender. Remember that our modo objects are twice as small as Blender objects. If we export our modo-created objects from Blender, then the 0.5 Scale Factor will now become incorrect. Because modo objects are twice as small as Blender objects, the process of importing and working with the modo object from Blender acts as a "prescaling operation" when we export the modo-created object from Blender, it will already be scaled twice as small and we can then simply set the Scale Factor in the FBX Importer to 1.0 upon importing into Unity iOS. In Fig. 5.3, you can see a modo-created cube exported from Blender and that it matches the default Unity iOS cube's scale exactly with a Scale Factor of 1.0.

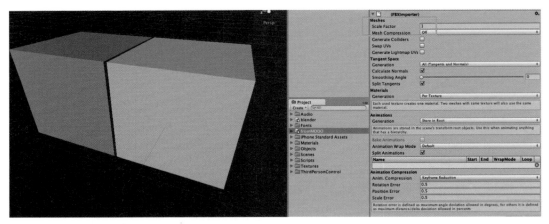

FIG 5.3 Show Modo-Created Cube Being Same Size as Unity iOS Cube at 1.0 Scale Factor.

So now, we have the correct workflow for sizing our Blender and modo objects to perfectly match the default Unity iOS scale. You can see the proper settings in the chart in Fig. 5.4.

Unity iOS Blender Support and FBX Workflow

In regards to Blender animation, Unity iOS supports all nodes with position, rotation, and scale. Pivot points, you set in Blender, as well as object names are also imported. Blender's Bones and Skinned Mesh Animation are also supported.

Using FBX

Unity iOS will import a ".blender" file and convert it on the back end using the Blender FBX Importer. However, this is not the workflow that I use with

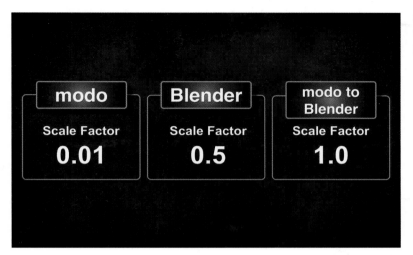

FIG 5.4 Here You Can See a Chart that Shows the Different Scale Factor Settings.

Blender and Unity iOS. Instead, I prefer to export the FBX from Blender. The reason being is mainly personal preference. In my day-to-day work, I mainly work with modo, Maya, Motion Builder, and Mudbox and have long established FBX to be the best method for sending objects through my pipeline. I like having the FBX intermediate file available in case I need to take it into another application and it stops me from having to open Blender to create an FBX file in these cases.

A major issue I have with Blender is the inability to import an FBX file. Luckily, I am only using Blender for character animation and this doesn't pose a huge problem, but it does make me add an extra step to my pipeline, which is to export, and OBJ from modo. Once Tater was ready for rigging, I exported an OBJ from modo so that I could get the model into Blender for rigging and animation. A big issue with OBJ files is that they only support one UV set. However, since my character doesn't contain overlapping UVs and typically, a character won't, I only needed 1 UV set. As you'll recall from Chapter 4, when creating the level, we needed to have a separate UV because we were using overlapping UVs for tiling. You can't correctly create lightmaps with overlapping UVs. With Tater, I didn't use a lightmap shader in Unity iOS and thus didn't need the second UV set. Instead, I baked the lightmap into the diffuse texture map as shown in Fig. 5.5.

Baking the lightmap into the diffuse texture map is not only a solution to my multiple UV set issue with OBJ but it's also a viable solution overall in regards to reducing texture memory. Instead of using a lightmap shader in Unity iOS, you can just use a vertex lit shader and one diffuse texture map as shown in Fig. 5.6. This effectively reduces the number of texture maps needed for Tater.

The complete workflow for the Tater 3D assets is shown in the chart in Fig. 5.7.

Blender and Collada
Besides the OBJ format, you can also utilize a Collada pipeline between Blender and modo since both apps can read and write the Collada format.

FIG 5.5 In Photoshop, the Lightmap Is Multiplied Over the Diffuse Texture. This Is What a Lightmap Shader Does.

Understanding Skinned Meshes within Unity iOS

In this section, we'll take a look at the technical aspects of using skinned meshes in Unity iOS. As you've seen in the previous chapters, it's very important to understand the process and how it relates to Unity iOS and the iPhone and iPad hardware. Being armed with this knowledge allows you to make important decisions on the rigging and animation process and can save a lot of headache when it comes time to optimizing your game's performance.

VFP-Optimized Skinning

As we discussed in Chapter 1, the iPhone and iPad have a very fast VFP coprocessor for handling complex math operations. Unity iOS optimizes skinning through the VFP coprocessor and it's significantly faster than GPU skinning. On the iPhone 4, 3GS, and iPad, Unity iOS can skin up to 5 million vertices per second. However, Unity iOS only supports specific VFP-optimized skinning paths, and it's very important to know what these paths are so that you can be sure to take advantage of them in your project. If you're not set to utilize one of these optimized paths, your skinning performance will be falling back on the CPU, which is much slower. It's also important to state that

FIG 5.6 Here You Can See a Vertex-Colored Shader that Uses One Texture. The Texture Contains Both the Color and Lighting Information.

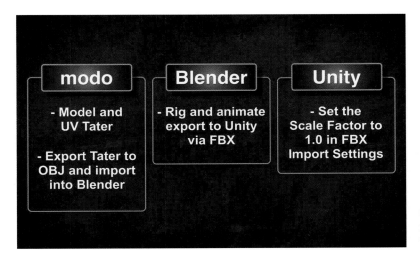

modo

- Model and
UV Tater

- Export Tater to
OBJ and import
into Blender

Blender

- Rig and animate
export to Unity
via FBX

Unity

- Set the
Scale Factor to
1.0 in FBX
Import Settings

FIG 5.7 Here You Can See a Chart that Shows My Modo to Blender to Unity Workflow.

the fewer the bone influences per vertex you have in your mesh, the faster the skinning process will be overall, so again, it's important to plan your rig accordingly.

Optimized Skinning Paths

In Unity iOS, there is a limit to the number of bones that can influence a vertex. You can't have more than 4 bones per vertex, and there are 3 VFP-optimized skinning paths in Unity iOS, which are targeted for 1, 2, and 4

FIG 5.8 This Chart Shows the VFP-Optimized Skinning Paths.

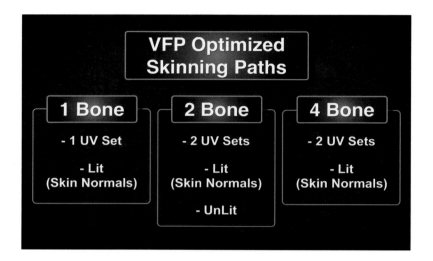

FIG 5.9 The Auto-Normalize Option Will Balance Any Overlapping Weights to 1.0.

bone influences. Each of these paths has a certain criteria to meet in order to be optimized by the VFP coprocessor. In Fig. 5.8, you can see a chart that shows the optimized paths and the criteria they must adhere to. First, we have the 1-bone path that in order to utilize VFP, it must have only 1 UV set and be lit (utilizing skin normals) in the scene. For the 2-bone path, the mesh can be lit or unlit and have up to 2 UV sets. This is the most common skinning path, so it's VFP optimized with 2 UV sets and works for both lit and unlit objects. Finally, there is the 4-bone path, and it must be lit and can use up to 2 UV sets as well.

To actually use the VFP skinning paths, you need to make sure that you adhere to the criteria. For instance, when assigning skin weights to your character in your 3D application such as Blender, you need to make sure that each vertex has a maximum bone influence of 4. Also, Blender 2.5 has an Auto-Normalize feature to balance any over-lapping weights to a total value of 1.0 as Maya does automatically. It can be activated in the tool menu, by pressing the T-key while in Weight Paint mode as shown in Fig. 5.9.

Once the character has been imported into Unity iOS, you need to make sure that the settings on the Skinned Mesh Renderer are correct for utilizing one of the VFP-skinning paths. Let's look at an example with Tater. If I wanted to utilize 4 bones per vertex, which is set on the Skinned Mesh Renderer Component via the Quality setting, I'd also need to enable Skin Normals as well in order to match the criteria for using the VFP-optimized skinning path on a 4-bone path as shown in Fig. 5.10. By lowering the Quality setting in Unity iOS, you can also gain performance at the cost of losing animation detail.

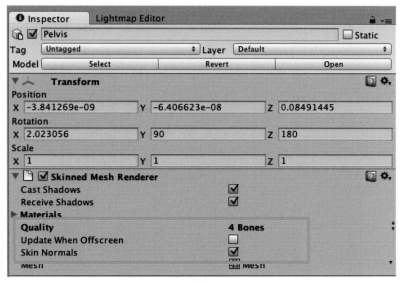

FIG 5.10 Here the Quality Was Set to 4 Bones and Skin Normals Is Activated.

Rigging Tater in Blender

This section will be devoted to creating a rig in Blender. Again, this is not going to be a step-by-step tutorial. There are entire books devoted to character rigging and animation, and it's a very deep topic. Instead, the focus of this section will be to provide you with the information that's specific to creating a rigged character for Unity iOS and a project targeted for the iDevices. Depending on your game, your rig or characters could be much different than mine, and it will be more helpful to detail the important aspects of rigging and how it relates to the iPhone and Unity iOS.

iPhone and iPad Rigging Essentials

Just as with vertex count, with bones you need to subscribe to the concept of "less is more." You need to reduce the amount of bones used per character. For example, the Unity iOS manual suggests that you don't use more than 30 bones. For example, the skeleton that was built for Tater contains 21 bones as shown in Fig. 5.11.

The goal is to reduce the level of complexity of your rig, yet still be able to perform the animations determined for the character. For instance, Tater's hands were modeled into fists, and there's definitely no need to create bones for each individual finger. Notice in Fig. 5.12 that the hands consist of only one bone.

FIG 5.11 The Image Shows the Basic Skeleton for Tater.

Adding bones to the Blender Armature that you're not using to deform the mesh results in a pointless performance hit. You don't want to include these bones in the Vertex Groups so you can simply tell them to not deform the mesh by disabling the Deform option in the Bones Properties as shown in Fig. 5.13. This essentially removes any influence for the bone. As you will see in Chapter 6, we will tell any controller bones used for IK and constraints to not influence the mesh by disabling the Deform option for these bones. When I first started using Blender, I was thrown off by the fact that bones are not considered objects themselves. They are in fact components of the Armature object and all rigging should be done with bones and constraints contained within one Armature. With Maya or 3ds Max, you can constrain or parent bones to Curves or other objects; however, with Blender, this can cause dependency issues. Instead, any control objects for IK or constraints are done with bones in the Armature object. Because of this, you need to make sure that the controller bones you create are just used for constraints and IK. You need to make sure that these bones are not influencing the vertices of the mesh. Again, the easiest method is to just tell the controller bone to not influence the Vertex Group or weighting by disabling its Deform option.

Front Ortho
Centimeters

(250) Armature Hand.L

FIG 5.12 The Hand Contains Only One Bone.

However, another good option for controlling bone influence on a vertex is by using the Clean Weights tool, which can be found on the Tool Shelf (T-key) while in Weight Paint mode as shown in Fig. 5.14.

The Clean Weight tool will remove vertices with low weights from the current group and will essentially remove the bone from influencing the mesh. This tool is helpful for controlling how many bones are influencing a particular vertex. Remember, in Unity iOS and most game engines for that matter, we can't have a bone influence of more than 4 bones per vertex. This tool can help pick up any stray bones that are affecting a particular vertex with only a small weight value, which may make it hard to detect while painting weights.

Now that we've discussed the essential principles for creating bones, we'll now look at creating some bones for Tater as well as painting weights. Remember, there are some key points to consider when building your rig. Be sure to reduce the amount of bones. Only use what is absolutely necessary, and don't exceed more than 30 total bones. Also, be sure to reduce the maximum influence of bones

FIG 5.13 You Can Tell a Bone to Not Deform by Disabling the Deform Option. This Will Cause It Not to Affect the Mesh.

101

to no more than 4 per vertex. Finally, be sure to disable bones that are used for IK and constraints, as you don't want these bones to influence the mesh. In Fig. 5.15, you can see a chart that shows these key points.

Creating the Basic Skeleton

During the modeling phase of Tater, he was built in the classic "T-Pose" for the purpose of rigging the character as shown in Fig. 5.16.

It's important to point out that the arms and legs were pre-bent for the purpose of applying IK to the bones that make up the arm and leg chains as shown in Fig. 5.17.

The reason being is that this pre-bend in the joint areas gives the IK Solver a preferred angle to work with when calculating the bone rotations.

There are many different ways to go about creating a skeleton for a character. In this section, we're going to discuss building the basic skeleton and then applying skin weights to that skeleton. In Chapter 6, we'll discuss adding extra bones, which will serve as animation controls and IK targets. The manner in which you create a skeleton for your character is completely up to your project requirements and the level of animation needed for your character. For the book's demo app, Tater will need to have basic animation cycles such as run, walk, and shoot. It's important to state that a lot can be achieved through a simple skeleton layout. As with all aspects of game development, it comes down to a delicate balance

FIG 5.15 Here You Can See a Chart Showing the Key Points for Using Bones in Your Characters.

FIG 5.16 The T-Pose Is a Default Resting Pose for Creating Bones.

of quality versus performance. Your goal is to use just enough bones to get the deformations needed, while still being able to maintain the performance desired for the project.

The first step was to create the bones on the centerline, which are the pelvis, spine, chest, and head bones. I started with the pelvis by setting the 3D Cursor to the correct position in the pelvis region. With Blender, I use the Maya preset for keyboard mapping since I'm much more acquainted with the Maya UI. With that said, I place the 3D cursor with a right-click and use Shift + S to bring up the snapping menu and select Cursor to Grid to make sure the cursor snaps directly centered on the grid as shown in Fig. 5.18.

With the 3D viewport in the set to the front, I then added an Armature object to create the skeleton. With the first bone created, I then positioned it in the pelvis region and renamed it to "Pelvis," as shown in Fig. 5.19. I created all of the bones in orthographic views to help with aligning the bone rotations correctly.

The center bones were extruded from the pelvis by pressing the E-key. I repeated the extrusion three times to create the spine, chest, and head bones as shown in Fig. 5.20.

103

FIG 5.17 Here You Can See that the Arms Have Been Modeled with a "Pre-bend" at the Elbows so that the Arm Bone Chains Can Be Created with This Bend.

From a side view, I then adjust each bone so that the tips are located on edge loops and that the bones are located near the back and curved like an actual spine to help create cleaner deformations during animation as shown in Fig. 5.21.

Next, I need to create the arm and leg bones. Now, you can create one side of the leg and arm bones and then mirror those over; however, I chose to use the Armature's X-Axis Mirror function to automatically create the bones on both sides as I work. In Fig. 5.22, you can see that with the chest bone selected and X-Axis Mirror enabled on the Armature options, I pressed Shift + E to mirror extrude the bones out for the shoulder, bicep, forearm, and hand.

Now, the shoulder bones are connected to the chest bone, which isn't what I want. In order to separate the shoulder bones, I pressed Alt + P and chose Disconnect Bone from the menu and then separated the bones as shown in Fig. 5.23.

I would like to bring attention to the placement of the arm bones as shown in Fig. 5.24. Notice that I placed the tips of the bones in the edge loops of the arms. Also notice that there is a nice "pre-bend" between the bicep and

FIG 5.18 The 3D Cursor Is Placed in the Pelvis Region to Set the Point Where the Armature Will Be Created. Snapping the Cursor to the Grid Ensures that It Is Aligned to the Center of the Grid.

forearm to help with IK and that the tip of the bicep bone is placed near the actual elbow of the mesh to help with deformations.

Next, I moved onto the legs. In order to use the X-Axis Mirror function of the Armature, I first extruded the first leg bone, the thigh, from the Pelvis bone and separated it using Alt + P, just as I did with the shoulder and arm bones. I then positioned the thigh in the leg and continued to mirror extrude the calf, foot, and toe using Shift + E. In Fig. 5.25, you can see the bones for the completed legs.

At this point, I needed to rename all of the bones. I used the typical naming convention of appending ".L" or ".R" to the bone name depending on the side the bone was located. This is important for painting mirrored weights and using the Copy Pose functions. I also created three Bone Groups so that I could color code the bones to indicate it's orientation, i.e., bones on the left are blue, bones on the right are red, and bones in the center are green. To create a Bone Group, select the bones in Pose Mode and click the

FIG 5.19 The Armature Is Created, and the Pelvis Bone Is Set in Place.

FIG 5.20 The Spine, Chest, and Head Bones Were Extruded from the Pelvis by Pressing the E-key.

FIG 5.21 Once the Bones Are Created, I Then Go Back and Position Them Correctly.

FIG 5.22 The Bones for the Arms Were Mirror Extruded Using the Shift + E Key with X-Axis Mirror Enabled on the Armature.

FIG 5.23 I Disconnected the Shoulder Bones Using Alt + P and Then Moved Them into Position.

FIG 5.24 The Arm Bones Are Placed at the Edge Loops of the Mesh.

FIG 5.25 The Legs Were Created in the Same Way as the Arm Bones.

FIG 5.26 Color-Coding Your Bones Helps to Organize Your Scene.

plus button in the Bone Groups section of the Armature properties and then choose a theme color in the Color Set menu as shown in Fig. 5.26. You also need to have the Colors option enabled on the Display section of the Armature properties. Color-coding your bones helps to better organize your scene.

109

Adjusting Bone Rotations

After the bones are created, you need to adjust the bone rotations so the axes are aligned correctly. The goal is to make sure that all of the bones are rotating in the same axis. For example, in Fig. 5.27, you can see that all of the center bones are aligned and rotating around the Z-axis in Pose Mode.

FIG 5.27 The Selected Bones Bone Rotations Are Aligned to the Z-Axis.

To align the bone rotations, you can use either Alt + R in Edit Mode to align the rotation of a selected bone or simply adjust the Roll setting in the Properties window (N Key). In Fig. 5.28, you can see that the forearm bone's Roll has been adjusted so that the X-axis is used to bend the arm at the elbow at a natural angle, which means the X-axis has been aligned parallel to the forearm.

Again, it's important that all of the bone rotations are aligned correctly. For instance, in Fig. 5.29, you can see an example of the forearm bone having an incorrect bone rotation, which results in having none of the axes aligned parallel to the forearm and thus doesn't allow you to correctly bend the arm. You can really see the difference by comparing Fig. 5.29 with Fig. 5.28.

FIG 5.28 Here I Used the Roll Property to Adjust the Bone Rotation for the Forearm.

FIG 5.29 The Bone Rotation Isn't Aligned and Thus Makes It Difficult to Get the Bend Correctly.

Fixing the Pelvis Bone for Hip Sway

In order to correctly setup the Pelvis so that the hips will swing correctly, I needed to add another bone. The reason being is that a bone's pivot will be located at the tail. However, I want to change the pivot of the Pelvis bone so that it will rotate more in the hip area of the model. First, I duplicated the Pelvis bone by pressing Shift + D. Next, I named this bone PelvisRotHelper and then selected the Pelvis bone and switched its direction by pressing Alt + F or by accessing the Switch Direction command in Edit Mode via the Specials menu, which can be activated by pressing the "W key" as shown in Fig. 5.30.

I then parented the PelvisRotHelper to the Pelvis with the Keep Offset option as shown in Fig. 5.31. Finally, the first Spine bone was parented to the PelvisRotHelper with the Connected option as shown in Fig. 5.32.

Finally, the leg bones (Thighs) are parented to the Pelvis bone. This setup creates a nice hip sway in that the Pelvis bone's rotation is located just below the first Spine bone and places the pivot of the rotation right in the hip area of the mesh as shown in Fig. 5.33.

Disabling Inherit Rotation

The last step in building the rig is to disable the Inherit Rotation setting for the first Spine bone, the Chest and Shoulder bones. By telling these bones to not inherit the rotations from its parent, the bone will effectively stay

FIG 5.30 The Pelvis Bone's Direction Was Flipped so that It's Pivot Would Be in the Correct Place to Produce a Nice Hip Sway.

FIG 5.31 The PelvisRotHelper Is Parented to the Pelvis.

FIG 5.32 The First Spine Bone Is Parented to the PelvisRotHelper.

in place when the parent bone is rotated and will provide a much better articulation in the skeleton. For example, in Fig. 5.34, you can see the difference between the Shoulder bones inheriting and not inheriting the rotations from its parent bone, the Chest bone. This is actually the same as creating a Hinge bone.

113

FIG 5.33 By Inverting the Pelvis Bone, Its Rotation Is Placed in the Desired Location for Hip Rotation.

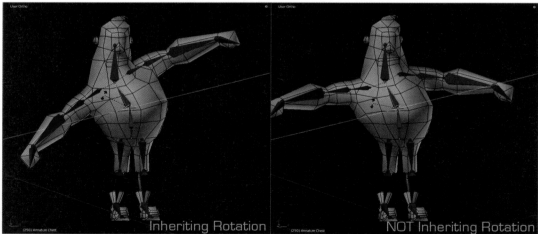

FIG 5.34 Here You Can See the Difference between a Bone Inheriting and Not Inheriting Rotations for the Parent Bone.

Weight Painting

The first thing to be aware of with Blender is that you need to make sure that every vertex in your model is weighted to a bone. If any of the vertices are not weighting, when you import the mesh into Unity iOS, it won't appear in the viewport.

Make sure that every vertex in your model is weighted to a bone. If any of the vertices are not weighting, when you import the mesh into Unity iOS, it won't appear in the viewport.

In order to make sure that every vertex has a weighted value, I select "With Automatic Weights" when parenting the mesh to the Armature. This not only weights every vertex but also provides a nice starting point for painting weights. From here, I then go through each Vertex Group and adjust the weights with the Weight Painting tools to fine tune how each bone is affecting the mesh. The goal here is to minimize any gross deformations in the mesh while making sure that no more than four bones are influencing a single vertex. Some very helpful options to pay particular attention to when painting weights are the Auto Normalize and X-Axis Mirror as shown in Fig. 5.35.

The Auto Normalize feature will automatically normalize each vertex as you paint so that you can't paint more than a weight of 1.0.

The Clean Weights function, also found on the Tool Shelf in Weight Paint mode, is good for making sure that a single vertex has a maximum influence of four bones. The Clean Weights tool will remove vertices with low weight values from the current Vertex Group. For example, when creating PelvisHelper bone, I had forgotten to disable the bone's Deform option. This bone was created with the sole purpose of helping the Pelvis with rotation and doesn't need to influence the mesh. If a bone doesn't need to directly influence the mesh, then it's best in terms of performance to make sure it isn't influencing the mesh. In Fig. 5.36, you can see that with the PelvisRotHelper Vertex Group selected, I used Clean Weights to remove any influence under the set Limit. Alternatively, I could have just deleted the Vertex Group for the PelvisRotHelper, but this example helps to showcase the usefulness of the Clean Weights tool. The Clean Weights tool is similar to the Remove Influence tool found in Maya and using this tool in Blender mimics my more familiar Maya workflow for rigging.

When it actually comes to painting weights in Blender, I rely heavily on the X Mirror option. This option allows me to mirror the vertex weighting values from one group to another on the X-axis. For example, I can bend the left leg, and with X Mirror enabled, I can adjust the weights for the right leg knowing that these changes will be mirrored to the left side of the mesh. This is extremely helpful since it allows me to use one side of the mesh to check deformations while adjusting weights on the other side that isn't being posed. By adjusting the weights on the side that isn't being posed, it's much easier to adjust the weights on vertices, while seeing my adjustments instantly on the posed half of the mesh as shown in Fig. 5.37.

FIG 5.35 Auto Normalize and X-Axis Mirror Are Found on the Tool Shelf in Weight Paint Mode.

FIG 5.36 Clean Weights Was Used to Remove Any Influence the PelvisRotHelper Was Having in the Mesh.

FIG 5.37 The X Mirror Option for Weight Painting Is Invaluable for Adjusting Weights. Here You Can See That I Can Work on Half the Mesh and See the Changes Mirrored to the Posed Side of the Mesh.

Summary

In this chapter, we discussed several key aspects for creating bones and painting weights as they pertain to the iPhone and Unity iOS. This chapter discussed the usage of Blender in a modo to Blender pipeline; however, the techniques and principles discussed in this chapter can be utilized in any 3D package. We discussed the importance of the iDevice hardware and how Unity utilizes VFP-optimized skinning paths and what you need to do to make sure you take advantage of these optimizations. We also discussed the importance of bone count and making sure you utilize a maximum influence of no more than 4 bones per vertex. Finally, we took a look at Tater's skeleton as it was created in Blender and some useful weight tools such as Clean Weights and X Mirror.

In Chapter 6, we'll focus on creating additional animation controller bones and IK target bones. We'll also discuss how FBX animation is imported by Unity.

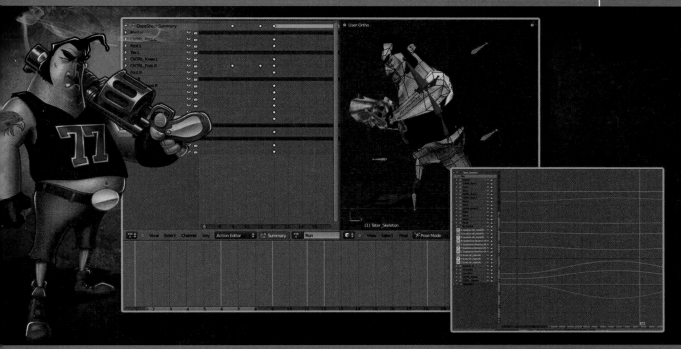

Animation Using Blender
IK and Basic Animation

In Chapter 5, we took an in-depth look at creating bones using Blender as they pertain to animating a character game asset for your Unity iOS or iPad game. In this chapter, we are going to continue where we left off with Tater and finish up his rig. We are going to look at adding constraints and IK to the Armature, and we'll also do some additional organization to the rig to make things easier when animating.

Once the rig is completed, we'll talk about creating animations for our character in Blender and exporting the animations to an FBX file for use in Unity iOS. Let's get started by completing Tater's rig by adding IK constraints.

Tater's Weapon Load Out
Go to the resource site to view the video walkthrough for this chapter.

Completing the Rig: Adding IK

Usually, in larger studios, a Technical Director, or more specifically titled as a Character TD, handles rigging. It's true, rigging a character can be a pretty difficult and technical process. However, I found that rigging is much like scripting in that at first, mosts, including myself, are weary of it until you actually get in there and see that while it is a technical process it has varying degrees

Creating 3D Game Art for the iPhone with Unity. DOI: 10.1016/B978-0-240-81563-3.00006-1

119

of difficulty with some stages being much easier than others. Let's look at it this way, there's a big difference between programming an entire OS versus writing a script to rotate an object in your Unity iOS game. By that same token, there's a big difference in having to create a character rig for a feature film versus a rig that allows you to create simple run, jump, and shoot animations for your game. Yes, you want your game animations to look great and set your work apart, but you're also working with a limited number of bones and your focus is on keeping the overall broad feel of the motion versus capturing every single minute detail. The point is, your game rig, especially in regards to the iPhone and iPad, doesn't need to have hundreds of overly complex and sophisticated controls. In fact, the simpler your rig is the better. In Fig. 6.1, you can see the completed rig for Tater. In Tater's rig, there are four IK targets and four pole targets used to rotate the knees and elbows. As you can see in Fig. 6.1, there aren't many controls used to animate Tater.

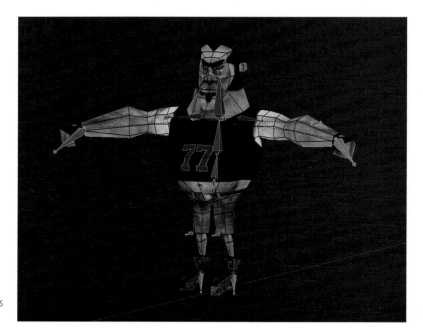

FIG 6.1 In This Image, You Can See the Controls Used to Animate Tater. Notice that There Aren't Many Controls to Deal With.

Let's examine the controls for the rig. First, we'll start with the feet and legs, which have a total of five controls as shown in Fig. 6.2.

In the feet, I have the IK target for the legs. The Foot Controller allows me to pick up Tater's foot and rotate it at the ankle as shown in Fig. 6.3. The Foot Bone is setup to allow Tater to raise his heel as shown in Fig. 6.4. The Toe Bone is used to articulate the toes as shown in Fig. 6.5.

Finally, I have the knee controls, which allow me to point the knees as shown in Fig. 6.6. These controls are Pole Vectors set on the IK Constraint.

FIG 6.2 Here You Can See the Controls for the Feet.

FIG 6.3 The Foot Controller Bone Is the Main Control for the Foot.

FIG 6.4 The Foot Bone Is Used to Raise the Heel. Notice that Its Direction Has Been Flipped.

FIG 6.5 The Toe Bone Allows You to Articulate the Tip of the Boot.

As you will see in the next section, setting up these controls for the feet and legs were actually a simple task, yet I'm getting a lot of articulation. These controls allow me to move the leg, animate toe taps, stomp the heel, and position the knees as well as when used together help to create a good articulation in run and walk cycles.

Next, let's take a look at the arms. The arms have an IK target as well. The Hand Bone is constrained to the IK target so that it drives the translation and rotation of the hand, and I can hide the actual Hand Bone. Basically by removing the Hand Bone as a control, I have one less control to worry about and a cleaner rig. I then have an elbow control, which is also a Pole Vector on the arms IK Constraint just as with the legs. This allows me to position the elbow as shown in Fig. 6.7.

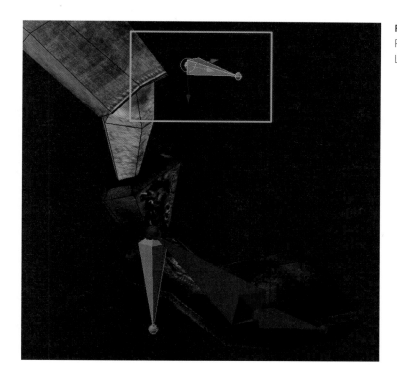

FIG 6.6 The Knee Bone Is Set as the Pole Target in the IK Constraint for the Leg. It Allows Me to Point the Knee.

FIG 6.7 The Elbow Bone Is Set at the Pole Target in the IK Constraint for the Arm. It Allows Me to Position the Elbow.

Finally, I have a Shoulder Bone, which allows me to move the shoulders to help in animation involving the arms as well as performing tasks such as shoulder shrugging as shown in Fig. 6.8.

FIG 6.8 In This Image, the Clavicle Bones Were Rotated to Produce a Shoulder Shrug.

The final controls on the rig are covering the centerline of Tater's body. There is a Pelvis Bone for controlling the hips as shown in Fig. 6.9. There are two Spine Bones and a Head Bone for articulating the upper body such as twisting as shown in Fig. 6.10.

Now that we've discussed an overview to the rig, let's now take a look at how these controls were created. We'll start with the legs.

Setting Up IK for Legs

The first thing I needed to do was to add another bone to the foot area that would act as the main controller for the leg and foot. I selected the tail of the Foot Bone and aligned the 3D Cursor to the tail by using Shift + S and choosing Cursor to Selected. I then added a new bone called CNTRL_Foot.L from this position as shown in Fig. 6.11.

Next, I needed to create a bone called IK_Foot.L that will be used as the IK target when using the IK Constraint. This bone is created from the ankle as well. In Fig. 6.12, you can see the correct position for IK_Foot.L.

FIG 6.9 The Pelvis Bone Is Used to Control the Hips.

FIG 6.10 The Bones Located at Tater's Centerline Are Used for Twisting the Body.

FIG 6.11 Here You Can See the Bone that Controls the Foot Location and Rotation.

FIG 6.12 Here You Can See the Correct Position for the IK Target Bone for the Foot.

When creating bones in Blender, it's important to adopt the .L and .R naming convention so that you can use the Copy Pose and Paste Pose functions.

Once these controller bones were in place, I could then start setting up the relationships. I needed to switch the direction of the Foot Bone heel by

choosing Switch Direction (Alt + F) from the Specials menu, so that I could use the bone to raise the heel. In Fig. 6.13, you can see the Foot Bone with the correct orientation. Notice that the rotation pivot of the Foot Bone is located at the toes so that the heel can be raised.

Right Ortho
Centimeters

(1) Tater_Skeleton Foot.L

FIG 6.13 Notice that since the Pivot Was Switched for the Bone, the Heel Can Now Be Raised.

Next, the IK_Foot.L Bone is parented to the Foot.L Bone as shown in Fig. 6.14.

Then, both the Foot.L and Toe.L Bones are parented to the CNTRL_Foot.L Bone as shown in Fig. 6.14.

As you can see, the rig isn't overly complicated, but it gets the job done. It helps to figure out your rig concept before hand. For instance, think about your game and your character's style and decide what type of animations will be needed. From there, you can sketch out some basic ideas of the range of motions your rig will need to allow.

Next up, I needed to apply the IK Constraint on the Bone Constraints menu. As you can see in Fig. 6.15, the target is my Armature called Tater_Skeleton and the Bone Target is the IK_Foot.L Bone that was created in Fig. 6.12.

FIG 6.14 Notice that the IK_Foot.L Bone Is Parented to the Foot.L Bone.

FIG 6.15 Here You Can See the IK Constraint and Its Settings.

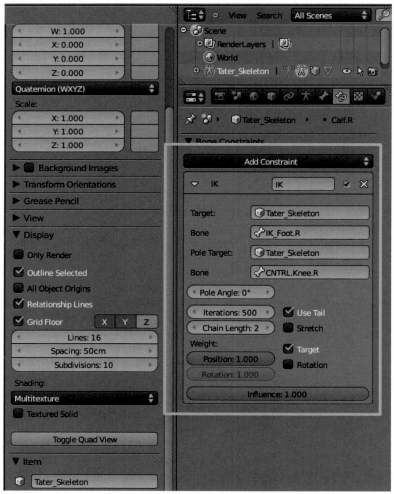

I also set the Chain Length to a value of 2, which essentially terminates the IK Chain at the Thigh Bone as shown in Fig. 6.16.

FIG 6.16 A Chain Length Setting of 2 Terminates the Chain at the Thigh Bone.

In order to add some extra control to the knee, I set a Pole Target on the IK Constraint for the leg. The Pole Target is the same as a Pole Vector Constraint in Maya. It allows you to rotate the IK Chain and thus give you a control for rotating or pointing the knee. I added a new bone called CNTRL_Knee.L in the knee position and set the Pole Target on the IK Constraint to this bone as shown in Fig. 6.17.

The CNTRL_Knee.L Bone is then parented to the CNTRL_Foot.L Bone so that as the leg is moved, the knee controller will move with it, which will also automatically point the knee as the CNTRL_Foot.L is rotated. In Fig. 6.18, you can see this basic control setup for the legs in action.

> *Don't forget to mark controller bones to not deform the mesh by disabling their Deform property.*

It's important to note that the CNTRL_Foot.L, CNTRL_Knee.L, and IK_Foot.L bones all have had their Deform option disabled. As we discussed in Chapter 5, this essentially removes their influence from the mesh. The purpose of these bones is strictly to control the bones in the rig that influence the mesh. In order to keep the skeleton optimized, you need to be sure that only the bones directly responsible for deforming the mesh are influencing the

FIG 6.17 Here You Can See the Position of the Pole Target for the Knee.

FIG 6.18 In This Image, You Can See the Basic Controls Working.

mesh vertices and disabling the Deform property for a bone is the easiest way of doing this.

Now that we've explored the leg controllers, let's take a look at the arms.

Setting Up IK for Arms

The arm setup is a bit less complicated than the legs. First, I need to add a bone for the IK target. This was done by simply duplicating the Hand.L Bone using Shift + D to keep the new bone in the same position as the Hand.L Bone and renaming it to IK_Hand.L as shown in Fig. 6.19.

FIG 6.19 The IK Bone for the Hand Was Duplicated from the Original Hand Bone.

Next, I setup the actual IK Constraint on the Forearm.L Bone with the IK_Hand.L Bone set as the Bone Target. The Chain Length was set to 2 so that the IK Chain would be terminated at the Bicep.L Bone. You can see the settings for the Forearm.L IK Constraint in Fig. 6.20

Just as with the knee, I also created a control for the elbow so that I could rotate it. Building in an elbow control is usually a must have in every rig as it allows you to have greater control over the arm. In Fig. 6.21 you can see the elbow control,

FIG 6.20 Here You Can See the Settings for the IK Constraint. Notice that the Chain Length Is Set to 2.

FIG 6.21 Here You Can See the Location for the Elbow Control Bone.

which is actually a bone called CNTRL_Elbow.L and that it's set as the Pole Target in the Forearm.L Bone's IK Constraint.

One thing to mention with the Pole Target is that you might need to adjust the Pole Angle. For example, if you look back to Fig. 6.21, you can see that I used a Pole Angle of 83 degrees in order to have the CNTRL_Elbow.L positioned correctly. In Fig. 6.22, you can see that without setting the Pole Angle correctly, the Pole Target will cause the arm to bend incorrectly. With that in mind, the Pole Target for the knees also had to have a correct Pole Angle. There isn't a special rule to setting the Pole Target; it's really only a matter of choosing an angle that doesn't deform the IK Chain when the Pole Target is applied.

FIG 6.22 Notice the Deformation Issues When the Pole Angle Is Set Incorrectly.

The last component to the arm rig is that I applied a Copy Rotation Constraint to the Hand.L Bone. With this constraint, the Hand.L Bone is set to copy the rotation of the IK_Hand.L Bone as shown in Fig. 6.23. The purpose of this constraint is to allow me to have one control to move the arm as well as rotate the hand. Since the Hand.L Bone is parented to the Forearm.L Bone, it will automatically follow the Forearm Bone, which is driven by IK. In that regard, I just need to copy the rotation of the IK_Hand.L Bone so that it would also drive the hand rotation.

In Fig. 6.24, you can see how the IK_Hand.L Bone is not only used to move the arm via IK but is also used to rotate the hand. It becomes easier during

FIG 6.23 The Hand.L Bone Has a Copy Rotation Constraint that Targets the IK Controller Bone.

FIG 6.24 The IK_Hand Bone Controls Both Position of the Arm and Rotation of the Hand.

animation since I only need to keyframe one item when moving the arm and rotating the hand.

In Fig. 6.25, you can see the entire rig in a default standing pose.

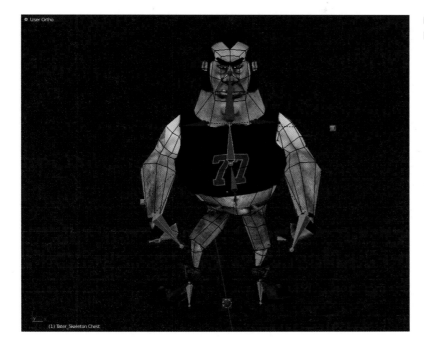

FIG 6.25 Here Is a Default Standing Pose for Tater.

Throughout these last sections, we've discussed the various rig controls being created on the left side. These controls can be simply mirrored to the right side, as their function is exactly the same. Now that we've covered the controls we'll now take a look at tidying things up a bit so that it's easier to deal with when it comes to animating. The easier you can set up a rig for keyframing, the better it is for productivity.

Tidying Things Up

Before we get into animation, I wanted to show some tweaks I made to the overall rig, so it would be easier to deal with when creating animations for Tater.

Fixing Rotations

After doing some initial poses, I realized that I wanted to change some of the Inherit Bone Rotation settings that were set in Chapter 5. For instance, on the Clavicle Bones, I had initially set them to not inherit rotations by disabling

the Inherit Rotation setting in the Bone Properties. However, after messing with the completed rig, I decided that it would be best if the Clavicle Bones did inherit the rotations for the Chest Bone. I also decided that the Head and Spine Bones should also inherit rotations. That's just a part of rigging, and it's important to thoroughly test your rig because once you start putting it through the paces, you inevitably find areas where you'll need to make changes.

Creating a Master Control

Again, once the final rig was completed, I created one last bone that would be used as a root in which all of the bones and controls would fall under. The purpose of this bone is that it allows me to move or rotate the character as a whole. In Fig. 6.26, you can see the Master control. The Pelvis, CNTRL_Foot.L, and CNTRL_Foot.R Bones are parented to the Master control.

FIG 6.26 The Master Control Is the Root of the Entire Rig and Can Be Used to Move Tater as a Whole.

Using Bone Layers

Blender has a nice layer system, and you can place bones on different layers within the Armature. This is good because it allows you to place all of the controls that will be keyframed on one layer and the bones that won't be keyframed on another. This really helps to keep the view clutter free and much easier to select controls for keyframing. In Fig. 6.27, you can see that all of the controller bones are located in the first Bone Layer. This makes it very easy to quickly select all of the bones by pressing the A key and setting a keyframing using the I key or clearing pose rotation (Alt + R) and pose location (Alt + G). Again, the easier you can make it on yourself, the more productive you'll be. Articulating and keyframing your character should be easy and intuitive. You shouldn't have to fight your rig to get work done.

FIG 6.27 Bone Layer 1 Is on the Left and Holds All of the Bones that Are Controllers and Will Be Keyframed. Bone Layer 2 Is on the Right and Is Essentially Hidden, as These Bones Will Never Be Keyframed.

Tweaking Weight Maps

Just as with the "Fixing Rotations" section above, I also found that once I started testing the completed rig, I needed to also tweak the weight maps to improve the deformations on the model. Being a very low-resolution mesh, the Tater model just doesn't have enough edge loops in areas such as in the thighs to provide clean deformations. You'll find that with game characters, especially targeted for mobile platforms such as the iPhone, the lack of polygons can cause some issues when animating your models. This is another reason it's so important to plan your model's polygon budget carefully so that you can be sure to place important resolution in areas of the mesh that will deform the most.

> It's important to plan your model's polygon budget carefully so that you can be sure to place important resolution in areas of the mesh that will deform the most.

In order to fix some issues I was having in the thighs, I decided to add an extra edge loop. I used the Loop Cut and Slide tool to add an extra edge loop as shown in Fig. 6.28.

FIG 6.28 An Extra Edge Loop Was Added to Aid in the Deformation in the Thigh and Hip Area.

I then made some adjustments to the Thigh.R weights by using the Blur Brush to essentially feather or blend the weight values in the hip areas and thus smooth out the distortions as shown in Fig. 6.29.

FIG 6.29 The Blur Brush Can Be Used to Smooth Out the Weights and Help Smooth Deformations.

In Fig. 6.30, you can see how adding the extra edge loop in the upper thigh improves the deformation in the hip area as well as helps to maintain volume.

FIG 6.30 The Extra Edge Loop Helps to Add Volume to the Thighs.

Well, that essentially covers the entire rig that was created for Tater. In the next section, we'll actually look at animation and using FBX files in Unity iOS.

Animating Tater

In the following sections, we're going to look at utilizing animations in Unity iOS in terms of how it relates to FBX. We're going to look at how Unity iOS interprets the animation data present in your FBX files, and we'll even look at how we can use Unity iOS to make adjustments to your animations using the

Animation Editor. Finally, we'll look at creating animations in Blender with the completed rig from the first half of this chapter.

Using FBX

As I've mentioned, I rely heavily on FBX for all my 3D pipelines even beyond that of game development. FBX is a great file format for transferring animation and mesh data to and from different 3D applications. Unity iOS has the ability to work with blender files natively in that if you place the Blender file into your Assets folder, it will be imported into your Unity iOS project. However, the blender file is actually being imported using the FBX translator behind the scenes, so in essence, your 3D files are always being translated via FBX at some point in the pipeline.

Multiple Clips per File Versus One Clip per File

The first thing to understand with FBX and Unity iOS is that there are basically two workflows to choose from when dealing with the animations for your character. The choices are having all of the animations for your character contained in one FBX file, and the other is using multiple FBX files for each action your character will perform. We'll take a look at these two options in-depth starting with utilizing only one FBX file.

Option One: Multiple Clips

An FBX file contains animation data, which is represented in the file and referred to as a "Take." What this means is that all of the animation that is present on the timeline in your 3D program is used in the Take file. So, the way this works in regards to Unity iOS is that you place different animations for your character at different points in the timeline. This means that all of the actions your character will perform are located on the timeline. For instance, frames 1–45 might represent a run cycle, whereas frames 46–66 could represent a jumping or a shooting action. In Fig. 6.31, you can see the Blender timeline with different animations being represented at different sections of the timeline.

FIG 6.31 Show Blender Timeline with Keys Representing Different Animations.

As you can see all of your actions are embedded into one FBX file. Once you've imported the FBX file containing all of your animations into Unity iOS, you'll need to configure the Importer Options to split the timeline into what is referred to in Unity iOS as Animation Clips as shown in Fig. 6.32. You can then use these Animation Clips when animating the character using Unity's scripting interface.

This workflow is best when you have an object with simple or few animations. With this workflow, you have some drawbacks in that you'll need to configure the Import Options to target various ranges of the timeline, which means you'll need to keep track of all the frame ranges, and with an object with lots of animations, this can become tedious quick. However, the biggest drawback is that it can be incredibly difficult to tweak the animations. Let say you need to fix some timing issues in the run cycle and this causes you to reduce some frames. You'll then need to make sure that all of the frames are properly represented back in the Import Options as you've probably reduced or extended the frame range. Again, imagine working with a complex character with several hundred frames of animation. Just thinking about it makes my head hurt!

Option Two: One Clip

This option is what I prefer to use in my workflow. This option includes breaking down each animation for your character into a separate FBX file that contains only that specific animation like say a run cycle. By using the naming convention of "modelName@animation," you tell Unity iOS to collect all of the animations within these files and have them be referenced by the main model file, which doesn't contain the "@" symbol. For example, in Fig. 6.33, you can see that the

FIG 6.32 You Can Split Animations into Clips in the FBX Import Options.

Tater.fbx file will reference all of the animations in the "Tater@" files. This is a good way to work in that if you need to make a change, you can simply change only one FBX file and it will automatically update in Unity iOS. Even if you change the frame range in Blender completely, it won't matter.

This workflow is much better for characters that contain lots of animation. The main drawback is that you have more files to consider in your project. However, being able to make changes to only one file makes it well worth it for me. As we'll discuss, in Blender, I setup Actions for each animation the character needs to perform. When it comes to exporting the FBX, I simply

FIG 6.33 The Animation Clips Are Referenced by the FBX Files Containing the @ Symbol.

select the appropriate Action and export the FBX. I have one Blender file that contains all of the animations, which are separated into Actions and then I can select a given Action and export it using the @ naming convention to Unity iOS.

How Animation Data Works in Unity iOS

Before we get to Blender workflow, it's important to discuss how Unity's animation data works as it's translated from the FBX file. I've mentioned that FBX is used to convert your animation data as its imported into Unity iOS. Under the hood, Unity iOS is converting all your rotations into Quaternions. So no matter what Rotation Mode you're using in Blender, which can be set on the object's Transform as shown in Fig. 6.34, the rotations will be baked into Quaternions upon import into Unity iOS.

Next, the keyframes are reduced or reduced and compressed according to the settings chosen in the Animation Compression within the Import Settings Dialog for the FBX file. You can choose to disable this feature all together or choose from reduction only or reduction and compression as shown in Fig. 6.35.

FIG 6.34 You Can Set the Rotation Order for Objects in Blender, However, These Rotations Will Be Converted to Quaternions When Imported into Unity iOS.

These reduction and compression settings work to basically "wrangle in" any errors in rotation, position, and scale, which are defined by the error in degrees for rotation and distance/delta deviation for position and scale. By reducing the keyframes, you can gain performance in your game as there's less animation data to process, but this comes at the price of possibly losing detail in your animations. The degree in which you choose to compress keyframe data is totally dependent on your own project requirements. It's just important to note that these settings can have an effect on the subtleties in your animations.

Names Are Match to Relative Animation Component

Another aspect worth mentioning is that you can reuse animations on different characters as long as their hierarchies are the same based on how the Animation Component references objects. Each character with animation data will have an Animation Component applied as shown in Fig. 6.36, which is placed at the root of the object. The Animation Component then references the objects based on their relative location to the Animation Component. As long as the names are the same, you can reuse animations across different characters.

Now that we have an understanding how animation data is interpreted by the FBX file and how the scene hierarchy works on the Animation Component, we can then begin to create animations in Blender. In the next section, we'll take a look at the workflow I use in Blender for animating my characters.

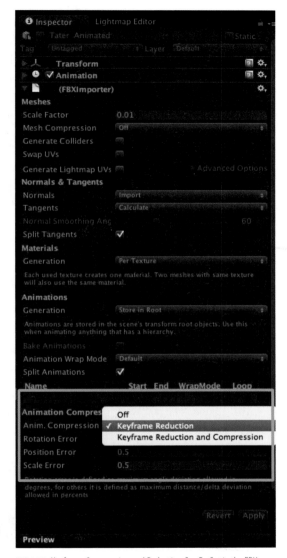

FIG 6.35 Keyframe Compression and Reduction Can Be Set in the FBX Importer Settings within Unity iOS.

Animating in Blender

In this section, we won't go through any step-by-step tutorials on how to create a run cycle. There are several books solely devoted to animation mechanics and principles. Animation is a very deep subject and definitely warrants an entire book on the topic. However, I will discuss my workflow for using Blender with Unity iOS to properly export your animated characters to the FBX format.

FIG 6.36 The Animation Component Is Set at the Root of the Object and References the Objects in the Hierarchy by Name. Tater's Hierarchy Is Shown in Blue.

Using Actions

As I stated earlier, with Blender I use the Action Editor and create separate Actions for each type of animation my character will need to perform. When it comes time to exporting the FBX file, I need to then select the appropriate Action from the Action Editor as shown in Fig. 6.37 and then export the FBX file with the correct naming convention, i.e., Tater@run.fbx. This allows me to keep all of the animations in one blend file while using the Action Editor to manage and switch between them.

FIG 6.37 You Can Create Actions in the Action Editor that Represent Each Animation the Character Will Perform.

Creating an Animation Cycle

In this section, I'd like to discuss the process of setting up an animation cycle such as a Tater's run. However, first I'd like to discuss setting the frame rate for your project. In Blender 2.5, you can set the frame rate in the Render Properties under the Dimensions Category as shown in Fig. 6.38.

FIG 6.38 The Frame Rate Is Set in Blender to 30 FPS, Which Matches My Game Project's Target Frame Rate.

Since I am targeting a rate of 30 FPS in my game, I've also chosen to animate at 30 FPS in Blender. Remember, your game's frame rate isn't something that is set in Unity iOS, but it's the overall time it takes to render a frame and is dictated

by the "frametime" variable in the Unity iOS Internal Profiler, which can be activated in Xcode. As we discussed way back in Chapter 1, your game's frame rate is something that you determine for your project and is used as a benchmark so to speak throughout your entire project as it becomes the baseline value for not only profiling your game but working with animations as well.

When creating any type of cyclic animation, such as a walk or run, you need to make sure that the first and last keyframes are the same as shown in Fig. 6.39.

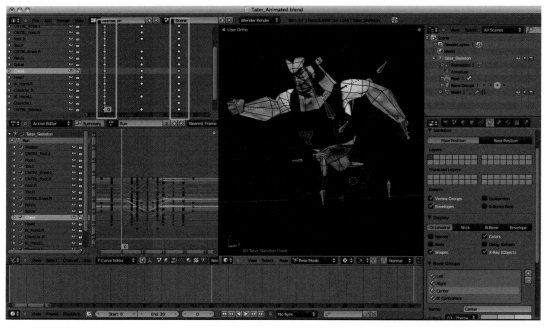

FIG 6.39 The First and Last Keyframes Have Been Highlighted to Show that They Are Identical for Looping the Animation.

Since, I've utilized layers in my Armature and placed all of the bones that would be keyframed in one layer, I can now quickly set and clear keyframes. For instance, in Fig. 6.40, you can see that I can quickly perform a bounding selection and hit the I key to set a keyframe for the location and rotation. It's important to note that I am only keyframing the location and rotation and I'm not setting a keyframe for the scale. I'm not going to be doing any scaling on these bones, and because of this, I don't want to set keyframe data for the scale if it's not absolutely going to be used in the animation. This is important in regards to performance as its less keyframe data that Unity iOS has to interpolate.

Only set keyframes for properties that you're going to be animating. Extraneous keyframes can lead to performance issues. If you don't animate it, then don't keyframe it.

FIG 6.40 The I Key Shortcut Can Be Used to Quickly Set Keyframes for the Location and Rotation.

Before any keyframes can be set, I needed to work out the basic timing of the animation. For instance, with the run cycle, I used a simple timing application I created for the iPhone called FPS Calculate in order to time the run as I performed it. Tater is an ex-high school football player, and I wanted his run to mimic that of a massive Linebacker. So, using FPS Calculate, I performed the run to get a feel for the timing. In Fig. 6.41, you can see the output I was getting from FPS Calculate. If you would like to use FPS Calculate, it can be found on the App Store by searching "FPS Calculate."

Once you have the timing ready, you can begin to create the animation. In Fig. 6.42, you can see the run cycle that I created for Tater while paying attention to the standard animation mechanics, i.e., timing, anticipation, arcs, and exaggeration.

When animating, you'll spend a lot of time in Blender's F-Curve Editor. To keep things simple, I use the V Key to set the visibility for a given channel so that I can get rid of the curve clutter as shown in Fig. 6.43.

One thing that I'd really like to share and that greatly helps in the animation process is the concept of "hold keyframes." I also found myself needing to create several hold keyframes such as for the Foot Bones,

FIG 6.41 FPS Calculate Has a Built in Animation Timer that Can Be Used to Time Out Animations while Performing Them Holding the iPhone.

FIG 6.42 In This Image You Can See the Run Cycle that Was Created for Tater.

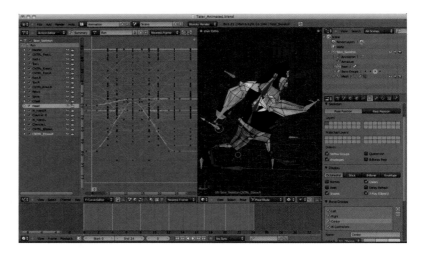

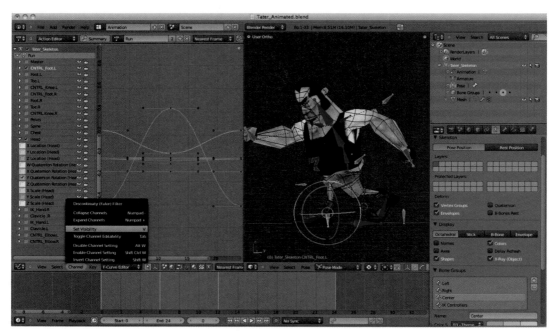

FIG 6.43 The Set Visibility Function Is Excellent for Hiding the Curves that You're Not Working On.

which are keys that simply hold a value so that you don't get that "floating look" when doing cyclic-type animations such as running and walking. In Fig. 6.44, you can see that I quickly create hold keyframes by using Shift + D to duplicate the key.

Hold keyframes are also good when performing the anticipation of placing the heel down on the ground. For instance, it was necessary to place two

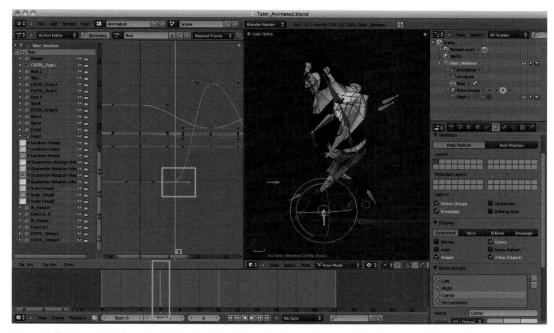

FIG 6.44 In This Image, the Keyframe Was Duplicated and Moved Over a Few Frames to Retain the Value from the First Keyframe and Thus "Holding" the Animation.

keyframes together to hold the heel up until that last frame hit where the heel actually touches the ground. In Fig. 6.45, you can see the hold keyframes and how they relate to the heel smacking the ground. These keyframes help to give the animation a bit more of a snappier feel as the heel smacks down to the ground. Also, the heel smacking the ground lends itself to the type of movement a big guy like Tater would make when running, so the animation lends itself to the character's style.

The animation should lend itself to the character's style.

When animating, my overall procedure for creating cyclic actions is to duplicate keyframes, using the Alt + G, Alt + R shortcuts to clear out values between setting keyframes as well as the Copy/Paste Pose functions for quickly copying pose values from one side of the rig to the other.

Exporting the FBX

Once the animation is completed, you'll be exporting the FBX from Blender, and there are a few thing you'll want to be aware of when exporting the scene. Remember, my workflow has been to create all of the animations as separate Actions in the Action Editor and then select the appropriate Action before exporting. Here are three other areas you'll want to be aware of when exporting FBX files from Blender.

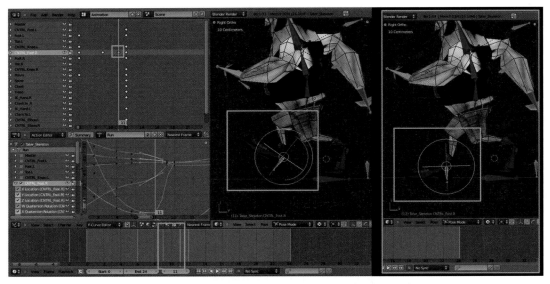

FIG 6.45 In This Image, the Highlighted Areas Are the Keyframes that Were Created by Duplicating the Previous Keyframe.

Make Sure Frame Range Is Set Correctly

Number one and the most obvious is that you'll need to make sure that you set the End Range for the animation. If your animation is 27 frames long, then be sure that the End Range is 27. For cyclic animations, you can set the clips to loop in the FBX Import Settings as shown in Fig. 6.46. If you leave extra frames in the loop, the animation will appear to pause before the loop cycles effectively breaking the loop.

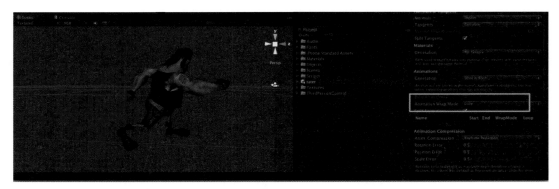

FIG 6.46 You Can Set the Loop Mode for Animations in the FBX Import Settings.

Baking Keys

When exporting animation data from a 3D program such as Blender into Unity iOS, you may need to bake the keyframes so that the animation is

interpolated correctly. If you find that your animation data doesn't seem to be translating correctly in Unity iOS and this will typically happen when using IK, you can choose to bake the animation values to a key on each frame. Essentially, this is taking the interpolation out of the animation curve by placing an exact keyed value at each frame in the animation. If you're using native formats from 3D applications such as .ma, .c4d, and .max, you can actually bake animations in Unity iOS by checking the Bake Animations options in the Importer Settings. An animation bake step happens during export from your 3D tool to the FBX format. When importing objects into Unity iOS using a 3D tool's native format, Unity iOS is actually opening the application behind the scenes and exporting an FBX file. However, the FBX exporter in Blender doesn't have an option for baking animation, so you can bake the F-Curves in Blender before exporting the FBX file. The quickest way is from the DopeSheet Editor. First, hit the A key to select all of the keyframes and then choose Sample Keyframes from the Key menu or press Shift + O. Sampling the keyframes will bake the curves and place a key on each frame as shown in Fig. 6.47.

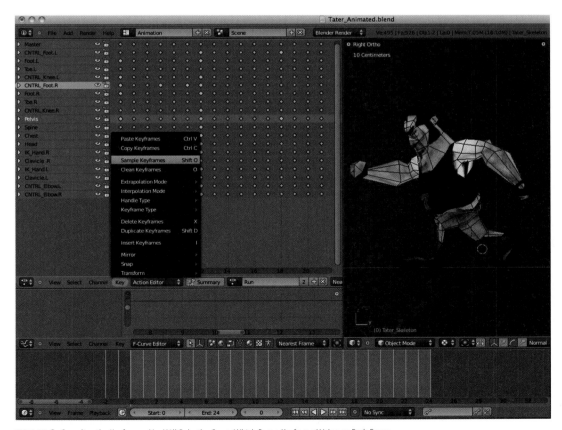

FIG 6.47 By Sampling the Keyframes, You Will Bake the Curve, Which Puts a Keyframed Value on Each Frame.

Disable Optimize Keyframes and Selected Objects

One final thing I want to mention in regards to exporting an FBX file from Blender is to be sure to deselect both the Selected Objects and Optimize Keyframes options in the FBX export dialog as shown in Fig. 6.48. The Selected Objects will only export the selected objects in your scene, and I find that more times than not, this is a hassle as you think everything is selected when exporting only to find that something is missing like your mesh when you import the file into Unity iOS. You can quickly deselect the unnecessary scene items such as Cameras and Lamps in the FBX export dialog. If you look back at Fig. 6.49, you can see that I've deselected Cameras, Lamps, and Empties from the export, as I don't need these items in Unity iOS.

The Optimize Keyframe setting is a big one. This option is supposed to remove double keyframes and should be harmless; but from my experience, this option almost always removes important keyframes and causes major issues when the FBX animation is played in Unity iOS or opened in any other 3D package for that matter. For example, in Fig. 6.49, you can see that with Optimize Keyframes enabled, the animation from Blender comes in with major distortions as important keyframes have been removed.

Summary

In this chapter, we completed the rigging and animation process for the Tater game asset. We discussed several key aspects for rigging such configuring bone rotation and using the IK Constraint. We also

FIG 6.49 This Image Shows the Effect of Having Optimize Keyframes Enabled on the FBX Export When the File Is Imported into Unity iOS.

discussed creating cyclic animations and creating Blender Actions to help in exporting multiple FBX files.

In Chapter 7, we are going to take a final look at animating game assets for the iPhone and iPad by discussing the animation of props. We'll take a look at using Blender's Bullet Physics Engine to create a Rigid Body simulation to animate exploding targets the player will shoot in the book's demo app. We'll also take a look at the animation for Tater's weapon, Thumper.

Animation Using Blender
Advanced Animation

In Chapter 6, we completed the rig for Tater and talked about creating cyclic animations, i.e., a run or walk cycle. In this chapter on animation, we're going to take a look at some advanced topics such as working with Blender's Nonlinear Action Editor (NLA) to create Actions that can be used in conjunction with Animation Layers and Additive-Blending in Unity iOS. We're also going to discuss how you can utilize Blender's Bullet Physics Engine to procedurally animate a game object.

This chapter will further build upon the animation concepts covered in the previous two chapters. The goal of this chapter is to give you the understanding of how to create your animations in your 3D application and how you can use Unity's Animation System to control these animations. We're not going to enter into the advanced scripting mechanics of the animations per se, but instead focus on how you need to create your animations so they can be used correctly within Unity iOS.

Let's get started by taking a look at the Unity's Animation System.

Creating 3D Game Art for the iPhone with Unity. DOI: 10.1016/B978-0-240-81563-3.00007-3
Copyright © 2011 Elsevier, Inc. All rights reserved.

Tater's Weapon Load Out
Go to the resource site to view the video walk-through for this chapter.

Unity's Animation System

Unity iOS has a very robust animation system. It allows you to blend, mix, and add animations, as well as syncing and controlling animation playback via time, speed, and blend weights.

> *Unity iOS has a very robust animation system. It allows you to blend, mix, and add animations, as well as syncing and controlling animation playback via time, speed, and blend weights.*

In Chapter 6, we discussed using the Blender's Action Editor to create separate animations that can be exported to multiple FBX files. Throughout your game, you will need to play these various animation clips during various states of the game play such as when a character is running, walking, or shooting. Now, it wouldn't look too nice if these animations were abruptly changing from one clip to the next. That is why Unity iOS supports animation blending.

In Unity iOS, you can have any number of animations playing on the character and all these animations will be blended together to produce the final animation. It's exactly the same concept as using Blender's NLA as shown in Fig. 7.1 to layer Actions together to produce a complex animation sequence.

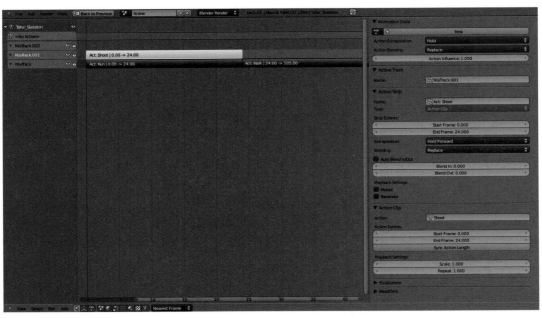

FIG 7.1 Blender's NLA Editor Allows You to Create Transitions between Animations and Scale and Blend Clips.

With Unity iOS, Animation System, you can smoothly transition from one animation clip to another. It's important to understand these capabilities of the Animation System so that you can build your Actions in Blender accordingly. There are basically two routes you can use in animating your character.

Route 1

Route 1 is to create each animation separately. For instance, let's say your character will need to be able to perform a run, walk, and a shooting action. What I mean by creating each animation separately in this case is that you'll not only need to create the run and walk actions but you also have to create a walk-shoot and run-shoot action. While you're at it, you'll also need an idle animation, which means you then have to create an idle-shoot animation as well. So, in order to adequately produce the three actions, that is, walk, run, and idle with a shooting action, you'll also need to create another set of these animations containing the shooting action as well. This brings you to a total of six animations you'll need to create for only three actions the character will be performing as shown in the diagram in Fig. 7.2.

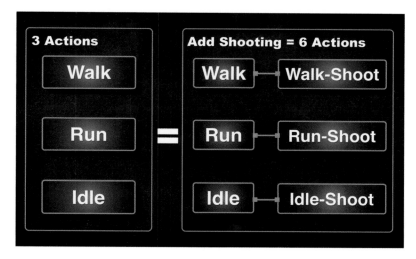

FIG 7.2 This Image Shows How Three Actions Can Mean Creating Six Separate Animations.

As you can see, even with a simple character with three actions plus shooting, you are already doubling the amount of work in terms of animation. Animation is fun, but it's not that fun. The solution to this issue can be found by heading down route two.

Route 2

In this route, you will only need to create the three actions plus the shooting action that your character needs to perform. The reason being is that you can take the shoot animation and additively blend that action with another such as the run animation as shown in Fig. 7.3.

As stated earlier, the blending of animations can be done within Unity's Animation System. You can set the blendMode using the AnimationState Interface. In Fig. 7.4, you can see the AnimationState has a variable for setting the blendMode. We will discuss this in depth in moment. For now, just know that the blending will take place at run time.

FIG 7.3 This Image Shows That by Using Blended Animations, You'll Only Need to Create Four Actions in Total.

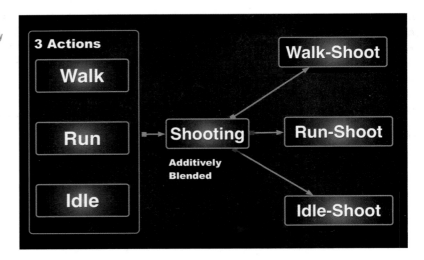

FIG 7.4 This Image Shows You a List of Properties for the AnimationState Class. Notice That the AnimationBlendMode Can Be Set to Additive.

In this chapter, we're going to exclusively look at creating animations for the purpose of additively blending them in Unity iOS and we'll start with Blender's NLA Editor.

Creating Animations Using Blender's NLA Editor

In Chapter 6, we talked about using the Action Editor to create different animations and then selecting an Action for exporting separate FBX files using the "model@action.fbx" notation. In this chapter, I'm going to introduce you to

a better workflow using the NLA Editor. However, we're going to need to take a small sidetrack first to discuss Tater's weapon animation.

Animating Weapons

In Chapter 6, we discussed creating a basic run cycle. However, we didn't discuss the fact that for my game and more than likely, most games will involve the character carrying a weapon. Now, you could import the weapon, Thumper in our case, into Blender and animate the gun as part of your actions, and then I could export both Tater and Thumper as part of the object. This works well, but what if you want to create a game where characters can pick up different weapons during game play? In that case, you'd have to create several new animations with the character holding each weapon and possibly swap out models when the character gets a new weapon. Again, we're back to creating more work for ourselves. My workflow is to export the animations in Blender without the weapon and then "parent" the weapon object to the character's hand bone in Unity iOS via a simple script as shown in Fig. 7.5. In

FIG 7.5 The Thumper Weapon Is Parented to the Hand Bone at Run Time.

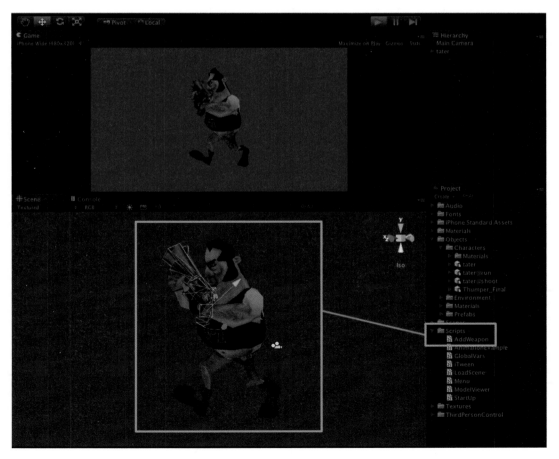

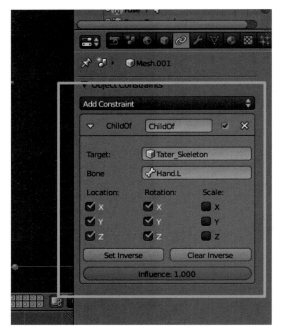

FIG 7.6 The Gun Was Parented to the IK_Hand.L Bone Using a ChildOf Constraint.

Unity iOS, all the bones are regarded as Transforms. This allows you manipulate each bone just as you would any other object in Unity iOS.

In Blender, I'll still need the weapon attached to the character in order to animate the action correctly. What I did was to parent the weapon to Tater's IK_ Hand.L Bone using a ChildOf constraint as shown in Fig. 7.6.

Notice that the constraint matches the location and rotation of the gun to the IK_Hand.L Bone. This is exactly what we'll be doing in Unity iOS. There are different ways to set this up in Unity iOS, but I just utilized Thumper's Pivot as it was originally set in modo to correctly attach Thumper to Tater's hand as shown in Fig. 7.7. In Fig. 7.8, you can see that you can work with pivots in Unity iOS by enabling Pivot mode in the Editor.

In Unity iOS, I attached a simple script to Thumper to parent it to the hand. The script takes a variable of type Transform, which represents the IK_Hand.L Bone in the mesh. In the script, the gun's Transform is then parented to the hand, and its local rotation is set to a Quaternion.identity, which aligns it to the parent axes. The local position is set to zero via Vector3.zero. Finally, I offset the Euler angles by −80 on the Y-axis and −90 on the Z-axis in order to properly line up the gun to the hand bone like it was in Blender as shown in Fig. 7.9.

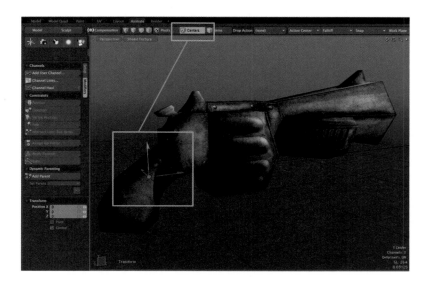

FIG 7.7 Here You Can See the Pivot Point That Was Set in Modo.

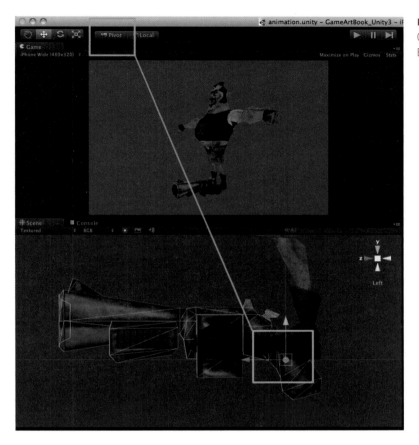

FIG 7.8 The Pivots Set on Your 3D Objects Are Available in Unity iOS by Enabling Pivot Mode in the Editor.

```
AnimationExample.js ×   AddWeapon.js ×
AddWeapon                                    ◇ ● Start()
 1   public var hand : Transform;
 2
 3   function Start()
 4   {
 5       // Create a rotation
 6       var rotation = Quaternion.identity;
 7       // Assign a rotation -80 degrees around the y axis and -90 around the z axis
 8       rotation.eulerAngles = Vector3(0, -80, -90);
 9
10       transform.parent = hand;
11       transform.localPosition = Vector3.zero;
12       transform.localRotation = rotation;
13   }
14
~
~
~
```

FIG 7.9 Here You Can See a Script That Offsets the Rotation of the Weapon Using rotation.eulerAngles().

With this setup, you can replace the weapon when needed. As long as the pivots in different weapons match positions and they're relatively the same size in regards to how the character is going to hold the weapon, this work-flow works well.

161

Using the NLA Editor

Now that we've discussed how to handle weapons so to speak, we'll continue on with discussing the NLA Editor. The NLA Editor is used to mix and blend Actions to create complex animations. Let's look at an example of creating a shoot while running animation. In Figs. 7.10 and 7.11, you can see the run and shoot animations that were created for Tater.

It's hard to tell from the images, but the shoot animation has no keys set on the legs. By clicking the plus sign in the Action Editor, I created a new Action that starts with the bones in position from the previous Action's pose as shown in Fig. 7.12. However, the keyframes are removed in the new Action. I then keyframed a shooting animation and renamed this action to shoot.

Using the NLA Editor, you can then work with your animations as strips as they're called. It's much like using a video editor in that you can add strips or clips to a track and bend and transition between them. In our case, we just want to layer the shooting animation over the run, and this is done by placing the shoot track above the run and changing its blending mode to Add as shown in Fig. 7.13.

FIG 7.10 This Image Shows the Run Action.

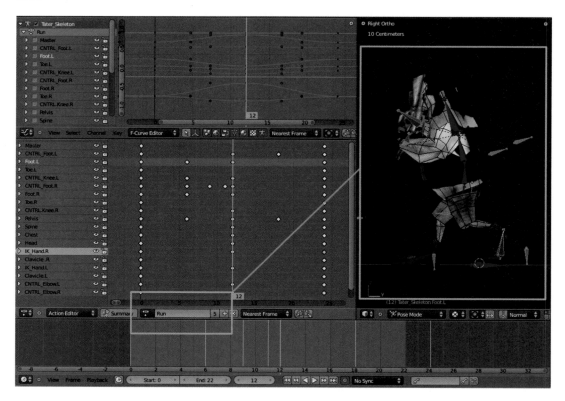

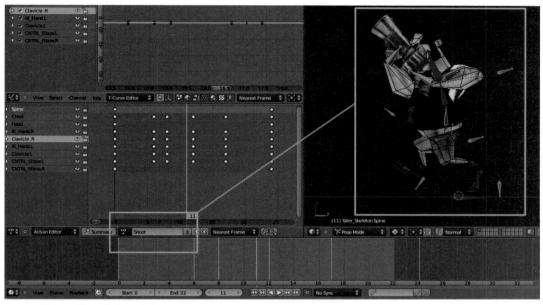

FIG 7.11 This Image Shows the Shoot Action.

FIG 7.12 The New Action Starts with the Bones in the Previous Action's Pose.

FIG 7.13 The Blending Mode for the Clip Is Set to Add in the Properties Panel for the Track.

Now, the shoot animation is being additively blended over top of the run animation. This is also what is happening in Unity's Animation System when you work with blending animations. By just using Blender's NLA Editor, you have a much more sophisticated workflow since you build Actions and layer them in the NLA. The NLA also allows you to do some interactive tweaks to your animation such as speeding up or slowing down the animation by adjusting the Playback Settings as shown in Fig. 7.14.

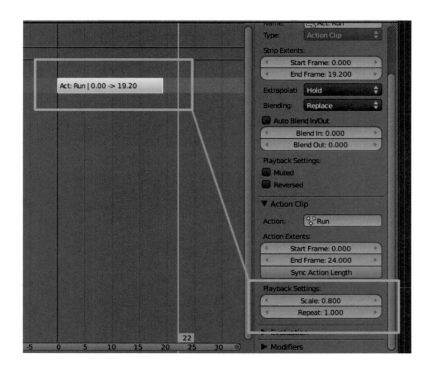

FIG 7.14 You Can Adjust the Speed of a Clip in the Playback Settings by Changing the Scale Property.

At this point, with the shoot and run Actions being blended via the NLA Editor, you could export this animation in Unity iOS to get a shooting while running animation ready to go. However, as we discussed earlier, this isn't the best scenario, as we'd then have to create another animation for shooting while walking or shooting while strafing to the left and on and on. As you can see, your project could end up with lots of animation files quickly. Instead, let's look at blending these animations in Unity iOS and cutting down on the number of FBX files that are needed in our project.

Blending Animations in Unity iOS

Continuing on with our shooting and running example, we'll now look at blending these animations in Unity iOS. We've been using the NLA Editor in Blender to create our animations, and in order to export only the run animation, you need to disable the shoot track by clicking Muted in the Playback Settings for the track as shown in Fig. 7.15.

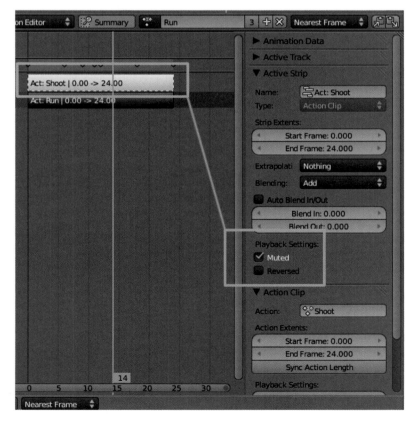

FIG 7.15 The Shoot Track Was Muted so That It Isn't Included in the FBX Export.

Muting a track will allow us to only export the run Action, which will give us the base run animation needed for our character. Next, we'll then re-enable the shoot track and disable the run, and then export this shoot animation to a separate FBX file using the "@" notation. Since the shooting animation only covers shooting, we can then effectively layer this animation over many other animations such as running, walking, and strafing, thus cutting down on the number of animations we need to create and import into our project. In order to additively blend these animations in Unity iOS as we did in Blender, we'll need to utilize Animation Layers and set the AnimationBlendMode for the AnimationState. This involves scripting, but thankfully, Unity iOS makes it quite simple.

Animation Layers

Animation Layers allow you to group animations and prioritize the weighting of animations. In Unity iOS, animations are blended, so there aren't abrupt changes when transitioning from one animation to the other. This is accomplished through assigning blend weights. For example, when using the animation.CrossFade() function, Unity iOS automatically handles the blending from one animation to the other. If you want to prioritize which animation receives the most weight, you can use Animation Layers. In our case, we want the run cycle to continue as the shoot animation is called when the user hits a fire button. This can be accomplished by placing the shoot animation on a higher layer. In Fig. 7.16, you can see how this is implemented.

FIG 7.16 This Code Example Shows That the Layer Property Is Set on the Shoot Variable, Which Is of the AnimationState Data Type.

```
AnimationExample                                    Start()
1    private var shoot : AnimationState;
2
3    function Start()
4    {
5        animation.Play("run");
6
7        //Set the Shoot Clip
8        shoot = animation["shoot"];
9        //Place the Shoot Clip on layer above run clip
10       shoot.layer = 1;
11       //Set the blend mode to additive
12       shoot.blendMode = AnimationBlendMode.Additive;
13       //Enable shoot
14       shoot.enabled = true;
15    }
16
17
18   function Update ()
```

First, a private variable data typed as AnimationState is created to hold the shoot animation. Next the shoot clip is set to the shooting animation stored in the FBX file. Finally, the shoot AnimationState is set to layer 1, which places

it above the run cycle, that is at zero since it wasn't assigned a layer. Now, the shoot animation will receive the blend weights before the run, and the run will only receive weights if the shoot animation doesn't use all 100% of the blend weights. When CrossFading the shoot animation by using animation. CrossFade("shoot"), the weights for the shoot animation will start from zero and increase to 100%. It's much like fading in an animation over top of another. The run animation will gradually decrease as the shoot animation is "faded in."

However, this isn't what I'm particularly looking to do, as I want the shoot animation to play as the character is running. This is where additive blending comes into play.

Additive Blending

In order to have the shoot animation play on top of and along with the run animation, we need to set the blend mode to additive for the AnimationState as shown in Fig. 7.17.

Now, when the player hits the fire button or, in this basic example, touches the screen, I can simply play the shoot animation, and it will be added on top of the run animation as shown in Fig. 7.18.

In Fig. 7.19, you can see both animations playing as they are added together via layering and additive blending. On the left side of the image, you can see the animations playing from Unity iOS and on the right, the same animations being added together in Blender. Notice through Unity's Animation System, we were able to produce the exact shooting while running animation in Unity iOS as was produced in Blender using the NLA Editor.

As you can see, this is a very powerful workflow as the shoot animation can now be added to any other animations such as a walk cycle. I no

```
AnimationExample                          ◇ ● Start()
1   private var shoot : AnimationState;
2
3   function Start()
4   {
5       animation.Play("run");
6
7       //Set the Shoot Clip
8       shoot = animation["shoot"];
9       //Place the Shoot Clip on layer above run clip
10      shoot.layer = 1;
11      //Set the blend mode to additive
12      shoot.blendMode = AnimationBlendMode.Additive;
13      //Enable shoot
14      shoot.enabled = true;                           I
15  }
16
17
```

FIG 7.17 The blendMode for the Shoot Variable Is Set to Be Additive.

```
AnimationExample                                    ◇  ● Update()
 1    private var shoot : AnimationState;
 2
 3□  function Start()
 4    {
 5        animation.Play("run");
 6
 7        //Set the Shoot Clip
 8        shoot = animation["shoot"];
 9        //Place the Shoot Clip on layer above run clip
10        shoot.layer = 1;
11        //Set the blend mode to additive
12        shoot.blendMode = AnimationBlendMode.Additive;
13        //Enable shoot
14        shoot.enabled = true;
15    }
16
17
18    function Update ()
19    {
20        for (var i: int =0; i < Input.touchCount; i++){
21            //Store touch
22            var touch: Touch = Input.GetTouch(i);
23            //Check to see if finger moved
24            if (touch.phase == TouchPhase.Began) {
25                print("Touch: Fire Weapon")
26                animation.Play("shoot");
27            }
28            if(touch.phase == TouchPhase.Ended){
29                print("Touch Ended");
30            }
31        }
32    }
~
~
~
```

FIG 7.18 Here You Can See the Script That Plays the Shoot Animation When the User Touches the Screen. Notice the Shoot Animation Is Placed on Layer 1 and That the AnimationBlendMode Is Set to Additive.

longer have to worry about creating different walk and run animations to encompass shooting, as I can easily layer it over any animations I create. Also, using this method, I could easily adapt new shooting animations for different weapon types knowing that these animations can be added to my existing walk, run, and strafing actions with ease. This makes adding new animations simple, as I don't need to create a set of special run and walk cycles for each new shooting animation. Think about creating sequels to your game, where new weapon animations can be created while allowing you to reuse some of your animations from the first game. Productivity is key when it comes to game development, and any time you can find a way to save yourself from re-creating something, you need to take it.

Productivity is key when it comes to game development, and any time you can find a way to save yourself from re-creating something, you need to take it.

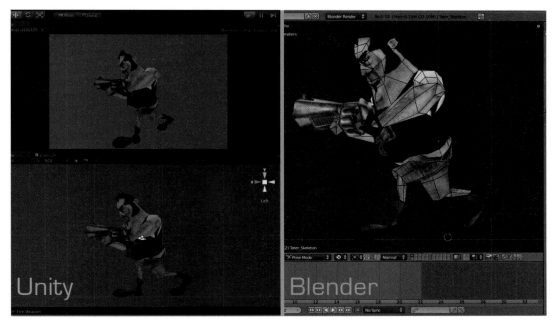

FIG 7.19 In This Image, You Can See That the Layered Animation in Blender Was Reproduced in Unity iOS Using an Animation Blending Just as Was Done in Blender via the NLA Editor.

Using Dynamics in Blender to Animate Objects

In this section, we're going to take a look at the process of using the Bullet Physics Engine to create some procedural animation. In the book's demo app, you play as Tater running through his training facility shooting targets. The target, as shown in Fig. 7.20, is a simple wood board with a spray painted zombie face. Be sure to notice Tater's artistic talent with a spray can! The animation goal for this object is to explode into pieces when it's hit from a blast from Thumper as shown in Fig. 7.21.

Using physics can be great for this type of effect. The process covered in this chapter will "bake" the physics simulation from Blender into keyframes, which will then be played in Unity iOS from the FBX file. However, it's important to note that using this method can be heavier on GPU side. That's not necessarily a bad thing, as we've discussed throughout the book, you'll need to profile your game for potential bottlenecks. With newer hardware, the CPU on the iDevices are becoming more capable than the GPU, which means if your game is already heavy on rendering, this method might not be the best solution. To compliment this section, in Chapter 9, we'll discuss creating the same explosion effect in Unity iOS using a physics simulation,

FIG 7.20 Here You Can See the Target Game Object That Tater Will Shoot in the Game. The Game Object Will Be Animated with Rigid Body Dynamics in Blender.

FIG 7.21 The Dynamic Simulation Created in Blender Will Be Baked and Exported to Unity iOS, So It Can Be Used in the Game as Shown Here.

which will shift the resources for the effect to the CPU. It's important to understand the process behind both methods as each can affect your game's performance in different ways.

Let's begin by taking a look at setting up Rigid Body Dynamics in Blender.

Setting Up Rigid Body Dynamics in Blender

The target game object was created in modo. Importing this object into Blender proved to be a bit trickier than when I transferred the Tater and Thumper models to Blender via FBX. Before we get into the actual dynamics setup, let's look at getting the target object into Blender.

Stay on Target…
The target object was created in modo. You can see how the target object was created in the video for this chapter found on the resource site.

Importing into Blender

A big issue you'll find with Blender is you can't import FBX files. Well at least it is for me. Blender does support a lot of formats, but as I've stated, I rely heavily on an FBX workflow to transfer data between programs. So my next option was to use the OBJ format. The OBJ format is quite limiting in that you can only use 1 UV set and you can sometimes run into issues importing multiple mesh layers, and in my case, it was the multiple mesh layers that gave me trouble. I found that in one build of Blender, the OBJ would import with the layers intact, whereas other builds would always merge the layers. The Blender OBJ Importer doesn't have an option to toggle single or multiple meshes like Maya does, as shown in Fig. 7.22. So, I found it to be a hit or miss type of operation, which called for me to either separate the mesh in Blender or rely on another format.

FIG 7.22 The OBJ Format Does Support Multiple Meshes but It Depends on the OBJ Importer Such as with Maya, There Is an Option to Import Multiple Meshes.

Instead of using another format, such as Collada, I opted to separate the mesh into layers using the Blender tool set. This is actually extremely easy and more efficient than doing it in modo. To separate the mesh into parts, from Edit mode, hit the P key and choose "By loose parts," as shown in Fig. 7.23.

Once the mesh is separated in to multiple meshes, you'll need to set the pivot point for each mesh so that it's positioned at this mesh instead of the origin. This is also a very easy task. To set the pivot, from Object mode, right-click to place the 3D Cursor where you'd like to position the pivot as shown in Fig. 7.24, and then press Shift + Ctrl + Alt + C and choose "Origin to 3D Cursor," as shown in Fig. 7.25. This will snap the pivot to the 3D Cursor. The pivot needs to be set correctly when adjusting the Radius in the Rigid Body settings. Now that the pivots are all positioned as shown in Fig. 7.26, we can set up the Rigid Body simulation.

FIG 7.23 The Separate, By Loose Parts, Command Will Break Up the Mesh into Separate Meshes.

FIG 7.24 Right-click to Position the 3D Cursor Where You'd Like to Place the Pivot.

FIG 7.25 Use the Origin to 3D Cursor Command to Snap the Pivot to the 3D Cursor.

Now, we are going to set up the scene for the Rigid Body simulation. We're going to set all of the meshes that make up the target board as a Rigid Body. The post, which holds the target, will not be a Rigid Body and thus won't be animated. The first thing will need to do is add some additional objects to help us with the simulation. We'll need to add a ground plane so that when the target pieces fall, they'll hit the ground and react. This ground object will stand in the actual ground in the game. In Fig. 7.27, you can see the ground object, which is just a simple plane that has been scaled up to cover the entire area the simulation will take place.

We'll also be adding a sphere to the scene, which will act as the shotgun blast so to speak. In the simulation, we'll "fire" this sphere into the target board meshes to explode them apart. In Fig. 7.28, you can see the sphere object, which is a UV Sphere that was scaled up to represent the blast zone. Notice the sphere's size in relation to the target. Again, this sphere represents the blast from Thumper when the player fires the weapon. The sphere is then positioned in front of and perpendicular to the target, as can be seen in Fig. 7.28.

FIG 7.26 Here You Can See That All of the Pivots Are Set Relative to the Mesh.

FIG 7.27 A Plane Was Added to Stand in for the Ground.

FIG 7.28 The Blast Zone Is a Simple UV Sphere Object.

FIG 7.29 The Rendering Engine Is Set to Blender Game at the Top of the UI.

FIG 7.30 This Image Shows the Physics Type Set to Rigid Body on the Physics Tab.

Now that all of the objects are in place, we'll start configuring the appropriate meshes to be a Rigid Body. First, set the engine for rendering to Blender Game as shown in Fig. 7.29.

We'll configure the sphere first. With the sphere selected, go to the Physics tab on the Properties panel and set the Physics Type to Rigid Body as shown in Fig. 7.30.

In the Physics tab, you can set the properties for the Rigid Body such as Mass and Radius. The Radius is an important setting as it pertains to the area of influence the Rigid Body will have on the scene. For the sphere, which represents the blast zone, the Radius was set rather high to make sure it effects the entire board as shown in Fig. 7.31.

You'll also need to make sure that the Collision Bounds is active and that the Bounds mode is set correctly for the object it represents. For the sphere, I choose the Sphere setting for the Bounds to match the Rigid Body's shape to the actual mesh it's applied to as shown in Fig. 7.32.

I then repeated this procedure of making each piece of the board a Rigid Body. However, for the piece meshes, I increased the Mass and lowered the Radius so that it only encompassed the bounding area of the mesh as shown in Fig. 7.33. This is important because if the Radius is too high, each piece would instantly affect the other pieces, pushing them apart as soon

FIG 7.31 The Radius Is Visualized in the Viewport as a Dashed Circle.

as the simulation is run instead of letting them react more to the blast, i.e., the sphere collision.

I also enabled the Collision Bounds for the target pieces, but I changed the Bounds setting to Box since it more closely resembled the actual mesh as shown in Fig. 7.33.

FIG 7.32 The Bounds Mode Is Set to the Shape of the UV Sphere.

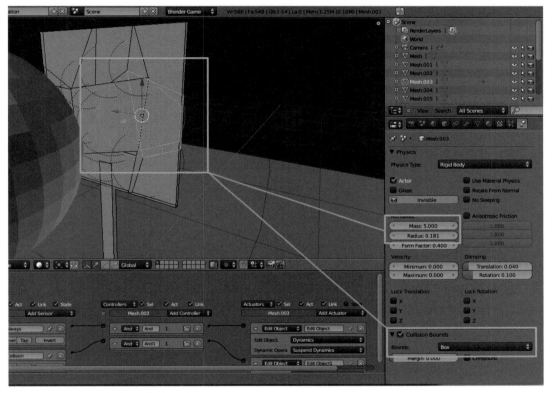

FIG 7.33 Here You Can See the Settings for the Mesh Pieces.

Well, we can't forget about the ground. The ground needs to have its Physics Type set to Static, its Collision Bounds activated, and the Bounds set to Box as shown in Fig. 7.34.

At this point, all of the setup is complete in terms of setting the Physics properties for the mesh items. However, if you run the simulation by pressing the P key, the board pieces will just fall and hit the ground before coming to a rest. This is because the Bullet Physics Engine has gravity applied, which can be changed on the World tab of the Properties panel, as shown in Fig. 7.35. This is not what we want to do. We want to have the target remain at rest until the sphere object is pushed into the target and thus break apart the pieces we've

FIG 7.34 The Ground Is Set to Static.

FIG 7.35 The Bullet Physics Engine Defaults to 9.8.

set as Rigid Bodies. In order to accomplish this, we'll need to set up some logic for the simulation, which can be done through the Logic Editor.

Setting Up the Logic

We'll first set up the logic for the sphere. First, we'll add a Game Property, which I called "col," by clicking the Add Game Property button as shown in Fig. 7.36. This property will be used later to only trigger the simulation for the target pieces when the sphere strikes them.

For the UV Sphere, we'll need to create two layers of logic. The first layer will suspend the dynamics so when we start the simulation, the gravity won't automatically affect the Rigid Body objects. The second layer, re-enable the dynamics, but only after we hit the space bar. In Fig. 7.37, you can see both layers highlighted. The first layer consists of an "Always" Sensor, a "And" Controller, and one "Edit Object" Actuator set to Suspend Dynamics. As you can see from Fig. 7.37, these items are piped together.

The second layer of logic consists of a "Keyboard" Sensor set to Spacebar, an "And" Controller, and two Actuators, an "Edit Object" set to Restore Dynamics and a "Motion" Actuator set to simple motion with a value of −2.0 in the Y-axis. Again in Fig. 7.37, you can see how this logic is piped together. The second layer of logic is stated that when the Spacebar is pressed, dynamics will be restored and a motion of −2.0 will be applied to the UV Sphere in the Y-axis, which will push the ball into the target.

Next, we'll need to set up the logic for each piece of the target. It's a very similar setup in that there are two layers of logic. The first layer will suspend the dynamics and the second layer will re-enable the dynamics, but instead of using a "Keyboard" Sensor, we'll use a "Collision" Sensor. The collision event will be the UV Sphere colliding with the ball, and we'll use the "col" Game Property set on the UV Sphere to tell our logic that we only want to test for a collision with the game object that contains the "col" Game Property, which in our case is the UV Sphere. When this collision happens, the second layer of logic will re-enable the dynamics, just as we discussed before. In Fig. 7.38, you can see the completed logic for the target pieces.

FIG 7.36 A Game Property Called "col" Is Added to the UV Sphere.

At this point, the entire simulation is set. If I were to hit the P key to start the game followed by the Spacebar, the sphere will hit the target and explode it into pieces as shown in Fig. 7.39. Next, I just need to bake the simulation into keyframes so that the animation can be imported into Unity iOS.

Baking the Simulation

To bake the Rigid Body simulation, you need to go to the Game menu at the top of the Blender UI and enable Record Animation as shown in Fig. 7.40.

With this option activated, you then need to run the simulation by pressing the P key. Remember, because we set up a Keyboard Sensor, we'll have

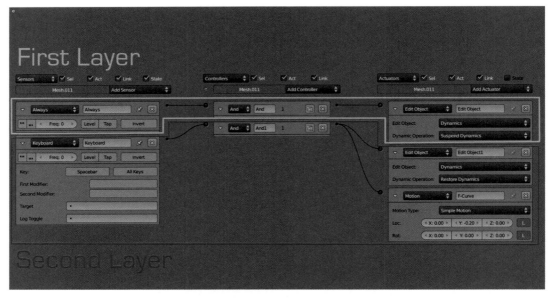

FIG 7.37 Here You Can See the Entire Logic Map for the UV Sphere Rigid Body Object.

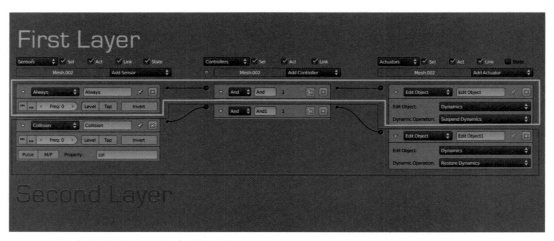

FIG 7.38 Here You Can See the Entire Logic Map for the Target Pieces.

to then hit the Spacebar to animate the ball and actually begin the simulation. Now, this can be a little tricky since as soon as the game is running, keyframes are being created. This means the longer you allow the game to run, the more the keyframes are created and the longer the baked animation will be. So, what we need to do is hit the P key to start the game, immediately hit the Spacebar, and as soon as enough of the animation we

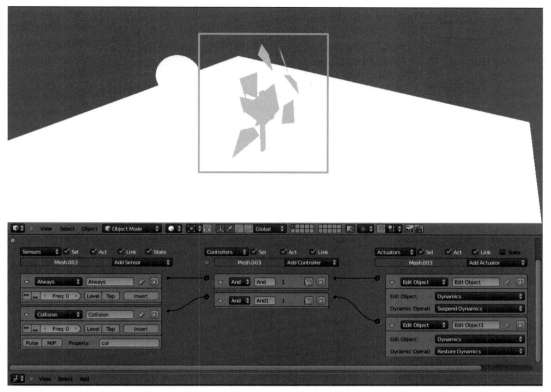

FIG 7.39 Here You Can See That the UV Sphere Is Shattering the Target Object.

want to bake has played, hit the Esc key to end the game, which also stops the baking procedure. In Fig. 7.41, you can see that by quickly starting the animation and ending as soon as possible, I only generated about 140 keyframes.

Now, we have too many keyframes for our animation, so we're going to delete unwanted keys using the Dopesheet Editor. The Dopesheet Editor allows me to see all the keys for each object in my scene. After scrubbing the timeline, I can see the range of keys that represent the range of the animation I want to send to Unity iOS. Then, I can go into the Dopesheet Editor and do a bounding selection by hitting the B key and dragging the selection box around the keys I want to remove as shown in Fig. 7.42.

FIG 7.40 Baking of the Simulation Is Handled by Activating the Record Animation Feature in the Game Menu.

In my case, the keys I wanted to keep were between frames 38 and 94. With these appropriate keys selected, and then simply delete them with the X key. With the remaining "good" keys left, I hit the A key to select all the keys and G key to move them so they start at frame 0. This leaves me

FIG 7.41 The Baked Animation Is Around 140 Frames as Highlighted in This Image.

FIG 7.42 You Need to Remove the Extra Keyframes That Aren't Apart of the Actual Animation Frames.

FIG 7.43 Here You Can See the Trimmed Animation. Notice the Total Duration Is 56 Frames.

FIG 7.44 The Bullet Engine Defaults to 60 FPS, Which Is Much to High.

with a total of 56 frames for the entire animation. In Fig. 7.43, you can see the trimmed animation and that the Timeline as been set to start at frame 0 and end at frame 56. At this point, you can also delete the ground plane and sphere, as they were only needed for the Rigid Body simulation.

Editing the Animation with the NLA Editor

We're almost finished prepping the animation. There's one last thing to fix and that's the frame rate. The Bullet Engine defaults to running at 60 FPS as shown in Fig. 7.44; however, for our animation needs, we need our baked animation to run at 30 FPS. If we were to export the animation as is, it would run 2X slower than needed and look like the target is exploding in slow motion. This is definitely an issue that needs some attention.

You could simply adjust the FPS setting to 30, but I found that this didn't produce a good enough physics simulation. So, we're going to rely on the NLA Editor yet again to scale the animation to an appropriate speed. If you go the NLA Editor, you will see that an Action has been created by default for each object as shown in Fig. 7.45. Blender has made it nice and easy

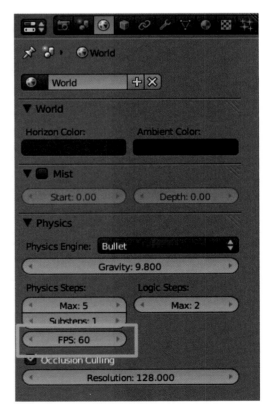

FIG 7.45 In the NLA Editor, You Can See the Actions in Red Before They Are Converted to Clips.

FIG 7.46 By Clicking the Snowflake Icon, the Action Is Converted into a Strip and Becomes Yellow.

for us as all we have to do now is convert each action into a Strip or Track by clicking the snowflake icon as shown in Fig. 7.46.

Now, from the Properties panel for the NLA Editor, you can adjust the scale to 0.5 or whatever you feel is the correct speed for the animation as shown in Fig. 7.47.

Now, the entire animation is only 28 frames, which runs just under 1 s, and is perfect for exploding the target effect. All that's left is to set the End Range on the Timeline to 28 and export the FBX file for use in Unity iOS. We now have a nice Rigid Body effect to play when Tater shoots a target.

FIG 7.47 The Scale Can Be Adjusted to Speed Up or Slow Down a Track, That Is, Animation.

Summary

This chapter concludes our discussions on creating animations for our game assets. In this chapter, we covered some important topics such as how to best use Unity's Animation System for layering animations, cutting down on the amount of work needed for animation. We also discussed using the Bullet Physics Engine in Blender to add some realistic dynamic effects to create the exploding target animation. Animation is a vital aspect toward creating a great gaming experience. It's important for it to look good, be optimized, and not take you years to complete.

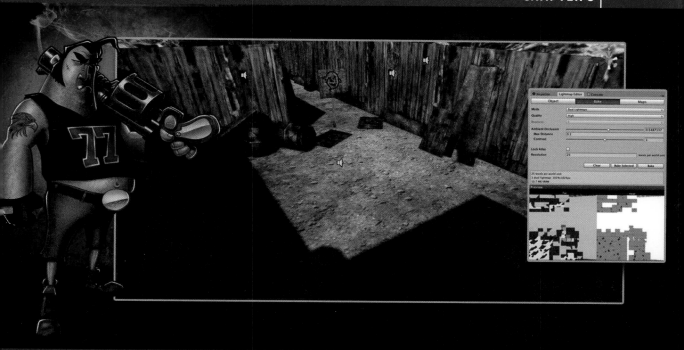

Creating Lightmaps Using Beast

The overall focus throughout this book has been creating optimized content that's targeted for the iPhone and iPad. In this chapter, we'll be discussing lightmapping, which is an excellent way to greatly improve not only the look of your game but also to optimize the scene by baking the lighting information to a map. As we've discussed in Chapter 2, in the section "Using Lights," real-time lighting can become expensive on the iDevices. This is where lightmapping comes to the rescue. Lightmapping is the process of baking the scenes' lights to a map, which can then be multiplied over the color map to combine the lighting information with the diffuse color as shown in Fig. 8.1.

With the lighting information baked to a map, you no longer need to have lights enabled in your scene and thus don't need to be concerned with the performance hit from using real-time lighting. However, the very nature of the scene lighting being baked into map means the lighting is fixed, i.e., the lighting on the lightmapped objects can't change. Also, the objects that are lightmapped in your scene can't move. However, Unity has the ability to blend real-time lighting and shadows with the lightmapped environment using the integrated Beast Lightmapping Toolset via the Dual Lightmaps

Creating 3D Game Art for the iPhone with Unity. DOI: 10.1016/B978-0-240-81563-3.00008-5

FIG 8.1 The Lightmap Is Multiplied over the Color Texture in the Shader.

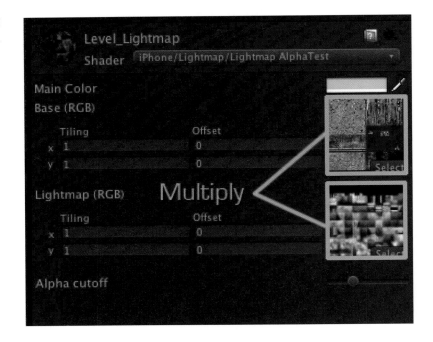

Mode. The capability of using Dual Lightmaps isn't available at the time of the writing this book when building for the iDevices due to deferred rendering not being supported on mobile platforms.

Lightmaps are created for environments or levels since these objects don't move. For example, in Fig. 8.2, you can see the environment that was created in Chapter 4 with lightmapping applied.

FIG 8.2 Here's the Level Fully Lightmapped.

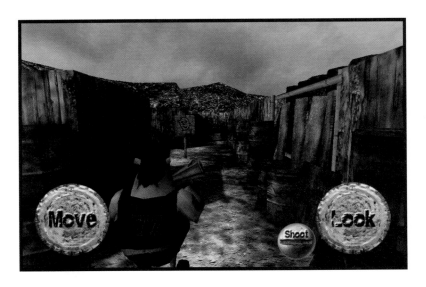

In this chapter, we're going to look at using the Beast Lightmapping Toolset in Unity iOS to create lightmaps for the level we created in Chapter 4, Tater's Training Yard. Beast is a phenomenal feature within Unity iOS and definitely provides the easiest and best workflow in terms of creating lightmaps for your games.

Beast Lightmapping

Beast is a content pipeline tool capable of baking advanced global illumination and lighting effects. Beast has been used on several AAA game titles and is now integrated into Unity iOS. As a 3D artist, I can definitely state that Beast is an amazing tool and provides the best workflow for lightmapping your content. In Fig. 8.3, you can see our level with Beast-generated lightmaps. Since lightmapping is fully integrated into Unity iOS, I could distribute my props prefab containing the barrels and boards throughout the level and have shadows casting into the scene, as well as Ambient Occlusion, as shown in Fig. 8.4. This becomes a tremendous workflow improvement, not to mention quality boost. Since the environment props are distributed across the level in Unity iOS, using Beast allows the light and shadow for the props to properly interact with the level. Over the next sections, we'll discuss the key aspects to using Beast. Let's begin by taking a quick look at Beast and HDR.

Tater's Weapon Load Out
Go to the resource site to view the video walk-through for this chapter.

FIG 8.3 Beast Was Used to Lightmap the Level.

FIG 8.4 With Beast, the Barrels and Boards Are Casting Shadows in the Scene.

As a 3D artist, I can definitely state that Beast is an amazing tool and provides the best workflow for lightmapping your content.

Beast and HDR

Before we get into actually using Beast, I want to point out that Beast is rendering in full 32-bit floating point in linear space. As a 3D artist and compositor, this is really cool. This means that the lighting being baked can utilize and benefit from HDR values which are referred to as super-white or having a value greater than 1.0 in floating point i.e. greater than 255 in 8 bit. Now, this is quite a complicated subject, which we won't get too deep into; however, if you're coming from a 3D background and are working with gamma-corrected rendering and linear space compositing, you'll find this to be an amazing feature of Beast. Speaking of gamma correction, with Beast, you don't have to linearize or remove gamma from your textures as you do in modo via the Gamma Setting on the Texture Locator in the case of rendering in linear space. Beast does this for you automatically! Again, this concept is a bit off topic for this chapter, but if you'd like to learn more about linear floating-point rendering, I have an in-depth chapter on this complex topic in my modo book, *Real World modo*. If this section doesn't make much sense, don't worry about it, just place it in the back of your mind for another time. You don't have to know anything about HDR or linear space to effectively create lightmaps using Beast. This section is here for those who have experience with rendering in linear space.

Correct Lightmap UVs

It's important to note that when creating UVs for lightmapping, it's imperative that none of the UVs are overlapping, they are contained in the 0–1 space, and there is enough space between the UV shells. In Fig. 8.5, you can see an example from modo that none of the UVs are overlapping in that each UV shell has its own defined space in the UV map and that all UV shells are contained in the 0–1 space.

FIG 8.5 None of the UVs Overlap.

You also want to make sure that the relative sizes of the UVs are proportional to each other. For example, in Fig. 8.6, you can see stair stepping in the top half of the map because the UVs are not scaled to the same proportions and thus half of the lightmap is receiving more resolution than other. The first section of the image shows the low-resolution issue due to the nonproportional UVs. The second section shows how the lightmap resolution is distributed across the map. Notice the lower half has much more resolution dedicated. The third section shows the actual UV map that was created in modo.

FIG 8.6 This Image Demonstrates the Low-Resolution Issue Apparent with Nonproportional UVs.

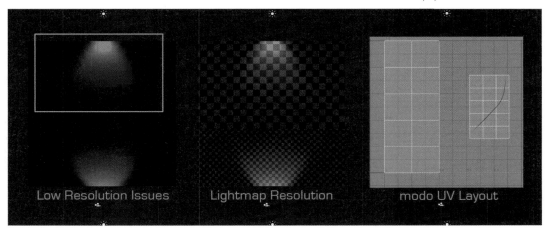

Low Resolution Issues Lightmap Resolution modo UV Layout

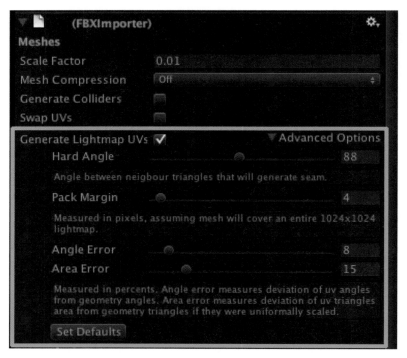

FIG 8.7 Generate Lightmap UVs Will Autounwrap Your Mesh and Create a Second Set of UVs for Lightmapping.

Autogenerate UVs

We've discussed the importance of creating appropriate UVs for lightmapped objects; however, you can choose to autogenerate UVs upon import in the FBX Importer Settings as shown in Fig. 8.7. This is a great time-saver, as you no longer have to worry about creating a second set of UVs for lightmapping in your 3D program. If you already have a second UV set, then Beast will use it in lightmapping process.

The Advanced Settings, as can be seen in Fig. 8.7, are for controlling the unwrap process in order to minimize the distortions that we discussed earlier in the section, "Correct Lightmap UVs," of this chapter. For example, Area Error will help to ensure that the scale between the UVs and the actual mesh geometry remains proportional to each other as shown in Fig. 8.5.

The Process

The process of lightmapping is very straightforward in Unity iOS. To begin, the objects that are to be lightmapped must be marked as Static, which also make them available for Static Batching as shown in Fig. 8.8.

FIG 8.8 Lightmapped Objects Must Be Marked as Static.

FIG 8.9 A Directional Light Was Added to the Scene.

Next, we'll add a directional light and adjust its direction and properties to produce the type of direct lighting appropriate for the scene as shown in Fig. 8.9.

I used a directional light for my scene since it is outdoor and I'm looking to simulate late evening light. I choose a very warm color for the light and set the shadows to soft as can be seen in Fig. 8.10.

Next, we'll go to the Tools drop-down menu and choose Lightmapping, which will open the Lightmap Editor panel as shown in Fig. 8.11.

The Lightmap Editor consists of three tabs, which are Object, Bake and Maps. Each tab presents you with a set of controls for adjusting various settings in regards to the lightmapping operation. The Object tab allows you to adjust

193

FIG 8.10 The Light Color Was Set to a Warm Tone to Simulate Late Evening.

FIG 8.11 The Lightmapping Tools Can Be Accessed Through the Tools Menu.

settings for selected objects in your scene such as adjusting properties or marking them as Static. In Fig. 8.12, you can see that from the Object tab, we can adjust the settings of our Directional Light.

The Bake tab, as shown in Fig. 8.13, presents you with all the settings for controlling the quality and features of the baking process such as Sky Light Color and Intensity, as well as adjusting Final Gather and Ambient Occlusion quality.

FIG 8.12 The Object Tab Contains Lightmap Settings for the Selected Object.

FIG 8.13 The Bake Tab Contains the Settings for Controlling the Features and Quality for the Lightmap.

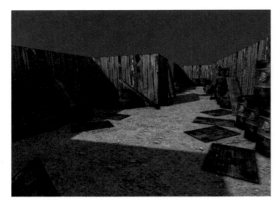

FIG 8.14 The Warm Sunlight Is
Balanced with Cool-Toned Shadows.

We'll talk about the important settings in the next section, but I'd like to point out that for my project, I set the Sky Light Color to a light blue. This was a stylistic decision as I often find a good artistic technique is to use a warm color for highlights such as sunlight, and then balance this with a cool tone for the shadows and indirect lighting as can be seen in Fig. 8.14.

The Maps tab allows you to choose the lightmap used for your scene and to toggle the option to compress the map. Once you've adjusted the lightmap settings to your liking, you'll then need to press the Bake button as shown in Fig. 8.15.

❶ Inspector	Lightmap Editor	▾≡
Object	Bake	Maps

Mode	Single Lightmaps
Sky Light Color	
Sky Light Intensity	1
Bounces	2
Bounce Boost	0.4603175
Bounce Intensity	0.6428571
Quality	High
Final Gather	
Rays	1000
Contrast Thresh	0.05
Interpolation	0.1507937
Interpolation Po	18
Ambient Occlusic	0.468254
Max Distance	0.1
Contrast	1
Lock Atlas	
Resolution	4 texels per world unit

Bake	Bake Selected	Clear

FIG 8.15 Pressing Bake Will Begin the
Baking Operation.

After the bake has completed, the lightmap will be applied to your scene, and in the 3D viewport, you will have a Lightmap Display control to disable the display of lightmaps and to visualize the lightmap resolution using the Show Resolution toggle. The Show Resolution feature is very useful as it overlays a

checker pattern over your scene that represents how the lightmap texels are being allocated to the objects in the scene as shown in Fig. 8.16.

FIG 8.16 The Checker Pattern Represents the Resolution in the Lightmap Allocated to the Objects.

The Resolution setting in the Bake tab is a global setting; however, you can allocate more resolution in the lightmap on a per object basis by selecting the object and adjusting the Scale in Lightmap setting in the Object tab of the Lightmap Editor as shown in Fig. 8.17. The great thing is that this procedure is completely interactive. Just select the object, adjust the Scale in Lightmap, and watch the checker pattern in the viewport scale to represent the texels in the lightmap being allocated to that object. You can also see from Fig. 8.17

FIG 8.17 Lightmap Resolution Can Be Set on a per Object Basis with the Scale in Lightmap Setting.

that the resolution for one of the barrels has been adjusted and can interactively be seen in the 3D viewport.

Using Dual Lightmaps

Earlier, we mentioned the usage of Dual Lightmaps and how they work to blend real-time lights and baked lightmaps. I also mentioned that Dual Lightmaps are not available on the iOS platform. Dual Lightmaps can only be used in the Deferred Lighting Rendering Path and currently this is not available on mobile platforms. It is also only available in the Unity Pro License. However, I thought it would be important to briefly mention the Dual Lightmap mode while discussing Beast. Dual Lightmaps are designed to make lightmapping work with specular, normal mapping and proper blending of baked and real-time shadows. By enabling the Dual Lightmaps mode in the Bake tab, Beast will bake two lightmaps, a Far map, which covers full illumination, and a Near map, which contains indirect illumination from lights marked as Auto, full illumination from lights marked as Bake Only, emissive materials, and sky lights. In Fig. 8.18, you can see that the mode has been set to Dual and that two light maps, a far and near, have been baked and saved into the project.

FIG 8.18 Dual Lightmaps Mode Creates Two Lightmaps.

With Dual Lightmaps, Lights set to Realtime Only are never baked. The Near lightmap set is used when the camera's distance to objects is smaller than the Shadow Distance quality setting. Within the Shadow Distance, Lights with

their Lightmapping property set to Auto as shown in Fig. 8.19, are rendered as realtime lights with specular bump and realtime shadows. These shadows blend correctly with shadows from Realtime Only lights and their indirect light is taken from the Near lightmap. When the camera is outside the Shadow Distance, lights marked as Auto no longer render in realtime and full illumination is taken from the Far lightmap. Lights marked as Realtime Only are still active, but have their shadows disabled. In Fig. 8.20, you can see the Shadow Distance Setting.

FIG 8.19 The Directional Light's Lightmapping Mode Is Set to Auto, Which Is the Default.

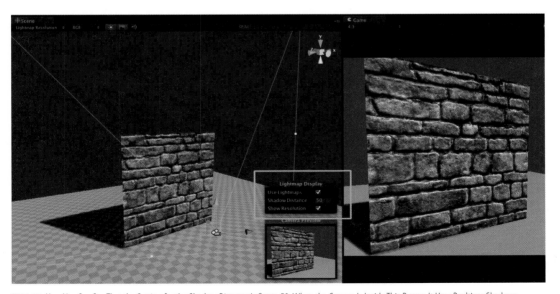

FIG 8.20 Here You Can See That the Setting for the Shadow Distance Is Set to 50. When the Camera Is Inside This Range, It Uses Realtime Shadows, But When It's Outside the Range, It Uses the Near Lightmap.

Beast Settings

There are a couple of important settings I'd like to point out in the Bake tab. Now, each project will inevitably require a different setup, but I often find myself mainly adjusting the Quality, Bounce, Interpolation, and Resolution settings to get the detail and quality needed in the bake as shown in Fig. 8.21.

Real-Time Lighting

Back in Chapter 2, in the section "Using Lights," we discussed that real-time lighting can possibly reduce performance. Although it can be best to use real-time lighting sparingly, that doesn't mean you can't use it. Your game type will dictate what can and can't be done in terms of performance. Remember to always test and profile your game and make decisions accordingly.

FIG 8.21 These Are the Settings I Mainly Check to Adjust Quality.

The Quality setting is pretty self-explanatory as it simply adjusts the quality of the lightmap. A good tip when testing the bake is to lower the Resolution to a low value and setting the Quality to Low. This will speed up the bake and allow you to quickly see the map applied to the geometry.

The Quality will also adjust the Final Gather rays that are sent into the scene. The more the rays are shot out into the scene, the higher the quality of the indirect lighting will be. You can use the Quality presets or manually adjust the ray count. The Contrast Threshold and Interpolation also affect the Final Gather solution. The Contrast Threshold controls new rays from being created based off a color contrast threshold. Higher contrast values will produce smoother but less detailed lightmaps. If you are using a lower number of Final Gather rays, then you may need to increase the Contrast Threshold to be sure that extra rays are not created. The Interpolation controls the smoothing

of color values. A value of 0 will produce a linear interpolation while 1 will produce a gradient-based interpolation, which can produce artifacts at the cost of detail.

Ambient Occlusion is also an important setting as it can produce subtle occlusion shading in your scene. The Max Distance controls how far a ray can travel before it's considered to be not occluded. A value of 0 means that the ray is infinity long. Contrast controls the transition between occluded and not occluded rays. Ambient Occlusion can provide a nice subtle shading effect to your scene. In Fig. 8.22, you can see the difference between a scene with Ambient Occlusion and without Ambient Occlusion. The difference is subtle. Ambient Occlusion tends to help anchor the object in the scene with increased shading in the corner areas where light has difficulty reaching.

FIG 8.22 Here You Can See the Difference between Occlusion On and Off. Notice That the Lightmap with Ambient Occlusion Seems to Anchor the Objects, Especially in Shadow Areas.

Something else to consider is that you can compress the lightmaps via the Compression toggle on the Maps tab of the Lightmapping Editor. Compression can cause artifacts to appear in your maps, as the compression setting toggles PVRTC 4 and RGB16 compression on your maps. However, by not compressing the files, you risk eating up texture memory. Again, you'll need to test and profile your game to see which is the best route to take in terms of compression.

Beast Custom Settings

At some point, you might find yourself needing to make some custom adjustment to the Beast settings. Beast reads baked settings from an XML file, which can be edited. From the Lightmap Editor, you can choose to generate a custom Beast file as shown in Fig. 8.23. This will add an XML file, which holds all of the Beast's render settings into your lightmaps folder. This XML file allows you to make custom adjustments such as Anti-Aliasing Settings and choose a different environment type as shown in Fig. 8.24.

FIG 8.23 A Custom Beast Render Settings File Can Be Generated to Make Specific Edits to the Render.

The most interesting setting is the giEnvironment node. By default, it is set to Skylight type, which correlates to the Sky Light Color and Sky Light Intensity settings found on the Bake tab of the Lightmap Editor. However, using the Custom Settings file, you can change the giEnvironment node to Image-Based Lighting (IBL), which allows you to use IBL instead of a Sky Light. With IBL, you can use an HDR in the HDR or EXR format to light your scene. In Fig. 8.25,

```
BeastSettings.xml ×
 3    <AASettings>
 4        <samplingMode>Adaptive</samplingMode>
 5        <clamp>false</clamp>
 6        <contrast>0.1</contrast>
 7        <diagnose>false</diagnose>
 8        <minSampleRate>0</minSampleRate>
 9        <maxSampleRate>2</maxSampleRate>
10        <filter>Gauss</filter>
11        <filterSize>
12            <x>2.2</x>
13            <y>2.2</y>
14        </filterSize>
15    </AASettings>
16    <RenderSettings>
17        <bias>0</bias>
18        <maxShadowRays>10000</maxShadowRays>
19    </RenderSettings>
20    <EnvironmentSettings>
21        <giEnvironment>SkyLight</giEnvironment>
22        <skyLightColor>
23            <r>0.86</r>
24            <g>0.93</g>
25            <b>1</b>
26            <a>1</a>
27        </skyLightColor>
28        <giEnvironmentIntensity>0</giEnvironmentIntensity>
29    </EnvironmentSettings>
30    <FrameSettings>
31        <inputGamma>1</inputGamma>
32    </FrameSettings>
33    <GISettings>
34        <enableGI>true</enableGI>
35        <fgPreview>false</fgPreview>
36        <fgRays>1000</fgRays>
37        <fgContrastThreshold>0.05</fgContrastThreshold>
38        <fgGradientThreshold>0</fgGradientThreshold>
39        <fgCheckVisibility>true</fgCheckVisibility>
40        <fgInterpolationPoints>15</fgInterpolationPoints>
41        <fgDepth>1</fgDepth>
42        <primaryIntegrator>FinalGather</primaryIntegrator>
43        <primaryIntensity>1</primaryIntensity>
44        <primarySaturation>1</primarySaturation>
45        <secondaryIntegrator>None</secondaryIntegrator>
46        <secondaryIntensity>1</secondaryIntensity>
47        <secondarySaturation>1</secondarySaturation>
48        <fgAOInfluence>0</fgAOInfluence>
49        <fgAOMaxDistance>0.223798</fgAOMaxDistance>
50        <fgAOContrast>1</fgAOContrast>
51        <fgAOScale>2.0525</fgAOScale>
52    </GISettings>
```

FIG 8.24 The Custom Beast File Is in the XML Format and Can Be Used to Edit or Change Settings Not Available in the Lightmap Editor.

you can see an example from the Beast API manual that shows how the XML file can be changed to use IBL. The Beast API manual can be found on the Illuminate Labs Web site. However, during the writing of this book, Illuminate Labs was purchased by Autodesk, which means this information will be shifted toward the Autodesk site at some point.

Adjusting Lightmaps

Once the bake is completed, you can then further edit the maps in an image editor such as Photoshop to adjust exposure and color, as well as paint grime, to break up any repeating patterns in the level.

It's important to note that in the following sections, we'll be changing the lightmaps used in Unity iOS by Beast, which are found in the directory of the scene in a folder named the same as the scene. If you decide to bake the scene again,

```
<EnvironmentSettings>
    <!--The type of Environment. None, Skylight (constant color) or IBL
        (texture)-->
    <giEnvironment>SkyLight</giEnvironment>        Change to IBL
    <rtEnvironment>SkyLight</rtEnvironment>
    <!--A scale factor for the intensity, used for avoiding gamma
        correction errors and to scale HDR textures to something that fits
        your scene-->
    <giIntensity>1.0</giIntensity>
    <rtIntensity>1.0</rtIntensity>
    <!--A constant environment color. Used if type is Skylight-->
    <skyLightColor>
        <r>0.7</r>
        <g>0.7</g>
        <b>0.7</b>
        <a>1.0</a>
    </skyLightColor>
    <!--The image file to be used in hdr or OpenEXR format. The file should
        be long-lat. Used if type if IBL-->
    <iblImageFile>filename.exr</iblImageFile>
</EnvironmentSettings>
```

FIG 8.25 Here You Can See That You Can Replace "Skylight" to "IBL" in the giEnvironment Key within the Custom Beast XML File.

you will lose your edits, as Beast will overwrite the files. A good workflow is to place the grime or dirt on a separate layer in Photoshop so that if you do need to re-bake the scene, you can easily re-apply your dirt layer. The same goes for any color correction. It's a good idea to use Adjustment Layers in Photoshop with Levels or Exposure changes so that you can easily re-apply these effects again.

Color Grading Maps

The lightmaps created are in the EXR format, which is an HDR format. This is great because since these files contain HDR floating-point values, you can take these files into Photoshop and interactively adjust the lighting and color values to create different looks without re-baking the scene. This works because Beast bakes the lighting within a full 32-bit floating-point HDR pipeline as mentioned earlier in the chapter. With Beast, you can use push lighting values above white, i.e., a value of 1.0, which is referred to as "super-white." This means that when editing the file in a program that supports HDR, you can have access to all this lighting information when adjusting exposure and color. For example, to have access to super-white values in Photoshop, I cranked the intensity of the Directional Light to 2.0. This results to my scene being blown out as shown in Fig. 8.26.

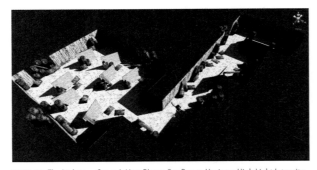

FIG 8.26 The Lightmap Scene Is Very Blown Out Due to Having a High Light Intensity.

Next, I opened the Far lightmap into Photoshop by simply double-clicking the file since I have the Image Application set to Photoshop in the Unity iOS preferences and tweaked the exposure, as well as increased the blue tone in the shadow areas.

In order to properly gauge your color grading, you'll need to adjust the Proof Setup in Photoshop. I mentioned earlier that Beast renders in floating-point linear space, which

means the files are at a gamma of 1.0. Files stored in linear space will look dark on your monitor, but in this case, we actually want to view the file in its default linear gamma of 1.0 in order to accurately set the exposure. To do this in Photoshop, go to View and make sure that Proof Colors is enabled. Then, go to View > Proof Setup and choose Monitor RGB as shown in Fig. 8.27. This will set the display to view the image in its default gamma, which will make any color correction or exposure changes done in Photoshop match how they'll look in Unity iOS.

Photoshop and 32-Bit HDR
Photoshop can work with 32-Bit HDR files, but most of the tools are not available in this mode. Some good tools to use in this mode are Levels, Exposure, and HDR Toning found under the Image > Adjustments menu.

FIG 8.27 We Need to Change the Proof Setup to Monitor RGB in Order to View the Image at Its Default Linear Gamma.

Since the EXR file contains HDR values I have access to the entire lighting range can lower the blown out areas of map. This gives me a lot of flexibility when editing the lightmap since I'm not locked to a limited range in lighting values as is found with typical 8-bit or low-dynamic range images. In Fig. 8.28, you can see that I used the HDR Toning tools to affect the overall look of the lightmap, which produces a more pleasing style to the game. Again, having the HDR values in the map allows me to make exposure changes in post instead of having to re-bake the lightmap repeatedly, as well as allows me to push and pull the lighting to create various looks. For instance, looking back at Fig. 8.28, you can see that I was able to introduce a little bit of a blooming effect by adjusting the lightmap.

Saving the EXR in Photoshop results in the file automatically being updated in Unity iOS. This is a great workflow for experimenting with different looks for the scene and in the visual effects world is referred to as color grading. In Fig. 8.29, you can see that by adjusting the exposure and color values,

FIG 8.28 The Exposure Was Adjusted in Photoshop Using the HDR Toning Tools.

FIG 8.29 Here You Can See the Difference That Color Grading Your Maps Can Have on the Style and Look of Your Levels.

I created a different look for my game as you can see in the comparison of the default-baked scene and the color-graded scene.

Adding Grime to Maps

The level looks great with the lightmaps applied; however, for a trash yard, the scene looks way to clean. We need to introduce some dirt and grime to the scene.

This is quite simple to do in Photoshop. First, I created a grime brush preset as shown in Fig. 8.30.

I then created a new layer and chose my preset brush, changed some settings in the brush editor so that I could stamp the grime down by simply left-clicking. I then began to stamp random dirt across the scene as shown in Fig. 8.31. It's important to be mindful of the seams as due to the nature of the lightmap UVs, there are lots of seams and careless painting can really reveal these seams as shown in Fig. 8.32.

FIG 8.30 I Took a Grime Map from My Texture Collection and Created a Brush Preset in Photoshop.

FIG 8.31 The Dirt Was Stamped Across the Scene and Was Placed on Its Own Layer.

FIG 8.32 By Painting Directly on the Seams, You Can See That the Seams Become Visible in the Lightmap.

Once the base layer of grime was laid down, I went back and then added a secondary layer to further hide the tiling effect of the dirt. In this second layer of dirt, I stayed completely away from the seams and used a combination of a smaller version of the grime brush and the eraser tool to create dirt accumulation around the edges of the walls and areas where the barrels were stacked in corners. In Fig. 8.33, you can see the secondary dirt layer.

FIG 8.33 The Secondary Dirt Layer Was Used to Create Accumulation in the Corners and at the Base of the Walls.

In Photoshop, you can then adjust the strength of the dirt by adjusting the opacity of the layer. Again, saving the file results in the lightmap automatically being updated in Unity iOS.

In Fig. 8.34, you can see a comparison between the default lightmap and the lightmap with dirt applied. Notice that the scene looks much better and more rich since the dirt layer provides a level of randomness and detail to the level, as well as match the overstyle of the level design being that of a trash yard.

FIG 8.34 Notice That the Dirt Layer Provides a Layer of Randomness and Detail, Thus Improving the Look and Style of the Level.

Summary

In this chapter, we discussed the usage of lightmaps not only to optimize your scene, but also to add a greater level of style and realism. The adoption of Beast has quickly become one of my favorite features in Unity iOS. Its quality and productive workflow is unparalleled, and in the spirit of being "Unity way," its full integration makes creating lightmaps a breeze and puts the creative power back into the hands of the artist.

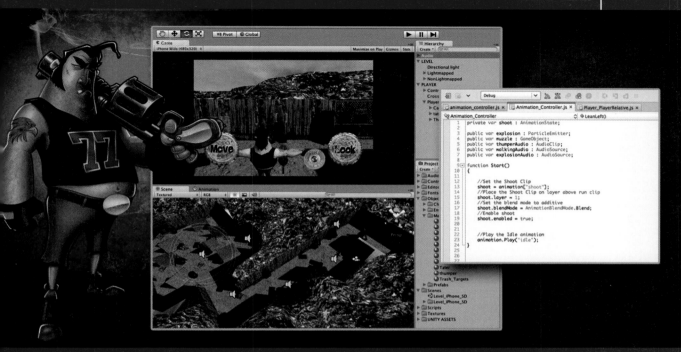

Working with Game Assets in Unity iOS

Throughout this book, we've been discussing creating game objects for a Unity iOS iPhone or iPad game using both modo and Blender. In this chapter, I'd like to discuss the Unity iOS component as it relates to art assets created in the previous chapters.

The goal of this chapter isn't about creating an entire game from start to finish. All of the previous chapters have paid close attention to how our game assets were built with the mindset of using Unity iOS to deploy them to Apple's iDevices. Now, we'll look at using Unity iOS in regards to how we can begin to integrate these assets into actual game components as well as further optimize them for the iPhone and iPad. We're going to discuss topics such as using Prefabs, texture compression, as well as iPhone- and iPad-optimized shaders. We're also going to revisit the usage of physics in your game by showing the usage of Unity's NVIDIA PhysX Engine as an alternative over the baked animation method discussed in Chapter 7. Finally, we'll look at publishing your game and the iPhone Player Settings as well as optimizing your game with the Internal Profiler.

Creating 3D Game Art for the iPhone with Unity. DOI: 10.1016/B978-0-240-81563-3.00009-7

Tater's Weapon Load Out
Go to the resource site to view the video walkthrough for this chapter.

Let's get started with taking a look at Prefabs and as always, be sure to drop in to Tater's Weapon Load Out to stock up on extra resources.

Prefabs

Prefabs allow you to create reusable game objects and are extremely useful when building complex objects in your scene. For instance, with the environment objects such as the barrels and boards, I created a prefab out of these items as shown in Fig. 9.1.

FIG 9.1 The Environment Props Were Created into a Prefab for Reuse Throughout the Level.

Creating Prefab for Environment Props

Since these objects were going to be duplicated and reused across the entire level, creating a Prefab for these objects makes a lot of sense. In the Prefab, I arranged the props in a predetermined setup. This setup allowed me to save time when duplicating the objects and arranging them in the scene as I only had to do some minor rotation and translation on the props to randomize their placement in the level. I also added the Colliders to the objects as shown in Fig. 9.2.

Target Prefab

I created a Prefab for the target object as well, since it will be reused throughout the level as well. In Fig. 9.3, you can see this Prefab. We'll talk more about the target object later in this chapter. This Prefab is more complex in that

FIG 9.2 Each Object Has a Box Collider Added to It so that the Character Won't Pass Through It in the Level.

FIG 9.3 The Target Object Was Also Created into a Prefab so that It's Complex Animation Could Be Easily Distributed Throughout the Level.

it contains Rigidbody objects, a Particle Emitter, and scripts for driving the particles and physics simulation. Being that the target object has a complex setup, creating a Prefab allows me to do this setup once, and then the Prefab can be arranged throughout the level with all of its functionality already worked out.

213

Camera Control Kit

The Third-Person Player controls, as shown in Fig. 9.4, are a modified Prefab that is available online at UnityPrefabs.com. UnityPrefabs is an excellent resource for purchasing high-quality game objects such as camera control kits, particle effects, and artificial intelligence. Setting up camera controls is a complex process, and for those, like me, who are more art oriented, being able to purchase a premade kit as shown in Fig. 9.5, with all the functionality needed for my game is a great time-saver. For instance, the Third-Person Camera Kit from UnityPrefabs.com, which was provided for the book by Efraim Meulenberg, quickly provided me with a ready-made control system that I could simply drop into my project.

The Prefabs can be easily modified with your own graphics to meet the style of your game. The Camera Control Kits work very well and contain advanced features such as the camera never going through walls and the character swaying left and right while strafing.

Probably the biggest challenge in game development isn't in creating content or programming, but in simply completing the game and getting it to market. Any headaches you can save yourself only help you to overcome that challenge, and UnityPrefabs.com is there to lend a helping hand.

> *Probably the biggest challenge in game development isn't in creating content or programming, but in simply completing the game and getting it to market.*

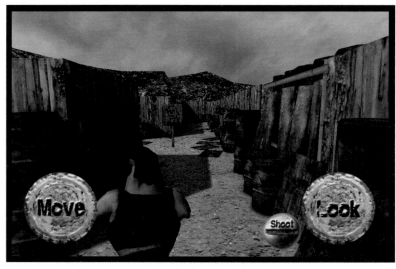

FIG 9.4 This Image Shows a Modified Version of the Third-Person Camera Control from UnityPrefabs.com.

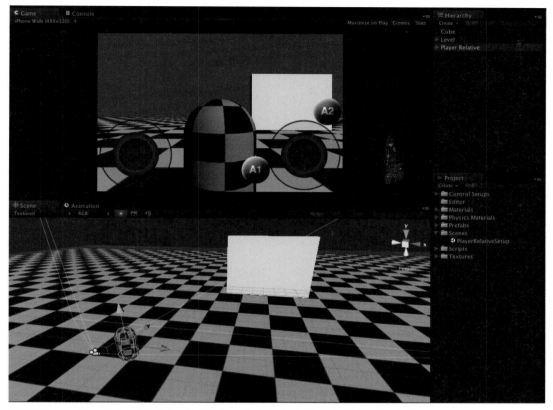

FIG 9.5 This Image Shows the Default Prefab from the Third-Person Controller for the iPhone Available on UnityPrefabs.com.

Setting up Colliders

In order to have your character react with the environment such as being able to move across the ground and stop when running into objects, you'll need to use Colliders.

Colliders can be very expensive on the iDevices and should be used with care. There are five types of Colliders you can use, and some are more expensive than others. In Fig. 9.6, you can see a diagram that shows each Collider type as they progress from cheap to expensive in terms of performance impact.

You can actually choose to have Unity iOS automatically create Colliders for you upon import by checking Generate Colliders in the Import Settings Dialog as shown in Fig. 9.7.

The Generate Colliders option will add a Mesh Collider to your object. The Mesh Collider builds a Collider based off the mesh it's applied to. It can

FIG 9.6 This Diagram Lists the Different Colliders in Order of the Least to Most Expensive.

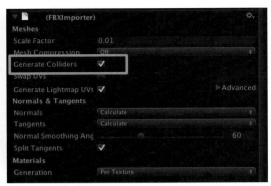

FIG 9.7 You Can Choose to Have Colliders Automatically Added to Your Meshes Upon Import.

be very accurate for collisions, but also very expensive depending on the mesh. In Fig. 9.8, you can see that a Mesh Collider is added to the level sections.

In my case, the Mesh Collider will work fine since the level sections are very basic with a lower poly count. However, on a more complex level model with a higher poly count, you'll want to use a more optimized Collider such as the Box Collider. Physics runs on the CPU so you'll need to use the Internal Profiler as we'll discuss later, to find possible bottlenecks and to see if the game is CPU bound, meaning expensive on the CPU. However, you can't just add a Box Collider to the section as it won't compensate for the ground and walls, but instead just make the entire section a Collider as shown in Fig. 9.9.

FIG 9.8 The Generate Colliders Option Will Add a Mesh Collider to Your Object.

Instead, in your 3D program, you can create a collision object that fits the area your level occupies, but it is much lower in resolution in which you can then safely apply the Mesh Collider. Again, this wasn't needed in my case, so we'll take a look at one of the Penelope tutorial assets that is available in the Resources section at Unity3d. com. In Fig. 9.10, you can see that the level mesh for the Penelope game is more complex and just using a Mesh Collider on this geometry could cause an unnecessary performance hit. Instead, a lower resolution collision object was created in order to optimize the performance of the Mesh Collider.

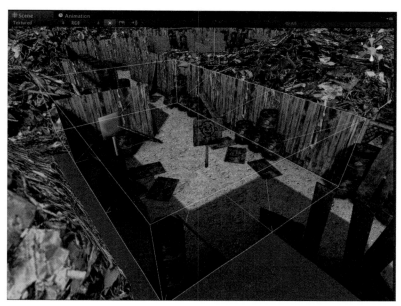

FIG 9.9 The Box Collider Is Covering the Entire Mesh Like a Bounding Box and Won't Work as an Effective Collider.

FIG 9.10 The Highlighted Mesh Above the Actual Level Is the Collider Object. Notice Its Much Simpler Than the Actual Level Mesh.

Texture Compression

In Chapter 3, we discussed texture size and format. You can actually compress textures and change their size within Unity iOS. In Fig. 9.11, you can see by checking Override for iPhone, you can then have access to setting the maximum size as well as the format for the texture. The size you choose for your textures depends on your game as well as the device the game is running on. For instance, you'll need to use higher resolution textures such as 1024 × 1024 for the iPad and iPhone 4. However, this is over-kill on the 3GS since its screen resolution isn't high enough to really showcase these higher resolution textures and thus would be a waste of system resources. In Chapter 3, we also discussed the importance of creating textures that are a Power of 2 (POT). Nonpower of 2 textures (NPOT) doesn't fit in the iPhone memory. It's important to note that the rule of thumb is to create square POT textures, i.e., 1024 × 1024 or 512 × 512 as nonsquare POT textures may end up not getting compressed, i.e., 1024 × 512 or 256 × 128.

You should monitor your texture sizes in the inspector and verify that you're using PVRTC4 or PVRTC2 compression. Now, there are always exceptions to rule, say for example if you want to create some high-quality icons for your game's UI, you could use RGB16 compression.

Mip maps

Mip maps, which can be set on the Texture Importer by checking Generate Mip Maps as shown in Fig. 9.12, are a series of progressively smaller versions

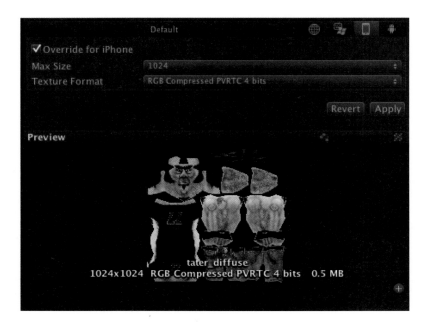

FIG 9.11 You Can Set the Texture Size as well as Format In the Texture Importer Dialog.

FIG 9.12 You Can Enable Mip Maps for a Texture in the Texture Importer Dialog.

of the image used to optimize performance. They can be extremely vital on the iPhone and iPad. Using Mip maps uses more memory, but not using them can cause major performance loss.

However, Mip maps can make your scene textures look blurry. To compensate for this, I typically set the Mip Map Filtering to Kaiser, which in my opinion tends to lessen this blur as shown in Fig. 9.13.

FIG 9.13 Here You Can See the Difference between Kaiser and Box Mip Map Filtering. Box Filtering Is Much More Blurry than Kaiser.

Mip maps are designed to optimized textures that can appear very small on screen as they are pushed into the distance in 3D space. However, as discussed in Chapter 4 in the "Building on the Grid" section, we can manually create this effect ensuring the meshes are using only a specific and proportional section of the texture atlas to mesh size, which directly relates as a one-to-one relationship between the meshes size in units and the texture size in pixels. This means that the textures will never be too small in the scene, and thus, we don't need to worry about using Mip maps. Profiling your game will ensure it's optimized correctly.

Optimized Shaders

It's very important to make sure that you're using shaders that are optimized for the iPhone and iPad devices. Unity iOS ships with several useful iPhone compatible shaders as shown in Fig. 9.14.

I highly suggest that you use these shaders as much as possible. Using the wrong shader can cause your game's performance to drop dramatically. There

FIG 9.14 Here You Can See the iPhone-Specific Shaders.

are two categories in terms of shader optimization, which are Pixel-Lit and Vertex-Lit.

Pixel-Lit shaders are much more expensive than Vertex-Lit shaders. Pixel-Lit shaders cause objects to be drawn multiple times depending on the number of Pixel Lights shining on the object since they calculate lighting at each pixel. This not only increases the load on the CPU to process and send commands to the GPU, but the GPU will also have to process the vertices and draw the pixels on screen.

Vertex-Lit shaders calculate light based off the mesh vertices using all of lights at one time, which means the mesh will only need to be drawn once.

It's important that you don't use any Pixel-Lit shaders in your scenes for the iPhone and iPad. To be safe, stick with the iPhone Shaders provided by Unity iOS unless you have a specific reason for using a different or custom shader. For example, when setting up Beast for my level material, I had accidently set it to use the Diffuse shader, which is a Pixel-Lit shader. When profiling my game, I realized that all of a sudden, my frame rate had dropped down 6 FPS. After digging around a bit, I realized my mistake. I then switched the level material to use the Diffuse Fast shader, which is a Vertex-Lit shader as shown in Fig. 9.15.

Shaders can have a dramatic impact on your game. It's important to be sure that you're strictly using Vertex-Lit shaders and that your shaders aren't performing any multipass operations, as this will cause your object to be drawn more than once and also impact performance on the iPhone and iPad.

FIG 9.15 For My Level Material, I Used the Diffuse Fast Shader Because It's a Vertex-Lit Shader.

Using Physics in Unity iOS

In Chapter 7, we discussed a method for baking a dynamics simulation in Blender. As I mentioned, that method can be more expensive on the GPU. Typically, with the newer iDevices such as the 3GS, iPhone 4, and iPad, the CPU is quite fast and the bottleneck for performance can fall to the GPU side with the higher resolution devices such as the iPhone 4 and iPad as we discussed in Chapter 1. If your game is already heavy on the rendering side, meaning it's already using up a lot of the GPU resources, it might make more sense in terms of performance to use Unity's NVIDIA PhysX Engine. This would shift the workload over to the more capable CPU rather than the GPU and can be an alternative to the baked animation method discussed in Chapter 7. Also,

as you will see, this method is much less complicated and quicker to setup within Unity iOS. Whether, you choose to use baked animation versus physics simulation all depends on your game content and the type of game you're creating. That's why it's good to have different options on how certain aspects, such as physics, will affect potential bottleneck areas in your game. The best way to gauge your game's performance is by using the Internal Profiler, as we'll discuss later.

The best way to gauge your game's performance is by using the Internal Profiler.

In the case of the book's demo app, I found through profiling my game using the Internal Profiler in Xcode that using baked animation ended up being the better route to take in terms of performance and maintaining my desired frame rate across the 3GS, iPhone 4, and iPad. In Fig. 9.16, you can see the results from the Internal Profiler as they pertain to the physics animation. Notice that the frametime variable increases on each device, which indicates a drop in frame rate. Also, notice that I've highlighted the physx variable as it indicates and increased time in physics calculation. The physx time in this image isn't an indication performance between the three devices, but is just a snapshot in time as the Internal Profiler display information every 30 frames.

I found that the iPhone 4 gave the best performance overall. When using the Internal Profiler to gauge performance between the baked

FIG 9.16 This Image Shows the Average Increased Frametime Values on Each Device Where Physics Was Used as well as the Physx Usage Variable.

iPhone 4

```
iPhone Unity internal profiler stats:
cpu-player>      min: 10.6    max: 194.8    avg: 19.4
cpu-ogles-drv> min:  1.7    max:   3.2    avg:  2.0
cpu-present>    min:  0.7    max:   2.6    avg:  1.2
frametime>      min: 32.6    max: 201.8    avg: 39.2
draw-call #>    min:  39    max:   45     avg:  40    | batched:   167
tris #>         min: 26384    max: 54485    avg: 28664   | batched: 16893
verts #>        min: 11712    max: 114364    avg: 40512   | batched:  9604
player-detail> physx:  1.9  animation:  0.3  culling  0.0  skinning:   1.0  batching:   0.2  render:   8.9  fixed-update-count: 1 .. 10
mono-scripts>   update:  5.5    fixedUpdate:  0.1  coroutines:  0.0
mono-memory>    used heap: 245760 allocated heap: 356352  max number of collections: 0 collection total duration:  0.0
```

iPad

```
iPhone Unity internal profiler stats:
cpu-player>      min: 13.4    max: 250.3    avg: 25.2
cpu-ogles-drv> min:  1.2    max:   3.0    avg:  1.6
cpu-present>    min:  0.5    max:   1.4    avg:  0.0
frametime>      min: 33.2    max: 256.3    avg: 41.1
draw-call #>    min:  30    max:   42     avg:  38    | batched:   130
tris #>         min: 20878    max: 23047    avg: 22132   | batched: 13165
verts #>        min:  8781    max: 82736    avg: 49451   | batched:  7490
player-detail> physx:  2.4  animation:  0.3  culling  0.0  skinning:   0.9  batching:   0.1  render:  12.6  fixed-update-count: 1 .. 13
mono-scripts>   update:  8.4    fixedUpdate:  0.2  coroutines:  0.0
mono-memory>    used heap: 266240 allocated heap: 266240  max number of collections: 0 collection total duration:  0.0
```

iPhone 3GS / Touch 3rd Gen

```
iPhone Unity internal profiler stats:
cpu-player>      min: 14.9    max: 309.8    avg: 28.7
cpu-ogles-drv> min:  2.9    max:   6.4    avg:  3.5
cpu-present>    min:  0.8    max:   2.0    avg:  1.0
frametime>      min: 33.2    max: 322.4    avg: 43.9
draw-call #>    min:  52    max:   52     avg:  52    | batched:   143
tris #>         min: 26901    max: 29835    avg: 27454   | batched: 15256
verts #>        min: 201313    max: 230473    avg: 203257   | batched:  8635
player-detail> physx:  2.6  animation:  0.4  culling  0.0  skinning:   1.3  batching:   0.2  render:  13.0  fixed-update-count: 1 .. 16
mono-scripts>   update: 10.5    fixedUpdate:  0.2  coroutines:  0.0
mono-memory>    used heap: 258048 allocated heap: 266240  max number of collections: 0 collection total duration:  0.0
```

animation, discussed in Chapter 7, and using physics in Unity iOS, the iPhone 4 and iPad didn't take a hit in frame rate at all (33.4 ms or 30 FPS) when using the baked animation method. The 3GS took a small hit from 33.4 ms (30 FPS) to 33.9 ms (29 FPS). When using the physics simulation, the iPhone 4 jumped to 39.2 ms (25 FPS), iPad to 41.1 ms (24 FPS), and the 3GS to 43.9 ms (22 FPS).

In my case, these drops in frame rate didn't cause a significant difference in game play; however, frame rate is something you'll always need to keep an eye on, and using the Internal Profiler is the best way to gauge performance. Let's now take a look at setting up the target explosion in Unity iOS.

Setting up the Target Object

To showcase the physics method in Unity iOS, we'll use the target game object from Chapter 7. In order to create the explosion effect, we'll need to add some Rigidbody and Collider Components to our target. Just as we discussed in Chapter 7, the target is made up of nine mesh items that we'll use to explode into pieces. Each mesh item has a Rigidbody and Box Collider Component added to it as shown in Fig. 9.17.

Now, with each mesh item representing a piece that will explode has its own Collider and this could be part of the issue causing the frame rate to dip. As we discussed earlier, Colliders can be very expensive on the iPhone and

FIG 9.17 Each Mesh Piece that Makes Up the Target Object Has a Rigidbody and Box Collider Component.

should be used with care. For each piece of the target, we are using the Box Collider, which is one of the least expensive Colliders.

Next, we'll add a Box Game Object, which will be used to test for collision when Tater shoots the target and is called "HitTest." This object will also have a Box Collider and will have its Mesh Renderer disabled so that it won't render and thus won't issue a draw call. In Fig. 9.18, you can see this object with its Mesh Renderer disabled.

I've also set a new Tag for this object called "Target." This Tag will be used to check the collision object that is encountered by the Raycast that is issued when Tater shoots. In Fig. 9.19, you can see that Tag Manager to add the new Tag.

FIG 9.18 The Mesh Renderer Is Disabled, so the Cube Won't Render and Thus Add to the Draw Count.

FIG 9.19 The Object Has Been Given a Specific Tag, Which Can Be Used to ID the Object in the Script.

Finally, we'll add a script for adding an explosion force. Luckily, as you'll see, this functionality is part of Unity's Rigidbody Class as shown in Fig. 9.20.

In Fig. 9.21, you can see that the explosion script is added at the root of the target object.

In Fig. 9.22, you can see that I've highlighted some key areas of the script. First, in the Awake function, we loop through the child objects and set their Rigidbody Components to Sleep Mode. Sleeping is an optimization that allows the Physics Engine to stop processing those Rigidbodies. Sleeping happens automatically when a Rigidbody comes to rest. In our case, we'll use it to stop the Rigidbodies from immediately falling to the ground due to gravity when the game starts.

Next, we have an Explode function that is called when the Ray shot from the Raycast collides with the HitTest object as mentioned earlier. The Explode function contains the call to the Add Explosion Force Function, which as we discussed is a part of the Rigidbody Class and actually explodes the pieces of the target. From there, the Physics Engine takes care of the rest.

Rigidbody.AddExplosionForce

function **AddExplosionForce** (**explosionForce** : float, **explosionPosition** : Vector3, **explosionRadius** : float, **upwardsModifier** : float = 0.0F, **mode** : ForceMode = ForceMode.Force) : void

Description
Applies a force to the rigidbody that simulates explosion effects. The explosion force will fall off linearly with distance to the rigidbody.

FIG 9.20 The Rigidbody Class Has a Specific Function for Creating an Explosion Effect.

FIG 9.21 The Explosion Script is Added at the Root of the Target Game Object.

```
Explosion                                          Awake()
1    //Public Vars
2    public var radius : float = 5.0;
3    public var power :float = 10.0;
4    public var upModifier :float = 1.0;
5    public var pEmitter : ParticleEmitter;
6    //Private Vars
7    private var colliders : Collider[];
8    private var explosionPos : Vector3;
9
10
11   function Awake(){
12       explosionPos  = transform.position;
13       colliders  = Physics.OverlapSphere (explosionPos, radius);
14           //Set RigidBodies to Sleep
15       for (var child : Transform in transform) {
16           if(child.rigidbody != null){
17             child.rigidbody.Sleep();
18           }
19
20       }
21   }
22
23   //blow up target
24   function explode () {
25       for (var hit : Collider in colliders) {
26           if (!hit){
27               continue;
28           }
29
30           if (hit.rigidbody){
31             hit.rigidbody.AddExplosionForce(power, explosionPos, radius, upModifier);
32             //activate particles
33             pEmitter.emit = true;
34           }
35       }
36   }
~
~
~
```

FIG 9.22 These Highlighted Areas Show the Key Areas of the Script for Creating the Explosion.

Adding Particles

If we're exploding the target from a gun blast, then we'll have to have some fire and smoke, and Unity's Particle System will be perfect to create this effect as shown in Fig. 9.23.

I simply used the explosion particle Prefab that I got from the Desktop version of Unity iOS and tweaked it to the desired settings and positioned the Emitter at the center of the target. Next, I disabled the Emit parameter and activated One Shot so that particles would only emit once on the Emitter as shown in Fig. 9.24.

FIG 9.23 Unity's Particle System Is Great for Creating Fire and Smoke for Our Explosion Effect.

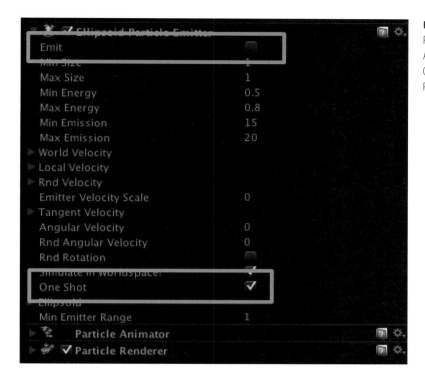

FIG 9.24 By Disabling the Emit Parameter the Emitter Won't Automatically Generate Particles. The One Shot Parameter Will Only Emit the Particles Once.

Finally, in the Explosion Script, the Particle Emitter's Emit parameter is activated when the Add Explosion Force is called as shown in Fig. 9.25. Also, notice that the script references the Particle Emitter as a public variable, which is set in the Unity iOS Editor.

FIG 9.25 The Explosion Script References the Particle Emitter and Then Sets the Emit Parameter to True When the Collision Happens, i.e., the Target Is Shot.

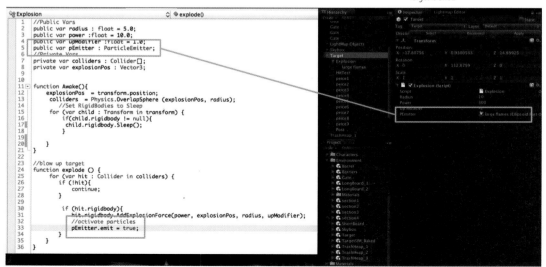

Now that the target is completed, I can create a Prefab of this object so that I can quickly place targets in the level with all the functionality already in place.

Optimizing Physics Using the Time Manager

Earlier, we talked about the physics causing the frame rate to drop. There are additional optimizations that can be down with physics. Rendering happens as fast as it can, and the rendering loop takes place all of the time. Physics need to be constant, so a separate loop runs at constant speed and is calculated independently of the game's frame rate. Using the Time Manager, you can adjust the Fixed Timestep and Maximum Allowed Timestep as shown in Fig. 9.26.

FIG 9.26 The Time Manager Allows You to Set the Fixed Timestep and Maximum Allowed Timestep for Optimizing Physics Calculations.

Essentially, the smaller the Fixed Timestep, expressed in milliseconds, the more accurate the physics will be but at a heavier cost to the CPU. The Maximum Allowed Timestep value, also specified in milliseconds, says that physics calculations won't run longer than the entered value. Basically, if you're frame rate drops below this threshold, the physics will slow down in order to let the CPU catch up. Both these values can be used to stop your physics from dropping the frame rate too much, but at the cost of the quality of the physics simulation.

Publishing Your Game

In this section, I want to take a look at the Player Settings for deploying your game in terms of creating Universal Builds. We'll then move on to optimizing your game. Over these next two sections, we'll focus mainly on the Basic License version of Unity iOS as it's an affordable option for getting into game development. The Advanced License gives you a bit more control such as being able to optimize the Player Size as well as using Umbra Occlusion Culling.

Player Settings

There are several important settings in the Player Settings. In Fig. 9.27, you can see the Player Settings. The Player Settings is where you set your Bundle Identifier, SDK version, Target iOS Version as well as application icons, splash images, and the default orientation.

FIG 9.27 The Player Settings Allow You to Set Settings Such As Resolution, SDK Version, as well as Icon and Splash Screen Images.

In the next sections, we're going to look at setting up our game so that it will run on both the iPad and iPhone in what is referred to as a Universal Application by setting the Configuration and Optimization settings.

Universal Builds

If you are deploying only to the iPad or building a Universal app, you'll need to be sure to support at least two of the four possible orientations on the iPad. For example, the book's demo app supports both Landscape Left and Landscape Right on the iPad and only Landscape Left on the iPhone. In the Configuration section of the Player Settings, we'll need set the Target Device to iPhone + iPad. We'll also set the Target Resolution to Native so the resolution will be set to play as high as the device can handle.

In the Optimization section, we'll set the SDK Version to iPhone OS 4.0 and the Target iOS Version to iPhone OS 3.3.1. The Target iOS setting will allow us to build for the iPad and any devices not running iOS 4. You can see these setting in Fig. 9.28.

FIG 9.28 The Target iOS Is the Minimum OS Required to Run Your Application.

Some developers on the Unity iPhone forums have had issues with app approval when the splash screen didn't start up in the default orientation the device is being held. You can read more about this issue by searching "iPad Rotation" on the Unity iOS iPhone forums. However, we'll take a look at the fix here.

We need to make sure the splash or launch screen starts in the correct orientation the device is being held in the event the app is run on an iPad. We'll accomplish this by editing the info.plist file in Xcode. In Xcode, simply right-click the info.plist file and choose Open As > Source Code File. You then need to add a new key, UISupportedInterfaceOrientations, and enter the supported orientations in your game. In Fig. 9.29, you can see that I have added support for the LandscapeLeft and LandscapeRight orientations.

Finally, you need to write code that will support and rotate the screen to adhere to the orientations your game supports. In Fig. 9.30, you can see a simple script for supporting different resolutions. The script only rotates the screen if the device running the game is the iPad, otherwise

```
1    <?xml version="1.0" encoding="UTF-8"?>
2    <!DOCTYPE plist PUBLIC "-//Apple//DTD PLIST 1.0//EN" "http://www.apple.com/DTDs/PropertyList-1.0.dtd">
3    <plist version="1.0">
4    <dict>
5        <key>CFBundleDevelopmentRegion</key>
6        <string>en</string>
7        <key>CFBundleExecutable</key>
8        <string>${EXECUTABLE_NAME}</string>
9        <key>CFBundleIconFile</key>
10       <string>Icon.png</string>
11       <key>CFBundleIdentifier</key>
12       <string>com.the3dninja.${PRODUCT_NAME:identifier}</string>
13       <key>CFBundleInfoDictionaryVersion</key>
14       <string>6.0</string>
15       <key>CFBundleName</key>
16       <string>${PRODUCT_NAME}</string>
17       <key>CFBundlePackageType</key>
18       <string>APPL</string>
19       <key>LSRequiresIPhoneOS</key>
20       <true/>
21       <key>CFBundleVersion</key>
22       <string>1.0.0</string>
23       <key>CFBundleDisplayName</key>
24       <string>GameArtBook</string>
25       <key>CFBundleIconFiles</key>
26       <array>
27           <string>Icon.png</string>
28           <string>Icon-iPad.png</string>
29       </array>
30       <key>UIInterfaceOrientation</key>
31       <string>UIInterfaceOrientationLandscapeLeft</string>
32       <key>UISupportedInterfaceOrientations</key>
33       <array>
34           <string>UIInterfaceOrientationLandscapeLeft</string>
35           <string>UIInterfaceOrientationLandscapeRight</string>
36       </array>
37       <key>UIPrerenderedIcon</key>
38       <true/>
39       <key>UIRequiresPersistentWiFi</key>
40       <false/>
41       <key>UIStatusBarHidden</key>
42       <true/>
43       <key>UIStatusBarStyle</key>
44       <string>UIStatusBarStyleDefault</string>
45   </dict>
46   </plist>
47
```

FIG 9.29 You Can Set the Splash Screen to Start at the Correct Orientation in the info.plist file.

```
1    //Run first at very beginning of game initialization
2    function Awake(){
3        //Set screen orientation to match Player Settings Preference
4        iPhoneSettings.screenOrientation = iPhoneScreenOrientation.LandscapeLeft;
5    }
6
7
8    function Update(){
9        //Support 2 orientations LandscapeLeft and Right if device is iPad
10       if(iPhoneSettings.model == "iPad"){
11       //Check to see if orientation has changed and rotate screen. LandscapeLeft and LandscapeRight are supported here
12           if ((iPhoneInput.orientation == iPhoneOrientation.LandscapeLeft) && (iPhoneSettings.screenOrientation != iPhoneScreenOrientation.LandscapeLeft)){
13               iPhoneSettings.screenOrientation = iPhoneScreenOrientation.LandscapeLeft;
14
15           }
16           if ((iPhoneInput.orientation == iPhoneOrientation.LandscapeRight) && (iPhoneSettings.screenOrientation != iPhoneScreenOrientation.LandscapeRight)){
17               iPhoneSettings.screenOrientation = iPhoneScreenOrientation.LandscapeRight;
18
19           }
20       }else{
21           iPhoneSettings.screenOrientation = iPhoneScreenOrientation.LandscapeLeft;
22       }
23
24       //Disable Keyboard rotion to remove outer window frame rotation - re-enable if keyboard needed
25       iPhoneKeyboard.autorotateToLandscapeRight = false;
26       iPhoneKeyboard.autorotateToPortrait = false;
27       iPhoneKeyboard.autorotateToLandscapeLeft = false;
28       iPhoneKeyboard.autorotateToPortraitUpsideDown = false;
29   }
30
31
```

FIG 9.30 Here You Can See a Simple Script for Supporting Screen Rotation.

no screen rotation takes place. The iPhone keyboard is set to not rotate as well since by having this activated will cause the screen to appear to rotate with a black mask, but the display doesn't actually rotate. If you need the keyboard for any reason, you can simply enable it for use then disable when it's not in use.

Optimizing Your Game

In this section, we'll look at some additional ways that we can further optimize our game by editing the generated Xcode project that Unity iOS creates when you build your application.

Tuning Main Loop Performance

You can set how many times your game will execute its rendering loop. By default, it's set and capped at 30 FPS. You can change this value to render at different frame rates such as 60 FPS. However, if you increase the value, rendering will be prioritized over other activities such as accelerometer processing and touch input. Performance always comes as a give and take, so you'll have to experiment with this value to see what works best for your game.

In order to change the frame rate, you select the AppController.mm file and change the "#define kFPS" value to new frame rate such as 60.0 as shown in Fig. 9.31.

Tuning Accelerometer Processing Frequency

If your game uses a lot of accelerometer input, this could have a negative impact on the overall performance. By default, Unity iOS will query the accelerometer input 60 times per second. You may be able to gain some extra

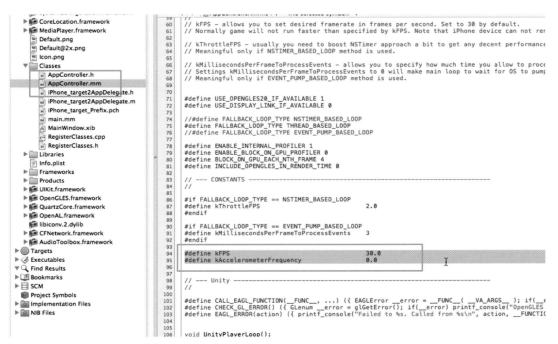

FIG 9.31 The #define kFPS Variable Will Allow You to Set the Desired Frame Rate.

performance by setting the accelerometer frequency to 0 if your game isn't using the accelerometer. You can also see in Fig. 9.31 the accelerometer frequency being disabled by changing "#define kAccelermoeterFrequency" in the AppController.mm file to 0.0.

Internal Profiler

The Internal Profiler is the most useful tool you have in testing the performance of your game. In order to use the profiler, you'll need to set "#define ENABLE_INTERNAL_PROFILER" to 1 in the AppController.mm file. When you run your game from the Debugger Console, Unity iOS will display vital information about your game every 30 frames. In Fig. 9.32, you can see the Debugger Console and the information that Unity iOS is displaying about your game.

It's important to note that all values you see from the Internal Profiler are measured in milliseconds per frame, and you can see the minimum, maximum, and average times over the last 30 frames.

There are several key values in the Internal Profiler that display vital information about your game, and the Unity iOS manual explains each on in-depth, so I don't want to just rehash the manual. Instead, I'll discuss the key statistics I look at when profiling my game.

The most important value is the "frametime" statistic as it tells you what frame rate your game is running at. Remember, these values are in milliseconds, so in Fig. 9.32, you can see my game is running on average 33.5 ms or 29.8 FPS (1000/33.5). As you play through your game, you can watch the "frametime" to see drops in frame rate. When you see drops in frame rate, you can then check other values in the profiler for clues on what could be causing the drop. For instance, you might check the "draw-call" value to see if too many objects are choking your game. If you think you have some complex scripts, you can check the "cpu-player" to see how long it's taking scripts to be executed on the CPU. The "player-detail" information breaks down what's taking place in the engine. Here you can check the "render" value to see how long your game is spent rendering. If this value is too high, then you know that you have too many objects rendering and need to reduce object count, increase batching or use occlusion. If you see "physx" showing a high value, then you need to optimize your physics simulation as we discussed

```
-----------------------------------------------------------------------
iPhone Unity internal profiler stats:
cpu-player>     min: 12.9    max: 15.0    avg: 13.8
cpu-ogles-drv>  min:  1.9    max:  2.9    avg:  2.0
cpu-present>    min:  1.0    max:  3.1    avg:  1.3
frametime>      min: 31.6    max: 35.3    avg: 33.5
draw-call #>    min: 41      max: 41      avg: 41      | batched:   243
tris #>         min: 32606   max: 32944   avg: 32700   | batched: 23488
verts #>        min: 30267   max: 30267   avg: 30267   | batched: 13407
player-detail>  physx:  0.8 animation:  0.2 culling 0.0 skinning:  1.0 batching:  0.3 render: 10.5 fixed-update-count: 1 .. 2
mono-scripts>   update:  0.4   fixedUpdate:  0.1 coroutines:  0.0
mono-memory>    used heap: 192512 allocated heap: 196608  max number of collections: 0 collection total duration:  0.0
-----------------------------------------------------------------------
```

FIG 9.32 The Internal Profiler Shows Vital Statistics about the Performance of Your Game.

earlier. The "animation" value indicates how much time is spent animating bones, and "skinning" shows applying animations to skinned meshes. If you see these values increasing, you can then optimize the quality on the Skinned Mesh Renderer Component as we discussed in Chapter 5 in the "Optimized Skinning Paths" section. The "batching" value shows time spent batching geometry, and it's important to note that Dynamic Batching is more expensive than Static.

The "mono-scripts" value tells you how much time is spent executing your Update and FixedUpdate functions as well as coroutines. Finally, the "mono-memory" information lets you know how much memory the Mono Garbage Collector uses. You can watch these values to get an idea how your memory is being allocated and how many times the Garbage Collector is running. If the Garbage Collector runs in the middle of game play, you'll more than likely see a stutter or drop in frame rate.

In this section, I've referred to the values in the Internal Profiler being too high. You might be asking, "How high is too high?" We'll, there's not an absolute answer to that question as it totally depends on your game. What I do is watch the "frametime," and when it drops, I then use the other information from the profiler to give me clues as to what's causing the drop. It's not a matter of knowing the right values, but knowing what the information needs so that you can use it to learn about how your game's performance is holding up. I can't stress enough how important it is to profile your game at all stages of development, and the Internal Profiler is a great tool for the job.

Summary

In this chapter, we discussed working with game assets in Unity iOS in terms of creating prefabs, using optimized shaders, working with collision objects, and using Unity's Physics Engine. We also looked at creating Universal Applications as well as editing the Xcode project to further optimize our game.

Unity iOS provides a unique experience for creating games on Apple's iDevices, and as an 3D artist, I can say that it brings the complex world of game development to a level that I can understand and easily work with. Well, this may be the end of the last chapter, but there's still much more to learn. Be sure to visit "Tater's Weapon Load Out" at the book's resource site to view the in-depth video walkthroughs for the topics covered in this chapter such as using the Internal Profiler, as well as throughout the book. See you there!

Bonus Resources

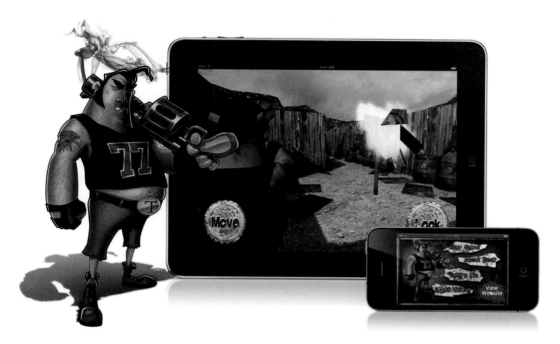

This book has a companion Web site where you can find useful resources such as video walkthroughs that will further illustrate the topics covered. These videos will further expand on the topics discussed in each chapter and provide a different perspective than can be covered on the printed page.

You can get to the book's resources by visiting http://wesmcdermott.com and clicking the "Creating 3D Game Art for the iPhone Book Site" link. From the book's official web site, click the "Tater's Weapon Load out" link. The login information is listed below.

Username: tater

Password: thumpNoggins

Also, be sure to check out the book's iPhone/iPad app, "Tater!" The app serves as a creative demo, running the content discussed throughout the book on the actual iDevices. With "Tater," you can run through Tater's Training Trash Yard shooting targets which provides practice in the art of "Thump'n Noggins!" The app showcases all of the game assets and animations discussed in the book. You can find more information on how to get the "Tater" app on the book's official Web site.

Creating 3D Game Art for the iPhone with Unity. DOI: 10.1016/B978-0-240-81563-3.00022-X

From wesmcdermott.com, Click the "Creating 3D Game Art for the iPhone Book Site" Link to Enter the Book's Official Web Site.

From the Book's Official Web Site, Click the "Tater's Weapon Load Out" Link to Get Access to the Book's Resources.

Creating Tater's Training Trash Yard

In this section of the book, we are going to take a look at the creation of "Tater's Training Trash Yard," the book's companion app. We are going to take a "scrap book" approach by exploring some key elements across several images. On the book's resource site, you will find actual video walk-throughs that explain the process in-depth. Before we get to the actual app, let us first take a look at the evolution of a hero.

Evolution of a Hero

In this section, we will take a look at the creative process of creating Tater throughout his design process. I mentioned in the book, that Warner McGee illustrated Tater. I knew early on that I would need an illustrator to create Tater, and I my first thought was to immediately contact Warner McGee. It was awesome to work with him on this project. I gave Warner some early rough sketches of my idea for Tater, and he began to work his magic from there. He would then send me proofs, and I would then make changes and suggestions as we worked to refine Tater to a final drawing that would match my overall idea for the character. Warner and I had a lot of fun developing Tater. We had a lot of creative discussions, and it was really cool to see an idea come to life. Early on, Tater did not have a name, so Warner and I referred to him as Bob.

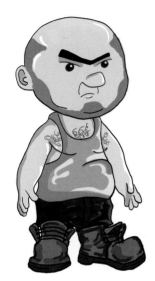

FIG A.1 This is a very early concept of Tater that I sent to Warner.

FIG A.2 This sketch shows some early ideas I was working out. I also sent this to Warner. So he would have some base ideas of what I wanted for Tater.

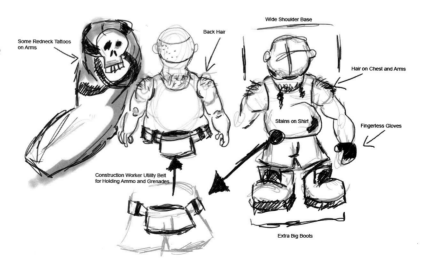

Creating 3D Game Art for the iPhone with Unity. DOI: 10.1016/B978-0-240-81563-3.00025-5

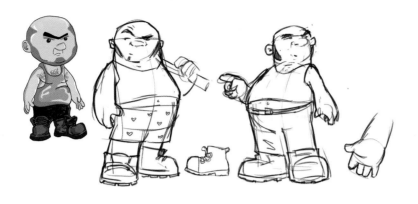

FIG A.3 Here, you can see early concepts that Warner worked up from my original sketch. This was in the "Bob" stage.

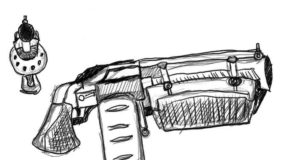

FIG A.4 Here is a concept sketch I gave to Warner with a rough idea of Thumper.

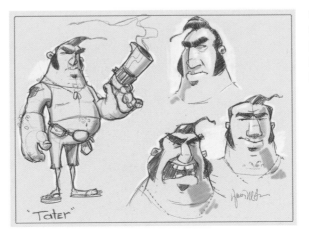

"Tater"

FIG A.5 At this point, Bob has transformed into Tater. Here are some character sketches that Warner produced. You can really see that Tater is beginning to take shape.

FIG A.6 Here is a color scheme for Tater that I gave to Warner. The "77" on the jersey is my birth year.

FIG A.7 Warner sent me the character turns that I could use as backdrop items in modo for modeling.

"Tater"

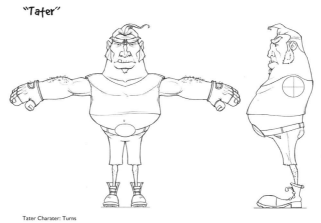

Tater Charater: Turns

FIG A.8 Here, we began to work on the cover. Since I am not an illustrator, it was easier for me to take some photos of myself in the poses I was wanting for Tater. You can see here that the middle photo is what we used.

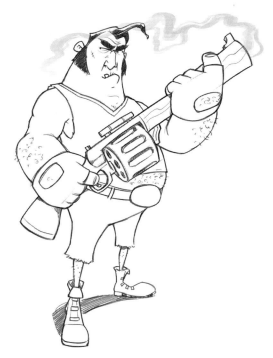

FIG A.9 Here is a preliminary sketch for the key pose. You can see that we were still working on designing Thumper.

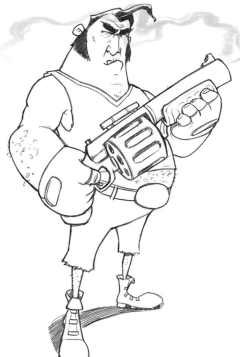

FIG A.10 This image shows some Thumper refinements.

FIG A.11 This image shows the key pose and the refined Thumper design.

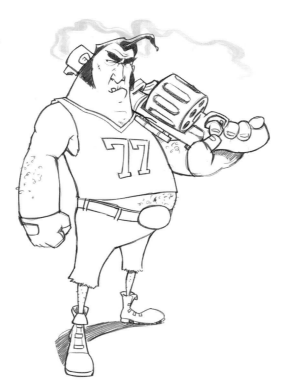

FIG A.12 Here is the final illustration that Warner created.

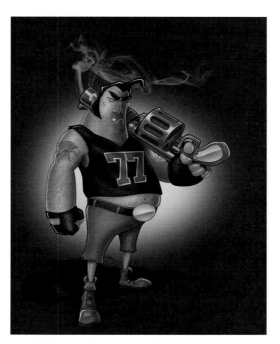

Developing the Menu

In this section, you can see the menu screens that were developed for the game. Tater is a character from my personal game project called "Dead Bang." The Dead Bang world is grungy, so I wanted to bring this style into the look of the book's companion app. To create the actual in-game

FIG A.13 This is an early version of the menu system. Most of the elements are there, but at this point, I was still exploring the overall style.

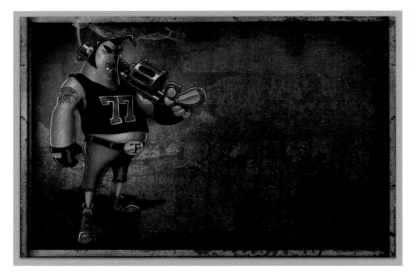

FIG A.14 This is the final background for the menu system. It is important to always explore your concepts and designs thoroughly.

menu system, I used EZ GUI from Above and Beyond Software, which can be found at http://www.anbsoft.com/middleware/ezgui/. EZ GUI is a great system for developing GUI elements and menus for your game, as it allows you to lower the draw calls for your GUI elements by utilizing texture atlases and shared materials. I also heavily relied on iTween, which was created by Bob Berkebile. The iTween library is a rich animation system that can be used to create various animation effects ranging anywhere from the simple to complex. It is a great time saver, and it was used to animate the buttons in my menu. You can find more info on iTween at http://itween .pixelplacement.com/index.php.

FIG A.15 This image shows the menu system scene that utilizes EZ GUI. Here you can see the panels that were created for each menu option as well as the game rendered in the Game View.

FIG A.16 Here are the menu buttons. By using EZ GUI, these meshes share a texture atlas and material and thus are only 1 draw call.

FIG A.17 This image shows the loading screen menu that is called before the actual game play screen is called. This image contains only 1 sprite and loads either the iPhone 4 or iPhone scene depending on the value that is held in a Global Variable called isHD.

The Game Play Scene

In this section, you can see various elements from the game play scene. In the video walk-through for the app, I will explain exactly how the app was created, which will also cover the coding of the game as well. I created two scenes to support the different resolution of the iPhone 4 and older iDevice generation. The device the user is running the app on determines the appropriate scene to load. It captures this device information in a Static Class and is used throughout the game.

FIG A.18 This is the full scene for the standard definition version.

FIG A.19 In this image, you can see the usage of Beast lightmapping in the scene. Here, you can see that I am checking the resolution of the light-map as it is denoted by the overlaid checker pattern.

FIG A.20 Here is the Prefab for my scene props. This Prefab is distributed randomly around the trash yard by simply copying and pasting elements. Each copy is batched.

FIG A.21 Tater's weapon is not part of the Tater mesh. Instead it is parented at run-time using a script. This gives me the flexibility to add new weapons in game i.e., the user picks up a new weapon.

```
public var hand : Transform;

function Start()
{
    // Create a rotation
    var rotation = Quaternion.identity;
    // Assign a rotation -80 degrees around the y axis and -90 around the z axis
    rotation.eulerAngles = Vector3(0, -80, -90);

    transform.parent = hand;
    transform.localPosition = Vector3.zero;
    transform.localRotation = rotation;
}
```

FIG A.22 This is the actual script that is used to parent the gun to Tater's hand bone.

FIG A.23 To create a shadow for Tater, I did not use a Projector. Instead I created a simple transparent sprite that was parented to the Tater.

FIG A.24 The target was also made into a Prefab. It consists of several small mesh items, a baked animation and Colliders. There is also a script on the target, which when hit, dispatches a message to play the attached animation for the FBX take file and instantiate a particle Prefab for the explosion at the position of the target.

FIG A.25 This image shows the explosion that is created by the instantiated particle emitter.

FIG A.26 This image shows the actual particle emitter that was used to create the explosion effect.

FIG A.27 To create the muzzle flash, I parented a GameObject, which consisted of three transparent sprites to the tip of Thumper. By default, the Mesh Renderer is disabled. When the user hits the fire button, a script toggles the Mesh Renderer for the muzzle flash to on. A coroutine is used to turn the muzzle flash Mesh Renderer off.

FIG A.28 Here, you can see the gate Prefab. This Prefab uses a transparent lightmapped shader that uses alpha testing.

Game Play Controls

A vital aspect of any game is the controls. Programming a control system can be a very complex task, which, depending on your system, can take lots of time to correctly implement. Instead of trying this venture on my own, I turned to the Tornado Twins and UnityPrefabs.com at http://www .unityprefabs.com/. Efraim Meulenberg, founder of UnityPrefabs.com graciously provided me with the 3rd Person Camera Kit Prefab for the book. UnityPrefabs.com Prefabs are not only amazing quality assets, but easily integrate into your own projects. By utilizing their 3rd Person Camera Kit Prefab, I was able to concentrate on the control's graphic elements and bypass the coding altogether, not to mention save tons of valuable time on the project.

FIG A.29 This image shows the control scheme from the UnityPrefabs .com 3rd Person Camera Kit Prefab that I re-skinned to match my game style. It was extremely easy to configure the Prefab as well as replace the graphics.

Index

Page numbers followed by *f* indicates a figure and *t* indicates a table.